Shah 'Abbas
& the Arts of
Isfahan

Anthony Welch

Asia House Gallery, New York:
October 11 - December 2, 1973

Fogg Art Museum, Harvard University,
Cambridge, Massachusetts:
January 19 - February 24, 1974

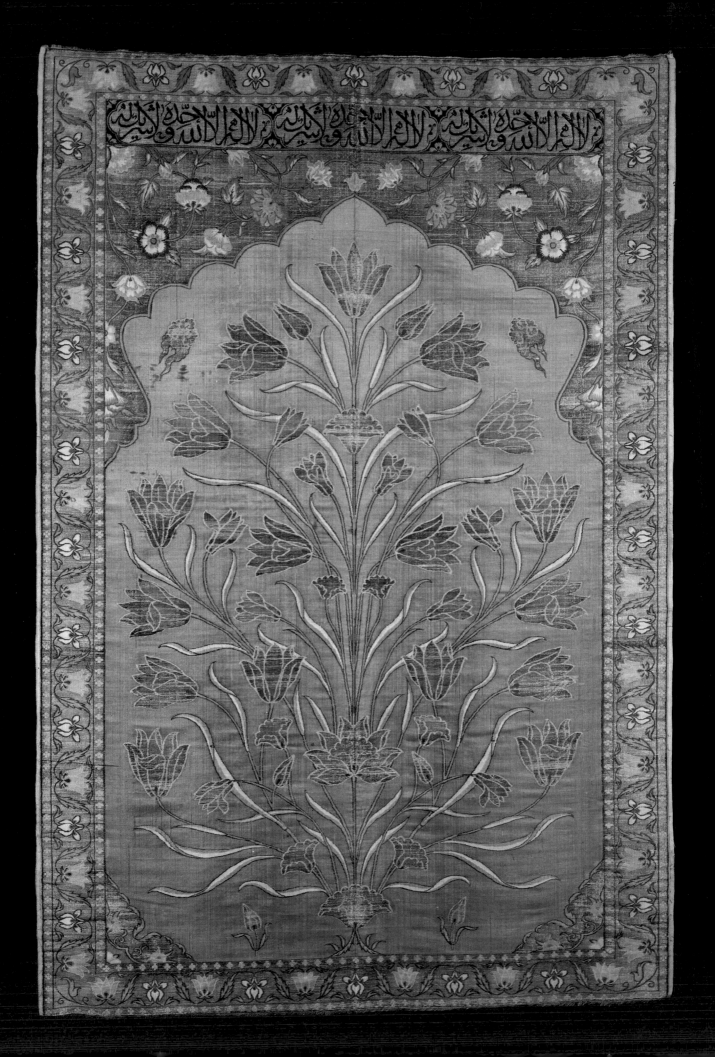

Shah 'Abbas & the Arts of Isfahan

Anthony Welch

The Asia Society Inc.

Distributed by New York Graphic Society Ltd.

Shah 'Abbas and the Arts of Isfahan is the catalogue of an exhibition prepared by the Fogg Art Museum and Asia House Gallery, and shown at Asia House in the fall of 1973 as an activity of The Asia Society, to further greater understanding between the United States and the peoples of Asia.

An Asia House Gallery Publication

This project is supported by a grant from the National Endowment for the Arts in Washington, D.C., a Federal Agency.

The publication of the catalogue has been made possible by a grant from the Mobil Oil Corporation.

20. **Prayer Cloth.** Silk and metal thread. L. 49 in., W. 33 in. *Frontispiece*

Contents

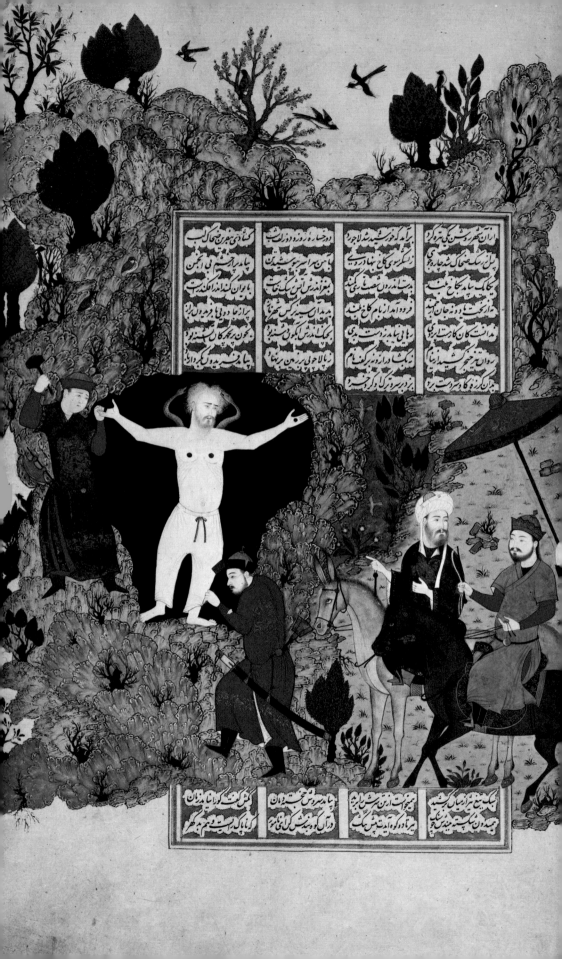

Forewords

Harvard University is fortunate to have a superb collection of Islamic art. It began early in the century when Edward W. Forbes acquired several pages from the so-called Demotte Shahnameh, and it developed rapidly under the Fogg's first Islamic curator, the legendary Eric Schroeder, who, over thirty years ago, published a distinguished catalogue of Harvard's Persian miniatures, subjecting each to rigorous historical and critical investigation. The present curator, Stuart Cary Welch, Jr., has continued to publish, and also to collect, and as a result there is probably no other institution in the United States that can offer such a wealth of original material.

Portions of this remarkable collection are regularly shown to the Harvard community, and all of it is systematically analyzed by students in the courses taught by Cary Welch and Oleg Grabar at the Fogg Museum. Now, one of these former students, Anthony Welch, has assembled an exhibition, "Shah 'Abbas and the Arts of Isfahan," which has two underlying purposes. The first is to focus on one time and one city, thereby examining both in depth and synchronically the multiple facets of individual artistic creativity and a unique cultural expression. The second is to emphasize a group of exceptional works of art chosen from the Fogg and from other museums which have never been seen together; in this way we hope to provide an opportunity to enjoy quality and to contemplate the abstract illustration of the endless possibilities of formal design. Our further hope is that this exhibition will succeed in arousing enough interest in the broader field of Islamic art and culture so that the Fogg Museum and Harvard University will be encouraged to continue their concern for a tradition that is still much too little known in our country.

We are deeply indebted to Gordon Washburn and Virginia Field of the Asia House Gallery, for without their cooperation we could not have undertaken a project so ambitious as this exhibition and its catalogue.

Daniel Robbins
Director, Fogg Art Museum

In presenting "Shah 'Abbas and the Arts of Isfahan," the Asia House Gallery has for the first time collaborated with another museum, The Fogg Art Museum of Harvard University in Cambridge, Massachusetts. We have often shared our exhibitions of Asian art with other institutions, but we have never before been a partner in such a joint undertaking. Had this collaboration not attracted support from both government and private sources, we might not have managed it at all. However, the National Endowment for the Arts, under the guidance of Miss Nancy Hanks, as well as the Mobil Oil Corporation, have each helped to provide us with portions of the aid that was required. The entire project has therefore been dependent on their generous grants, and it goes without saying that both our institutions are profoundly grateful.

These donations have resulted in an exhibition that reveals a remarkable period of art in somewhat greater depth than is usually possible. Most displays of Iranian art have dealt with the whole sweep of Persia's creative history or, like our exhibition of Iranian ceramics which was organized for us by Charles Wilkinson in 1963, have surveyed the story of a single art. Here, instead, we have been able to focus our attention on one notable dynasty and particularly on its chief ruler, Shah 'Abbas I, whose reign encouraged an artistic flowering of a most wonderful richness and beauty.

The exhibition presents, then, one of those moments in human history when a focus of artistic effort was achieved, not unlike that of the Genroku period in seventeenth-century Japan. Perhaps the beauty that was materialized during the Isfahan period may not strike us as one of the noblest expressions of the human spirit, but it cannot fail to charm and even sometimes dazzle us by the vigor of its refinements and the princeliness of its style. A more luxurious art has seldom been produced, whether one examines the paintings or turns to the fabulous textiles, ceramics, and metal objects.

Entering Isfahan through these artifacts, we are in a world beyond anything we will have experienced in our own meager lives—a world not only of exquisite appurtenances but also of much harder realities—of things that are made of steel though they are also inlaid with gold. Even the cruel swords and daggers, we will observe, while obviously sharp, are inlaid with pretty tendrils and flowers. We may look at them as signifying either death or life—or perhaps as both—which is the way things were in Isfahan.

Gordon Bailey Washburn
Director, Asia House Gallery

14a. Zahhak Being Nailed to Mount Demavand (folio 38 from the *Shahnameh* of Firdausi). H. 14½ in., W. 8 in. *Opposite*

Acknowledgements

It is hardly possible to present an exhibition which can give a full picture of the cultural wealth of Isfahan under Safavi rule. Without its buildings no great city can be fully sensed, and Isfahan more than any other Iranian city has been shaped by its architecture. But throughout the seventeenth century it exhibited remarkable cultural homogeneity, and the qualities which characterized its architecture can also be perceived in its artifacts. As a result much of this catalogue's essay attempts to give at least a verbal impression of Isfahan's architecture and of the qualities of the seventeenth-century city itself, while a more detailed investigation of the portable arts which make up the exhibition has been left to the individual entries.

Mention should be made that in the interests of simplicity and readability I have chosen to anglicize Iranian names and terms rather than use scholarly transliterations.

It would be impossible to thank here all of the many people who have made this exhibition possible. To the lending institutions I am grateful for their generosity, as I am to their staff members who gave up many hours in helping me track down the treasures exhibited here. I wish there were space to thank each of them by name. To the private collectors who have so willingly lent some of their prize possessions I am also greatly indebted.

To the two sponsoring institutions—Asia House Gallery and the Fogg Art Museum—I am grateful not only for their enthusiasm for this project but also for their scholarly, technical, and financial assistance. Some five years ago the Fogg's former director, Agnes Mongan, encouraged my first ideas about this exhibition and urged me to conceive of it on the large scale which Isfahan deserves. More recently, the museum's present director, Daniel Robbins, has brought these ideas to fruition, guided my planning of the exhibition, and shared my enthusiasm to the full. To other members of the faculty and staff of the Fogg Museum I am also indebted, not only for continuous, skillful assistance with this exhibition, but also more generally, for my training as an art historian. To two scholars there I am especially grateful. Oleg Grabar and Cary Welch gave constant encouragement, guidance, wise advice, and thoughtful criticism, and for their kindness and readiness to help I am deeply thankful.

The Director of Asia House, Gordon Washburn, enthusiastically supported this exhibition from the beginning and watched over its progress with care. The Assistant Director, Virginia Field, and her staff were responsible for transforming my less than polished manuscript into a book, and their ability to move swiftly, remember countless details, and produce fine work is wholly admirable.

Credit for nearly all the translations occurring in the individual entries goes to Dr. Manoutchehr Mohandessi of Cambridge, Massachusetts, who has not only taught me what Persian I know but who has always been ready to put his profound knowledge of Persian language and literature at my disposal. I deeply appreciate his kindness.

To Alan Gowans of the University of Victoria I am grateful for new insights which have influenced my thinking about this period.

To Gwyneth Welch goes the credit for designing the map of Iran and to Michael D. Willis for the exciting rendering of the Royal Square in Isfahan.

My wife, Muriel, has provided tangible assistance in studying objects and reading my manuscript, but to less obvious and more profound supports this book and exhibition owe their existence.

I should like to dedicate this book to the memory of Eric Schroeder, who taught me that scholarly thought can spring, like poetry, from deep passions, and to the city he also loved, Isfahan, and its future.

Anthony Welch
Victoria, British Columbia

Lenders to the Exhibition

Prince Sadruddin Aga Khan
American Numismatic Society, New York City
Collection of Edwin Binney, 3rd
The Art Institute of Chicago
Cincinnati Art Museum
The Cleveland Museum of Art
Corcoran Gallery of Art, Washington, D.C.
The Detroit Institute of Arts
Fine Arts Gallery of San Diego
Fogg Art Museum, Harvard University, Cambridge, Mass.
Mr. Mehdi Mahboubian
The Metropolitan Museum of Art, New York City
University of Minnesota, James Ford Bell Library, Minneapoli
Museum of Fine Arts, Boston
National Gallery of Art, Washington, D.C.
Nelson-Atkins Gallery of Art, Kansas City, Mo.
The New York Public Library, Spencer Collection
Princeton University Library, Garrett Collection
Mrs. Eric Schroeder
Seattle Art Museum
The St. Louis Art Museum
Textile Museum Collection, Washington, D.C.
Victoria & Albert Museum, London
Worcester Art Museum
Yale University Art Gallery, New Haven

Iran in the Seventeenth Century

Isfahan, Royal Mosque, 1612-38, detail of northwest arcades of courtyard. Photograph by Arthur Bullowa. *Following page*

● Ottoman Sultanate ● Uzbek Khanates ● Safavi Empire Under Shah 'Abbas I ● Mughal Empire

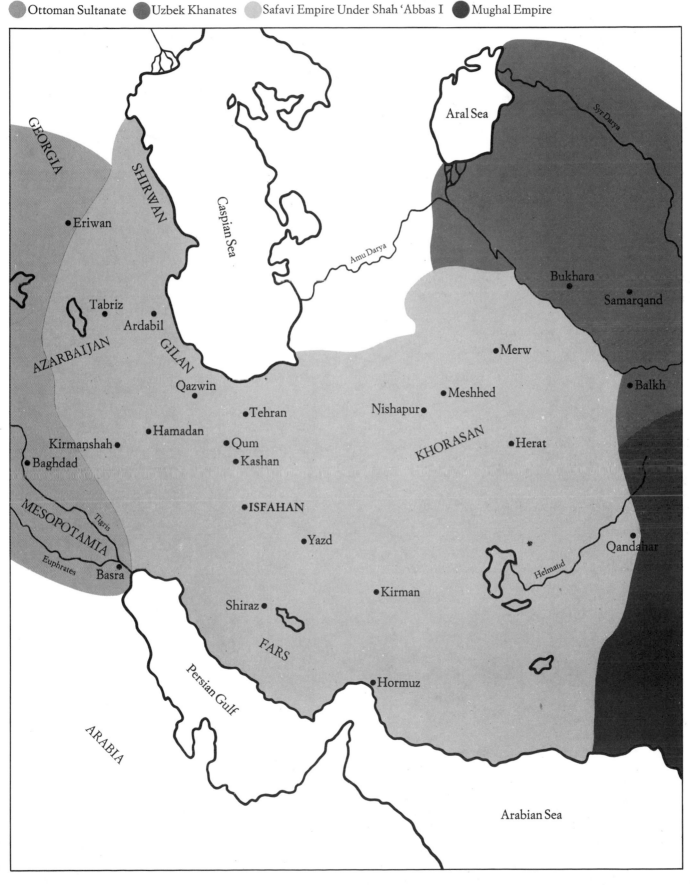

GEORGIA

SHIRWAN

Aral Sea

Syr Darya

Caspian Sea

Amu Darya

Eriwan

Tabriz

Ardabil

AZARBAIJAN

GILAN

Bukhara

Samarqand

Merw

Qazwin

Meshhed

Balkh

Tehran

Nishapur

KHORASAN

Herat

Hamadan

Kirmanshah

Qum

Baghdad

Kashan

●ISFAHAN

Yazd

MESOPOTAMIA

Tigris

Helmand

Qandahar

Euphrates

Basra

Kirman

Shiraz

FARS

Persian Gulf

Hormuz

ARABIA

Arabian Sea

9

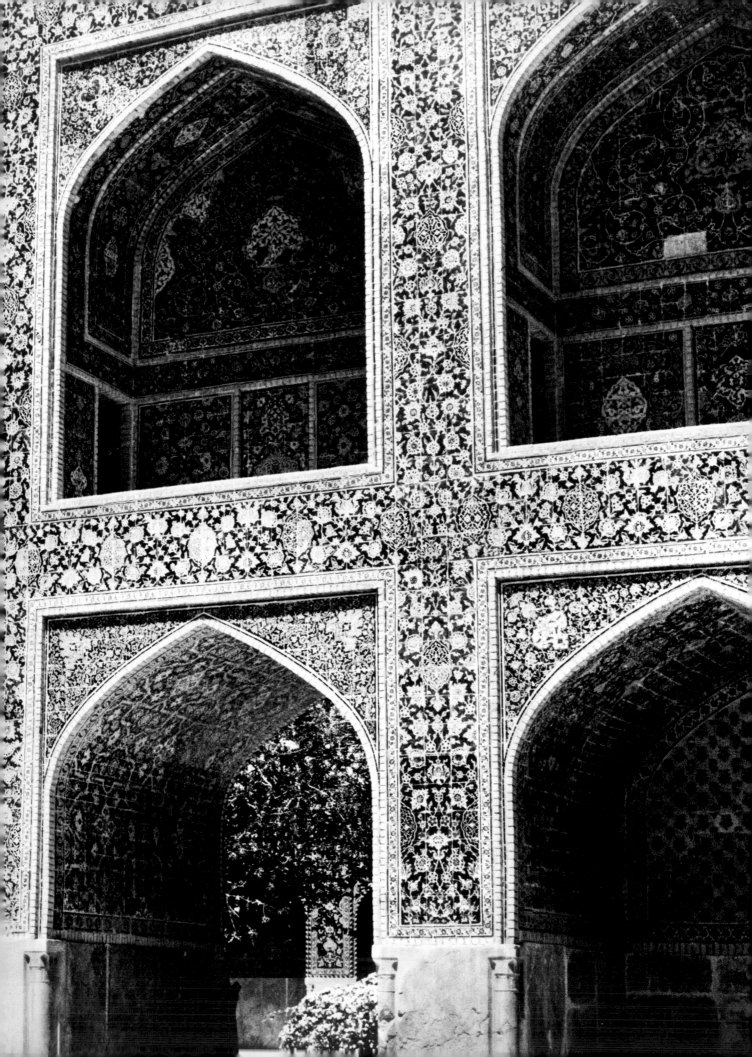

Introduction

The splendors of seventeenth-century Isfahan's buildings are more widely known in the West than any other architectural masterpieces in Iran. They were almost equally famed in the age when they were built, and enjoyed a fabled reputation in all of Europe. Merchants, travelers, and diplomats alike lauded the city's beauties in dozens of accounts, and most of them felt that Isfahan was on a par with the great Mughal Indian cities of Delhi and Agra, and unequaled by anything in Europe. But it was not only buildings which caught European attention. Seventeenth-century Iran's silk textiles were eagerly sought; its pottery was an economic rival to Chinese export ware; and its rich, shimmering carpets softened the floors and decorated the walls of many a noble house in Europe. Although less well known in Europe, Iran's paintings, calligraphies, and metalworks were also the products of careful skill and thoughtful patronage and were emanations of vital traditions reaching back centuries into the country's past.

The "Isfahan period" covers a span of some 125 years from 1597/98, when Shah 'Abbas I (1587-1629) established Iran's new capital in the city, to its conquest in 1722 by the Afghans. An era of remarkable cultural homogeneity and unquestionably the high point of the city's long, rich history, it is a period whose institutions are largely the work of a single administrative genius— Shah 'Abbas I—whose creation was so firm that the next century proceeded almost inexorably after his death. What 'Abbas I founded was neither undone nor markedly amplified by his successors. They lived within his system.

But any student of its history is left with the uneasy feeling that the arbitrary order superimposed by the great Shah concealed slow decay and only delayed what might otherwise have been a swift collapse of the social fabric. On one level there is institutional consistency; on another there is gradual social decay.

Similarly, there was both continuity and instability in the arts, and in the 125 years when Isfahan was Iran's cultural center a tradition was convincingly sustained, even though, after the death of Shah 'Abbas I in 1629, once-dynamic patronage ceased to be creative. But what do we look for in all the richness of Isfahan's art? What guidelines must we keep in mind in order to approach it on its own terms and not to demand of it what it does not purport to offer?

It is preeminently an art of brilliant surface— whether in architecture, painting, textiles, ceramics, or metalwork—an art which for the most part relies on immediate impact, whether to dazzle or startle or shock. The play of light and the concern with surface values of form largely delineate its style, though these can be used with a subtlety which only reveals itself after long observation. It is also an art in transition—using old traditions in new ways and seeking new motifs from other sources, largely European. In the late sixteenth and early seventeenth centuries we find occasional objects and monuments of great profundity but as the century unfolds art deals more often with the exploration of line, light, and color

than with significant content. For the most part it is not an art in search of original forms, and in this aspect it makes a striking parallel with the poetry of Isfahan, whose beauty lies neither in originality of thought nor in profound expression, but rather in verbal brilliance and in novel ways of voicing traditional sentiments.

It is also an art on three levels: the precious, the monumental, and the useful. Some works—especially painting—are intended largely for private perusal; meant to be treasured and admired, they are luxury items for privileged connoisseurs. Other creations—like most of the famed architecture of Isfahan and at least one of its manuscripts (No. 14)—are designed to convey the glories of the state, the power of the monarch, and the strength of the faith. And still others—particularly ceramics and textiles—are "useful" objects of commerce, both national and international, their styles as much dependent upon the taste of foreign consumers as upon Iranian traditions.

It is a complex period, historically fascinating and with arts rich, varied, and provocative. Some of its many aspects will be explored shortly, but we must first turn briefly to the city which is its focus.

Isfahan occupies a choice site. Situated near the geographic center of Iran, its temperate climate, fertile soil, and adequate water supply from the Zayendeh river made it from earliest times a logical area for settlement. Its name was probably acquired in the Sasanian period (226-652 A.D.), when armies ("aspahan") gathered in the fertile plain around the city.

In 643 A.D. Isfahan fell to invading Muslim armies and became part of the vast empire created by nascent Islam within the span of a single century. During the next three hundred years the city changed hands often, passing from one dynasty and feudal lord to another. Only in the tenth century under the Buyid dynasty does its history become clearer and brighter. In the eleventh century it became the principal residence of the Seljuq Sultan, Tughril Bek, and enjoyed lavish patronage: the architectural wealth left by the Seljuq rulers of Isfahan rivals that of the Safavis themselves (1501-1722) centuries later.

During the otherwise brutal Mongol conquest of Iran in the thirteenth century Isfahan, surprisingly, was spared and continued to enjoy reasonable prosperity and high urban rank until the end of the fourteenth century. Tamerlane's savage sack of the city and massacre of its inhabitants in 1387 reduced it to desperate conditions. Under his successors, the Timurids (1405 - ca.1509), the city's fortunes only slightly and slowly improved, for the Timurid rulers of Iran established urban centers in other areas—in southern and northeastern Iran—rather than in Isfahan. And while their great cities, chief among them Shiraz and Herat, developed the styles in architecture and the portable arts which were to form the basis for the achievements of sixteenth- and seventeenth-century Iran, Isfahan itself sank into relative unimportance.

Under the first rulers of the Safavi dynasty in the sixteenth century, however, it once again became a major

Isfahan, Royal Mosque, 1612-38, southeast eyvan. Photograph by Arthur Bullowa.

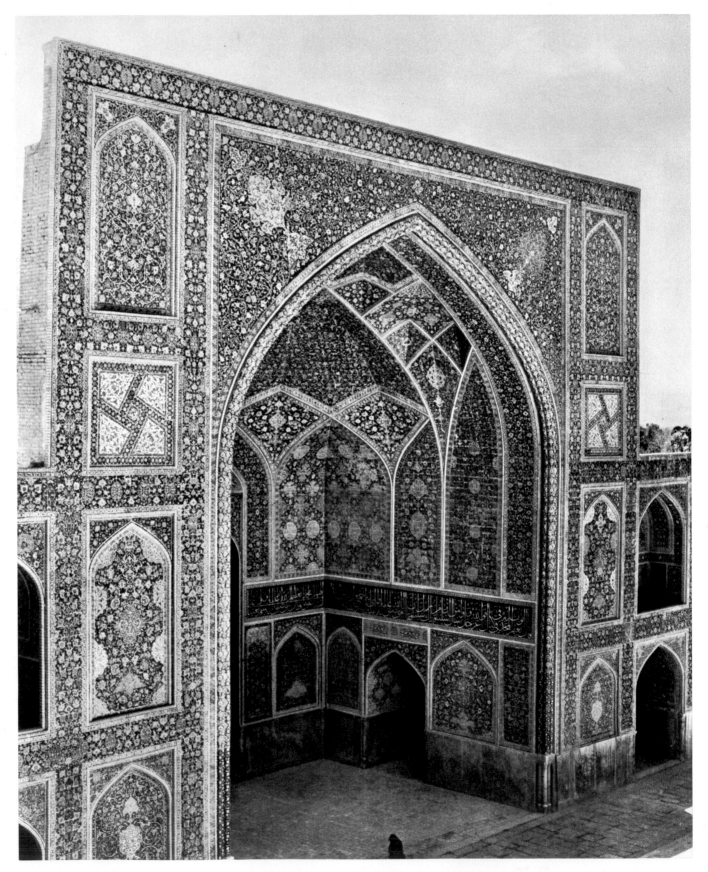

Isfahan, Spandrel from the portal of the Royal Bazaar, early seventeenth century. Nelson-Atkins Gallery of Art, Kansas City, Mo.

center of trade, culture, and manufacture. The city cannot be separated from the dynasty which brought it to its greatest visual glory, and for an understanding of how and why this happened we must turn to the Safavis themselves and link Isfahan to its patrons.

The Early Safavis

The dynasty had deep roots. In the middle of the fourteenth century its founder, Shaikh Safi al-Din, established a devoted religious following in the town of Ardabil in northwestern Iran. For the next 150 years his descendants expanded this Sufi order, increasing its territory, size, and militancy, until by the end of the fifteenth century it had become a serious contender for power in fractionalized Iran. By this time too it had acquired its own distinctive flavor: the Safavis and their followers had accepted Shi'ism, one of Islam's principal sects, which held the Prophet's son-in-law 'Ali and his descendants in special esteem.[1] The Safavis themselves claimed descent from 'Ali and were regarded by their followers as holy figures in their own right. Religiously distinct from the main body of Islam, what was now the Safavi "movement" reached a peak of irresistible force under the charismatic genius of a fourteen-year-old youth who, in 1501, was crowned Shah under the name of Isma'il I.

He created what was in essence a theocratic state and in the process converted the greater part of Iran's population to Shi'a Islam. But though supplied with a new regime and a new persuasion, much of Iran's system did not change. The rulers were of Turkish origin, as they had been for centuries, and spoke Turkish in preference to Persian. There was ill-concealed hostility between the Persian-speaking Tajik population of Iran and the clans of its Turcoman overlords (known as Qizilbash), and animosities could and did break out into brutal slaughters. Ruling over a feudal military aristocracy to whom choice and powerful provinces had been parceled out, the mon-

arch acquired his armies by levies—which might or might not be delivered—and his taxes by arbitrary assessment, threat, and outright confiscation. In short, there was no regular system of government and little central control. When a king lacked the respect or fear of his subordinates, he lost his authority, and distant provinces could defy imperial fiat.

Isma'il's son and successor Tahmasp had none of his father's charisma and personal courage; he ruled by cunning. For fifty-two years he consolidated the Safavi rule and continued his father's policies. The political history of his reign is characterized more by petty intrigues than by noble moments, but its art history is rich and compelling. For the first two decades of his rule Tahmasp, a young and highly sensitive man, seems to have turned to art as a surcease from the endless political responsibilities of his position. As a result his patronage was as significant as his politics.

The art he chiefly favored was the most refined in the early Safavi world, the art of the precious book. Precious manuscripts—each one the product of the collective efforts of painters, calligraphers, paper-makers, illuminators, and binders—had been one of the most highly regarded Islamic art forms for two hundred years, and Tahmasp brought to it a highly developed, determined aesthetic of his own, for he had been educated in Herat, the "Athens" of Iran. He was a gifted, exacting patron who followed his artists' work as closely as if it were his own. As far as we know, other arts under his direction were as carefully encouraged. The tradition of royal Iranian patronage placed the country's most highly skilled

1. Shi'ism basically holds that the caliphate (or succession to the Prophet Muhammad) should have passed directly to Muhammad's son-in-law 'Ali and to his male descendants, the first twelve of whom are known as the twelve imams (or leaders). 'Ali's murder in 661, followed by the murder of his sons and relatives, is the central religious tragedy of Shi'a Islam, a martyrdom still poignantly alive to millions of Shi'as and the focus of the pilgrimage to the Shi'a holy sites of Nejaf and Kerbala in modern Iraq.

Isfahan, The Royal Mosque seen from the 'Ali Qapu Palace, 1612-38. Photograph by Anthony Welch.

Isfahan, Mosque of Shaikh Lotfallah, 1601-28. Photograph by Arthur Bullowa. *Opposite*

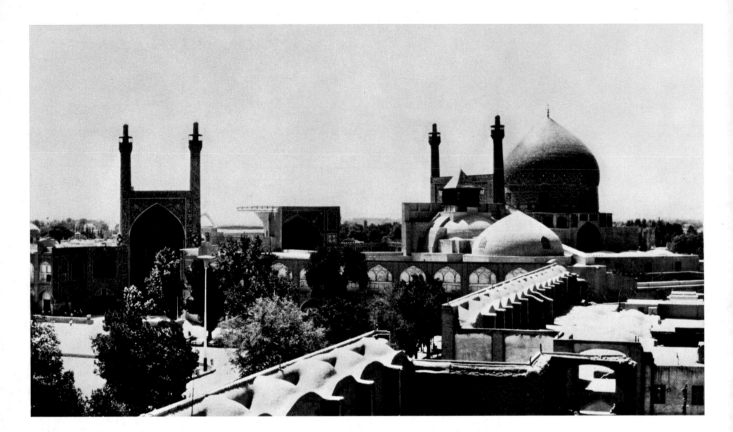

artists in ateliers often actually attached to the royal palace: artists were "extensions" of the ruler's own personality or his own name, for they created objects either for his own perusal or for the glorification of his reign.

Under Tahmasp this highly sophisticated royal patronage reached its apogee. And although a few less-than-major buildings were constructed during his long reign, the focus of Tahmasp's finely honed aesthetic sense was on the creation of beautiful and precious objects—exquisite silk carpets, superb royal robes and silk hangings, a few sumptuous examples of luxurious metalwork, and unequalled manuscripts—all made of the choicest and costliest materials by the most gifted artists in all Iran.

A refined world of rare sophistication and high gentility was created in which the young aesthete-monarch could escape from his ill-fitting role as Shah. To be sure, beauty was created, but it was created at enormous expense, and Iran's wealth during Tahmasp's reign was not great. A considerable portion of the empire's limited resources was expended in the monarch's highly personal and very private "self-expression." New mosques were rarely built; roads were neither extended nor repaired; necessary fortresses and caravanserais were not constructed. Where China was reaping economic rewards from its export wares, Iran's art was being directed into a more narrow channel, and the country's potential wealth in silk production and manufacture was being haphazardly sold or hoarded. Neither were there impressive monuments to the Shi'a convictions which formed the

fundament of the state: no major construction at any of the great Shi'a pilgrimage centers occurred during his reign nor were there any buildings exalting the Safavi state. Instead, much of Iran's wealth served a single aesthetic sense: the artifacts of use and the arts of conviction languished under his rule, while the fine arts of the personal aesthetic flourished.

The decade following Tahmasp's death in 1576 is less remarkable for its patronage than for its political turbulence. The basic disorders of the Safavi state had been subtly controlled by Tahmasp's cunning, but now they surfaced. Turcoman Qizilbash jockied for power, and potential kingmakers surfaced in nearly every province. The Shi'a religious establishment became restive, and the militant Sufi darvish orders were even less governable than before. Even the usually passive Tajiks conspired for more favorable conditions, and minority peoples like the Georgians, Gilanis, and Kurds showed signs of withdrawing vital support. One of Tahmasp's sons, Isma'il II, ruled over this threatening brew for eighteen months, disintegrated under his own fearful paranoia and drug addiction, and was eventually assassinated by a conspiracy of dissident feudal chiefs. Another son, the feeble Muhammad Khodabandeh, ruled only in name. For two years his energetic wife tried to bring the Shah's unruly vassals under control. When she proved too threatening, they murdered her, and for eight more years Iran was dismembered in bitter, fratricidal feuds under the figurehead aegis of Shah Muhammad.

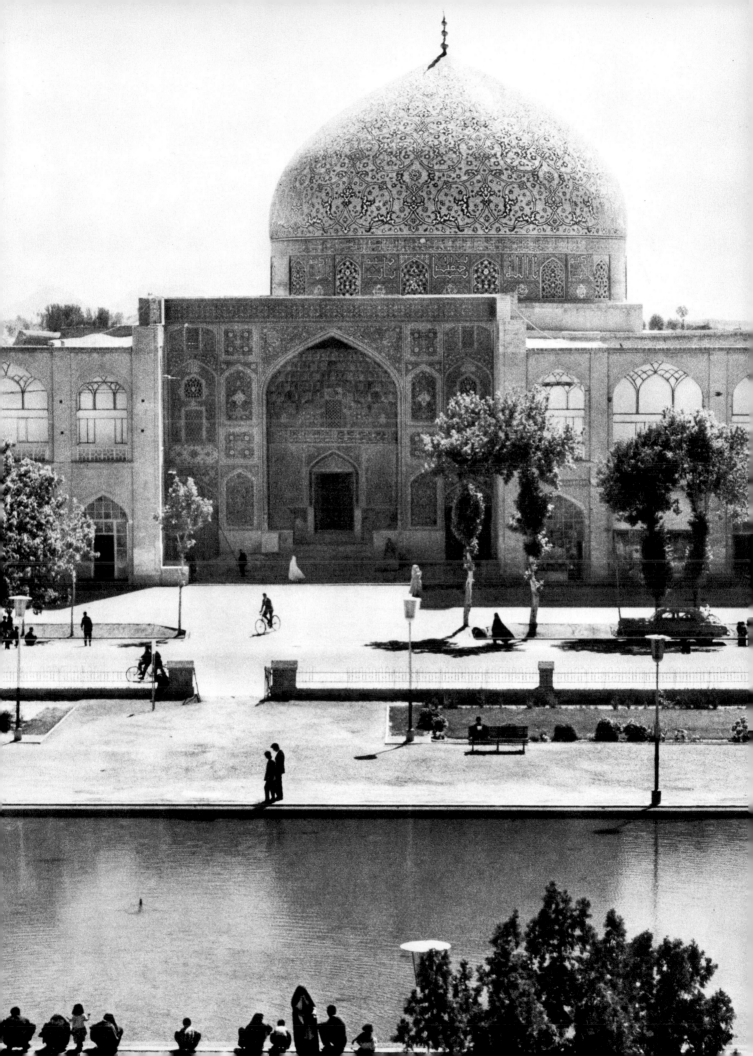

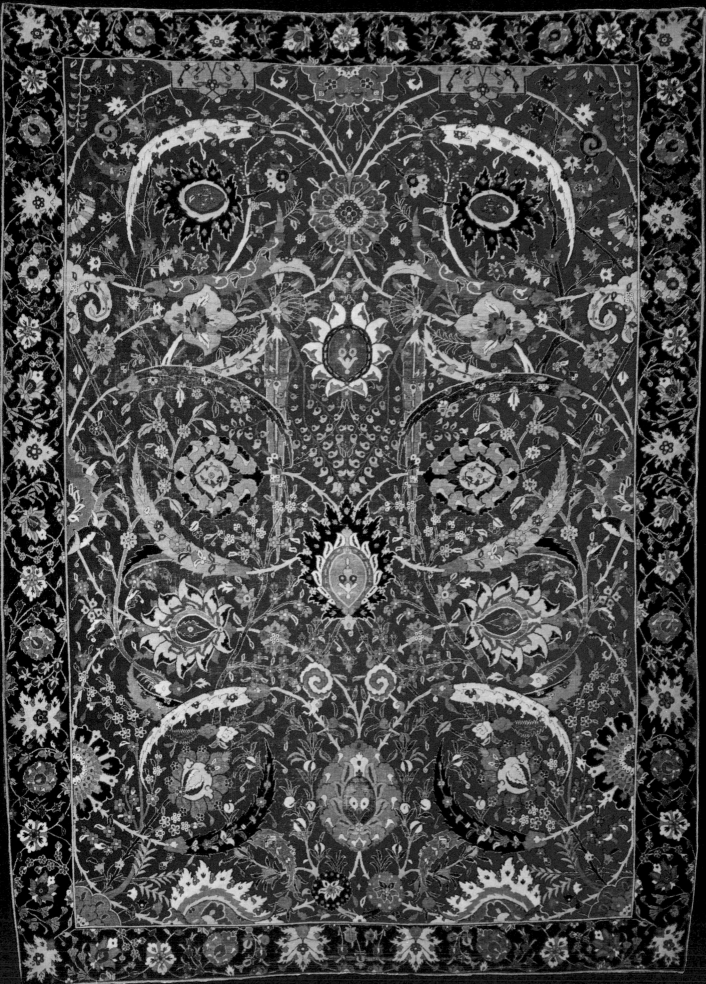

Shah 'Abbas I (1587-1629)

It is clear that the unsteady state of the nation in which Shah 'Abbas (son of Muhammad Khodabandeh and grandson of Tahmasp) came of age affected his reforms in both government and patronage. He was sent off, while still an infant, to Herat to be the princely figurehead under the real control of the province's Qizilbash governor. Well into the sixteenth century this great Timurid city had been the cultural and intellectual center of Iran, the home of its most famous artists and patrons; even under the Safavis, when the artistic focus shifted to western Iran, it still remained a celebrated city. The influence of Timurid architecture, painting, and calligraphy in shaping 'Abbas' taste was crucial.

Undoubtedly the young prince was taught some of the requisite aristocratic accomplishments: he acquired appropriate military skills and developed his physical abilities. (Indeed, European travelers remarked on his superior strength and agility.) He also must have learned something about history, theology, and government. It is clear too that he showed precocity as a connoisseur of the arts. When 'Abbas was seven years old an emissary from the royal court arrived in Herat accompanied by his favorite painter, Habibullah of Saveh. 'Abbas took a determined fancy to the artist's work and unceremoniously appropriated him from his master.

The act was typical of his personality. He was already accustomed to act decisively where he could. At the age of seven this was only in the aesthetic realm, for in the political he was still under the thumb of his Qizilbash protectors. Never more than barely literate, the role of the contemplative royal aesthete could not, however, have been farther from his essential character. He was preeminently a man of action. His passion in life would be not art but politics.

In 1587 the political situation in Iran deteriorated completely, Shah Muhammad abdicated, and 'Abbas was crowned king at the age of seventeen. Ruthlessly, he turned against those who had made (and could unmake) him Shah. Within a year the new king had executed his more unruly underlings and terrified the others into submission. In 1591 he appointed as his grand vizier a gifted aristocrat, Hatim Bek Ordubadi, an honest and determined man who reordered the "system" which had depended upon Qizilbash good will and the Shah's own determination. A central bureaucracy was set up, principally composed of Persian-speaking Iranians, to increase the Shah's control over the entire country. Provincial lands began to change from inherited vassaldoms to grants whose tenure was wholly subject to the Shah's will. The inequitable and inefficient collection of revenue through confiscation and tribute was largely replaced by a careful, regular system of taxation administered by the central bureaucracy.

At first the Shah's reform of the military was restricted to governing his levied forces with an iron hand, rapidly and brutally punishing insubordination or rebellion throughout the country. But within a few years he had established a permanent military force under the command of Allahverdi Khan, a Christian Georgian convert to Islam. Paid directly from the royal treasury, a large portion of the army was made up of Georgians, Tajiks, and lower class youths who owed their advancement solely to the Shah's benevolence. They were fiercely loyal to him. Well equipped and well trained due to the organizational skills of Allahverdi Khan and his English "advisor" Robert Sherley, the army included thirty-seven thousand men and a sizeable musketry and artillery corps. It was a force more than sufficient to pacify Iran's eastern borders, suppress any internal dissidence, and later to humble the mighty Ottoman power to the west.

The power relationships of this period have been too little studied. Can we equate Hatim Bek Ordubadi with Colbert, and Allahverdi Khan with Louvois? 'Abbas' "revolution from above" precedes that of Louis XIV, but it is at least as far-reaching. By the end of the sixteenth century Iran was ruled by an "enlightened despot."

Thus in his late twenties he was near the height of his power. He was not only a decisive military campaigner and gifted administrator and statesman; he was also a passionate hunter, skilled craftsman, perceptive patron, and able conversationalist with a thirst for useful knowledge and a thorough dislike of obfuscation and laziness. Robert Sherley has left us a glowing account of the young monarch:

His person is such as well-understanding nature would fit for the end proposed for his being—excellently well-shaped, of most well-proportioned stature, strong and active; his color, somewhat inclined to a man like blackness, is also more black by sun-burning; the furniture of his mind infinitely royal, wise, valiant, liberal, temperate, merciful; and an exceeding lover of justice, embracing royally other virtues as far from pride and vanity as from all unprincely sins or acts.

We have studied only the governmental portion of 'Abbas' reforms, but in his role as enlightened despot he reached into nearly every facet of Iranian life. While he was always careful to promote his position as head of the Safavi Order and a holy Sufi shaikh in his own right, he also encouraged official toleration. He made frequent visits to the family shrine at Ardabil and repaired the extensive damage done by Uzbeks and Ottomans to the Shi'a holy sites of Meshhed, Kerbela, and Nejaf. But at the same time he welcomed Christian missionaries to Iran, allowed them to preach openly, and even built churches for them. Like his contemporary Akbar in India, 'Abbas apparently enjoyed religious discussion with the Christians and found it amusing to see his own clerics struggle with their arguments. But he was almost certainly more motivated by political considerations: he was profoundly interested in developing commercial and military alliances with Christian Europe against the Ottoman empire.

His predecessor, Tahmasp, had shunned contact with the Christian infidels who had journeyed to his court in

30. "Vase" Carpet. L. 8 ft., 9 in.; W. 6 ft., 3½ in. *Opposite*

17

search of commercial agreements. 'Abbas actively sought them out. Later in the seventeenth century the critical French jeweler Tavernier understood the monarch's motives clearly. He wrote:

Shah 'Abbas, who was a man of great genius and a person of great undertaking, considering that Persia was a barren country, where there was little trade, and by consequence little money, resolved to send his subjects into Europe with raw silks, so to understand whence the best profit would arise, to bring money into his country. To which purpose, he resolved to make himself master of all the silk in his own country by purchasing it himself at a reasonable rate, taxed by himself, and to reap the gains by his factors: and withal, thought it necessary to seek an alliance with the great kings of Europe, to engage them on his side against the Turks.

All of this well directed activity meant augmented revenue for the imperial coffers. Not only was business increased at the royal workshops, but funds flowed in from regular duties imposed on the foreign merchants traveling in Iran.

By 1597 Iran was stronger than it had been for decades, and when an Ottoman ambassador appeared at the royal court in Qazvin (capital of Iran 1548-1597/98) with peremptory demands, 'Abbas shaved off the envoy's beard and sent him packing. The country's new confidence was the prelude for greater advances. Gifted with both vision and energy, 'Abbas determined to move the country's capital to Isfahan. The new seat of authority was a vital embodiment of Iran's new system and new strength, as well as a strategic move to the Persian-speaking center of the Iranian plateau. With a fine climate and bustling commerce Isfahan had already become the richest city in the empire. It was to become richer.

The city's change of status from a provincial to an imperial capital brought a great increase in population. Many of the newcomers were highly skilled artisans who followed their necessary patronage. Others were bureaucrats, literati, and members of the army. Still others came for commercial reasons, and among them were numbered thousands of Armenian Christians, forcibly moved by the Shah from northwestern Iran to Isfahan. These able merchants with far-flung international contacts were the vital center of Iran's expanding commercial activity. Protected by the Shah, who built schools and churches for them, they were relegated to the "suburb" of New Julfa, a portion of greater Isfahan separated from the central city by the Zayendeh river but linked to it by the most important thoroughfare and bridge in the city. But the Armenians were only one segment of the polyglot, cosmopolitan population of the new capital: there were Iranians of all persuasions—Sunni and Shi'a Muslims of various sects, Christians of different inclinations, Jews, and Zoroastrians—and merchants from China, India, Central Asia, Arabia, Turkey, and Europe.

'Abbas did not radically alter the structure of the old city. Instead he chose to build somewhat apart from the center of Isfahan. As a result, the "new" Isfahan which he began in 1597/98 is largely his own creation. The focus of the entire plan is the Royal Square, Maidan-i Shah, a rectangle measuring some 1,664 by 517 feet. Over the space of more than two decades the area was enclosed within a two-storied arcade, and a major building was constructed on each of its four sides. The buildings are symbolic of the supports of the revitalized Safavi state. On the north side is the portal to the royal bazaar, a sprawling "department store" on one level which was the heart of the empire's economic activity, and its size and splendid revetments were a measure of 'Abbas' energetic efforts to stimulate trade and create new manufactures. On the south side is the imposing Royal Mosque, the dominant note of the entire complex and 'Abbas' affirmation of the dynasty's adherence to Shi'ism and of the vital connections between church and state. The west side contained the Shah's palace and offices: it housed the activities of the major bureaucrats and was the administrative heart of the country's new autocratic, centralized system. Across from it, on the east, was the Shah's personal mosque of Shaikh Lotfallah, a jewel-like chapel, stressing the monarch's own "holy" origins and his role as a religious leader of his people.

City planning was, of course, not new in Islam, nor did such ideal conceptions mirror ideal social structures. But if, on the one hand, the Royal Square stridently proclaims the state's official convictions, it also contains elements of subtle and highly personal refinement. The fact that the Royal Mosque was hastily constructed and that much of its tile work is not of the best quality only slightly detracts from its imposing and very public message. But the mosque of Shaikh Lotfallah, the Shah's chapel on the east side, is in every sense a private building, exquisite in conception and sophisticated in execution. In its interior the finest materials were used, and the most gifted craftsmen were chosen to create a superbly refined space for the Shah's personal worship.

Whereas Shah Tahmasp devoted himself almost wholly to the arts of the private connoisseur and cultivated an aesthetic of the utmost refinement, though of little official conviction and less public utility, his grandson 'Abbas functioned with equal ability in all three kinds of patronage.

His personal aesthetic, already highly developed at the age of seven, favored the traditional arts of the royal connoisseur: the graceful innuendoes in the figures of his esteemed painter Riza and the calligraphic mastery of his great scribe 'Ali Riza, who provided the Shaikh Lotfallah mosque with the most brilliant inscription he ever created. Here 'Abbas continued the tradition of those luxurious arts so favored by Tahmasp.

But official convictions, proclaiming the power of the state and its unshakeable religious foundation, were equally important, and as a result 'Ali Riza also worked on the Royal Mosque, though his inscriptions there, like every other detail of the building, are less exquisite than those of the mosque of Shaikh Lotfallah. For in the Royal Mosque it is the overall and overwhelming first impres-

sion that matters; it is a building which was created as a proclamation of conviction and not as a refined jewel-box. Curiously, too, it is not an original structure but is clearly based upon the early fifteenth-century Timurid mosque of Gauhar Shad in Meshhed. It is a grand example of revival architecture with all the accompanying political overtones. While imitating the form of the great Timurid building, 'Abbas was also asserting his own aspirations to recreate the wealth, stability, and size of his dynasty's great predecessor. Surely this is the reason, too, that a number of Timurid-revival manuscripts issued from the royal book ateliers. And like the Royal Mosque the very finest of them (No. 14) makes a stunning first impression but does not wear well.

In the Royal Bazaar on the Maidan we face the third facet of 'Abbas' many-sided patronage—the building of solid, utilitarian structures, essential to the prosperity of Iran. It is in this latter area that the Shah expended his greatest efforts: caravanserais, forts, hospitals, schools, bridges, and roads were built throughout Iran. Most of them were based on tried, traditional models, ably constructed, and intended both to promote the welfare of the people and to encourage trade. Concomitantly the imperial state encouraged the highly economic arts which could be valuable in this trade—those of ceramics, textiles, and carpets. Under 'Abbas these arts became, in large measure state industries, fostered quite as deliberately as Colbert encouraged the textile and ceramic manufactures of Louis XIV's France. In a notable break with the previous tradition of royal patronage, these arts were no longer subject to the aesthetic mandate of the Shah: instead, we find ceramics imitating Chinese designs which were popular in India and Europe, and we are told by Chardin[2] that in the Royal Bazaar ". . . is sold porcelain from Kirman and Meshhed, two great cities of Persia where such fine porcelain is made that it can pass for that of Japan and China. . . . And thus the Dutch . . . mix it with the porcelain of China which they sell in Europe."

'Abbas was establishing Iran's own art markets, partly at least through the imitation of products of other cultures, both Chinese and Ottoman Turkish. But he was also securing home markets, as Iranians themselves had developed a pronounced taste for Chinese export ware. Workshops producing textiles, ceramics, and carpets were set up under state patronage in major cities throughout Iran and, as a result, it is difficult, if not impossible, to determine which of these actually might have been produced in Isfahan. What is certain, however, is that 'Abbas viewed them as important economic assets and that their forms were governed not so much by royal taste as by commercial exigencies—that is, by what would sell both inside and outside Iran.

Perhaps this is one of the reasons why those arts most dependent on the monarch's deliberate aesthetic attention did not flourish in the Isfahan period, and calligraphers, painters, poets, and literati of all sorts left Iran for the richer pastures of India, where royal patrons still offered royal attention and regal rewards. 'Abbas' prede-

cessor, Shah Tahmasp, had been notably uninterested in promoting traditional forms of poetic composition, and as a result his reign had been marked by an impressive exodus of poets to India; in the latter part of his reign, when he also forswore his predilection for painting, some of his most famous artists took the same road. That the same process of emigration was, according to our sources, accelerated under Shah 'Abbas and permitted to continue during the rest of the seventeenth century is striking evidence that the arts of economic advantage flourished in 'Abbas' system, rather than those of the personal aesthetic.

But there is a disquieting quality about much of Iranian art of this period. The great Shah 'Abbas carpets are only rarely of the quality of No. 28. More often they are made less densely, with a brilliant surface appearance achieved through a deep, shaggy, silk pile and a lavish, though technically less than sound, use of gold and silver strands. A shimmering surface was created which, unless treated with utmost care, could soon be worn away.

In textiles, too, technical quality declined in the course of the seventeenth century, although there was a marked increase in production. Though design and surface could be of the highest quality, the weaving itself often was not.

Similarly, Iranian potters never achieved true porcelain, and the porcelain-like ware they did create did not carry with it the strength of its model. Fired at a lower temperature, Iranian glazes were softer and more fragile and developed extensive crackle more easily.

Although extensive use of precious metals had been generally avoided in Iranian metalwork due to religious strictures, fine and deep gold and silver inlays had been used to decorate the surface of baser metals like brass or bronze. Although Safavi craftsmen made an impressive addition to the repertory of materials—cut steel—they relied, except in the finest pieces, on less expensive and less enduring gilding and silvering to decorate metallic surfaces.

In painting, precious manuscripts declined in number, supplanted in part by a preponderance of single-page paintings and drawings, appealing to a more varied public. Royal artists no longer existed solely in the royal employ. Some sold their works to minor patrons and even to merchants, who carried the pages to the bazaars of India and Turkey. Although later Shahs continued to order manuscripts, the books were all too frequently of a less distinguished sort: derivative or repetitive in style, hasty in technique, and less lavish in materials than work of the sixteenth century.

Less lavish patronage, as well as increased commercial interest, undoubtedly exerted a major influence on the arts of painting and drawing. Drawings were far more abundant in the seventeenth century than ever before, perhaps because they were cheaper. Were idyllic images of beautiful, listless youths so popular because a more

2. J. Chardin, *Voyages du Chevalier Chardin en Perse*, ed. L. Langlès, 10 vols. (Paris, 1811).

Plan of the Royal Square, Isfahan.

'Abbas's architectural masterpiece was built on a north-south axis. This plan presents a view toward the entrance to the Royal Bazaar on the north side; the Bazaar's portal spandrel is reproduced here (page 13). On the west side is the governmental palace of the 'Ali Qapu, and across the square on the east is the Mosque of Shaikh Lotfallah. Occupying most of the south side is the huge complex of the Royal Mosque. Due to the strict north-south orientation of the Square, each of the two mosques fronting on it had to be tilted on its axis so that its qiblah (prayer wall) would face toward Mecca.

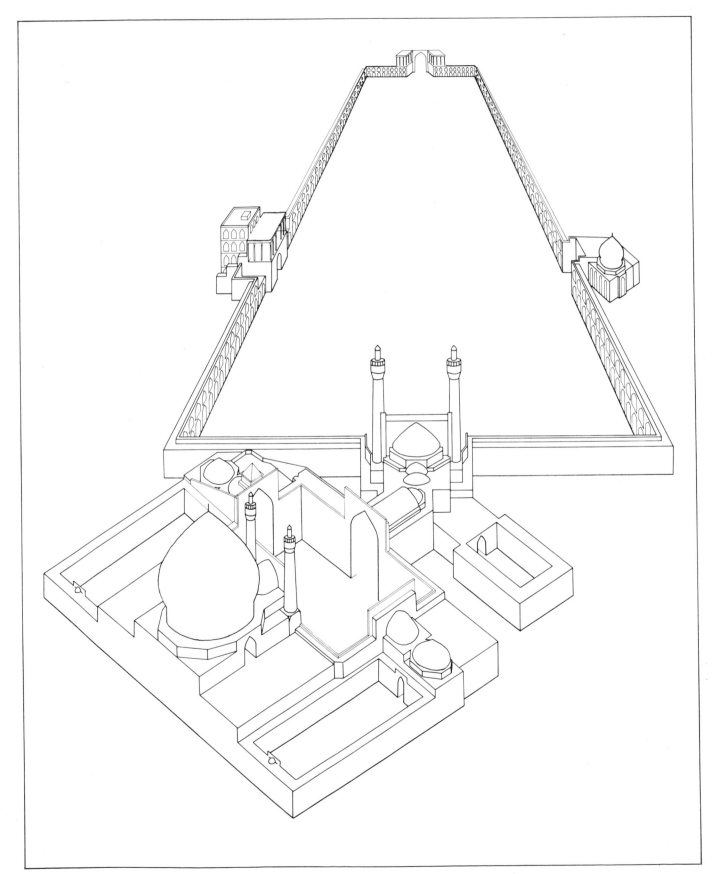

materialistic and less spiritual middle class aspired to symbols of ideal aristocratic elegance? Signed work became the rule, rather than the exception it had been in earlier times. Aristocratic patrons had no need for signed work: they recognized an artist's hand by his work, not by his signature. Did a less connoisseurly buying public in the seventeenth century need artists' names, and did merchant "art dealers" require (or add) them in order to sell the works? There was also unquestionably a greater sense of artistic individuality: Sadiqi for one signed his work, wrote autobiographical prose and poetry, and sold his paintings and drawings through Isfahan merchants who carried them as far as India. The artist as "creative genius" is almost as evident in seventeenth-century Iran as in the West.

And what of architecture? Neither 'Abbas' great Maidan nor that Square's largest building—the Royal Mosque—is an original conception: both lean heavily on Timurid models. Like its European contemporaries, Safavi Isfahan architecture is largely a revival style, an attempt to re-create specific bygone forms, as much for their ideological overtones as for their appealing shapes. Less than original, it can also be less than fine. Built hastily to complete the monarch's grand designs, 'Abbas' buildings often suffer from severe structural weaknesses, and even the finest of them—the Mosque of Shaikh Lotfallah—rests on a shaky foundation. Painted tiles (far less costly than earlier mosaic faience) clothe the structures of later Safavi architecture: they work effectively at a distance but often disappoint when seen close up. Yet viewed from a proper distance this architecture creates images of dazzling beauty, where reflecting surfaces catch light in brilliant color in a way strikingly similar to Safavi textiles and silk carpets. Structure becomes indistinct, even visually unimportant, and the repetitive surfaces of the glistening tiles become translucent visions, disembodied and ethereal.

Thus in many respects seventeenth-century art in Iran relies on surface values, on strong first impressions, on a glittering and overwhelming impact that may not bear up well under detailed examination. The real material and technical opulence of the less abundant arts of the sixteenth century was converted into something showier but less rich. Cheaper materials and techniques were employed; greater numbers of objects were produced by active state and royal workshops; but quality and subtlety were often markedly diminished.

Is this the reason why images of luxury, of idle wealth, of dreamy (and often brainless) sophistication abound in seventeenth-century painting? Is this why both exotica and erotica flourished under the later Safavis, lending "shock value" to an art whose real content had worn dangerously thin? The subtlety in Riza's early work, still reminiscent of the previous generation of Safavi painters, was altered into surface values in his later pages: curves are less volumetric; pigment is less rich; expressions coarsen and become less winning. In the work of his many students and followers these trends are emphasized.

There is a narrowing rather than an expansion of subject matter, which comes to rely heavily on images of external beauty—delicate young men and wistful young women who seem to assume the role of secular icons. Svelte in appearance but vapid in content, they are the evident ideals of the new social order. Where they are explicitly erotic, as they often are, their activity conveys an unreal feeling—titillating rather than passionate, like so much of later Safavi poetry with its endless verbal niceties, its sleek innuendoes, its innumerable posturings around an absent center. It is, largely, an a-spiritual art, requiring not an eye searching for meaning but one receptive to beautiful form.

1. Seated Princess. Sadiqi Bek. H. 13⁹⁄₁₆ in., W. 8⅞ in.

4. Different Kinds of Spirit. Ascribed to Muhammadi. H. 8⅜ in., W. 5⅜ in. *Opposite*

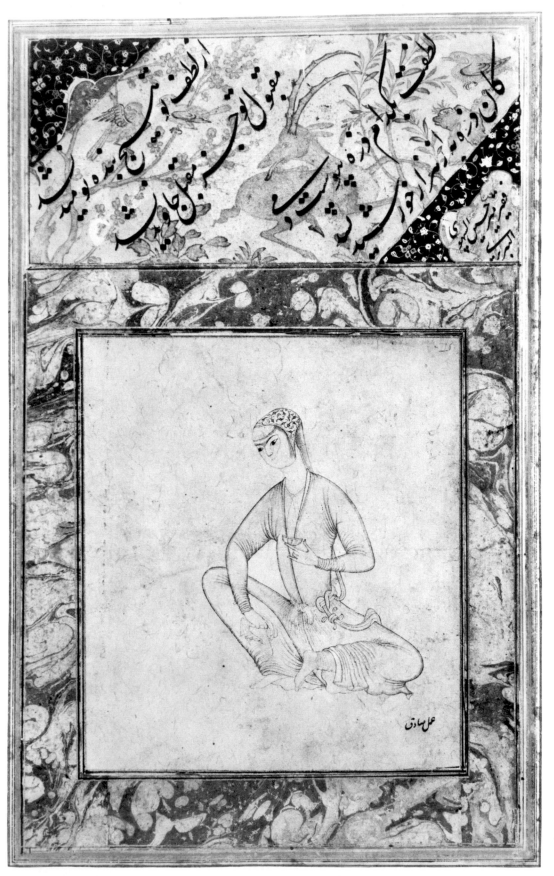

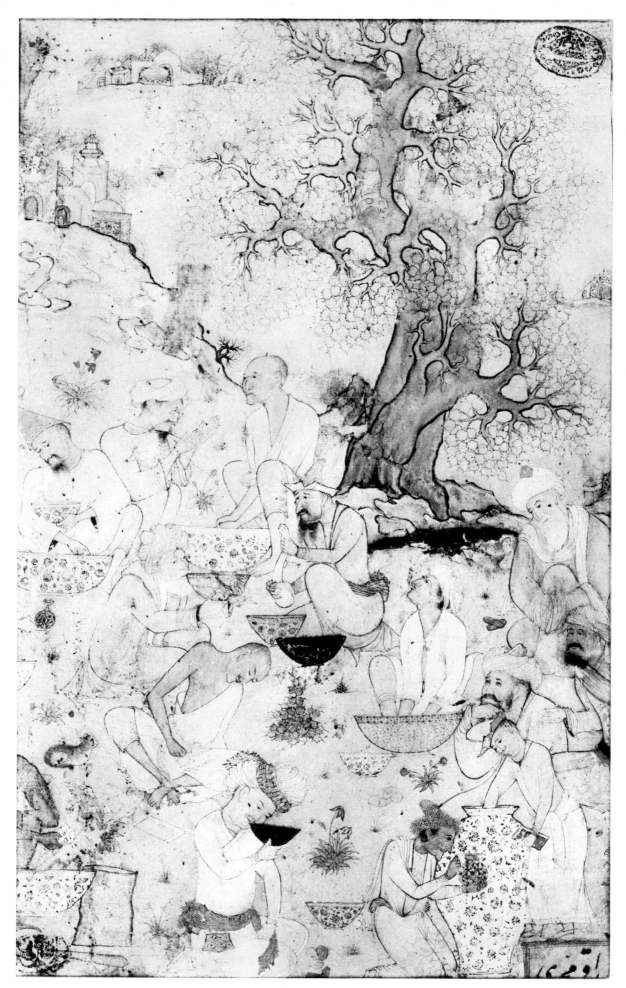

23

2. Seated Man. Sadiqi Bek. H. 4 in., W. 7 in.

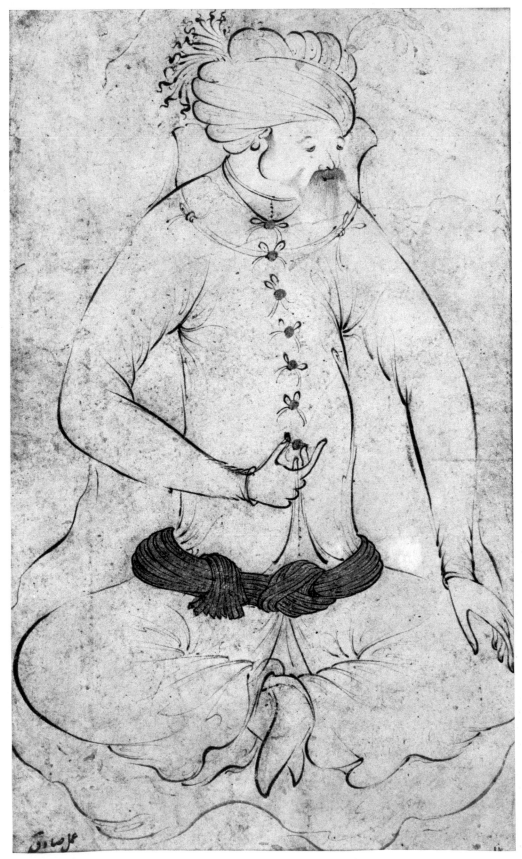

5. Youth in Red Shoes. Attributed to Mirza ʻAli. H. 4½ in., W. 2⅜ in.

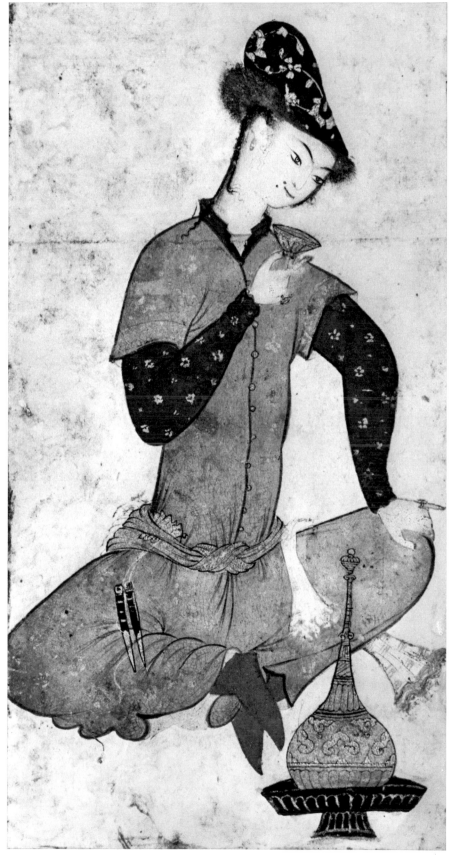

8. Man with a Ram. Riza. H. 5⅞ in., W. 8⅞ in.

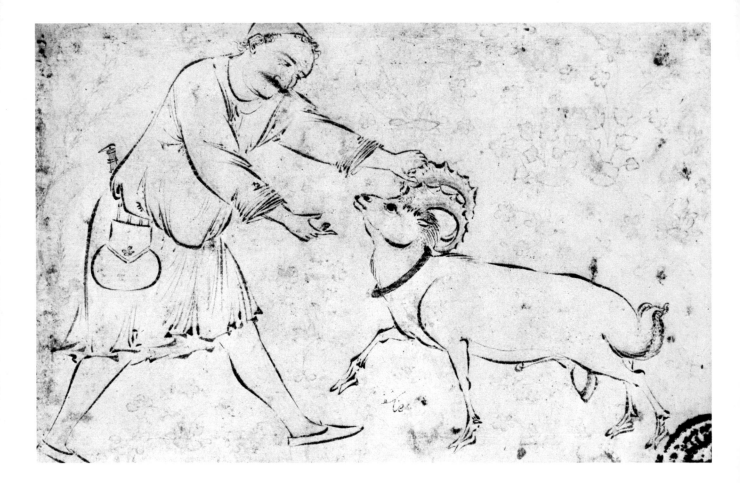

3. Lion Tamer. Attributed to Sadiqi Bek. H. 5¾ in., W. 9¼ in.

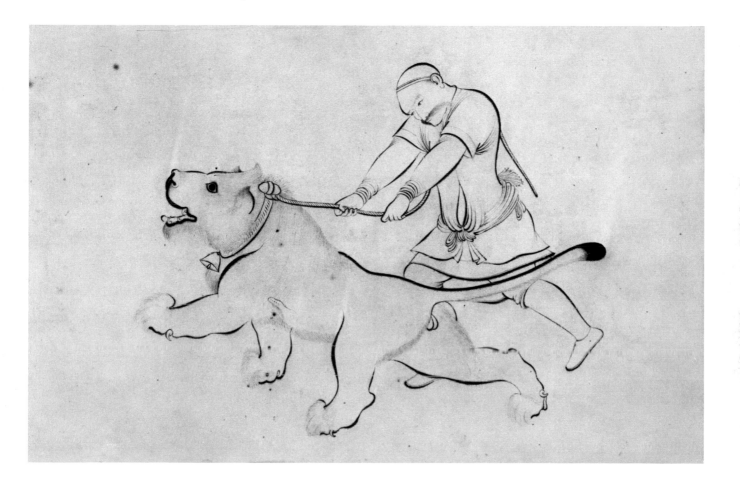

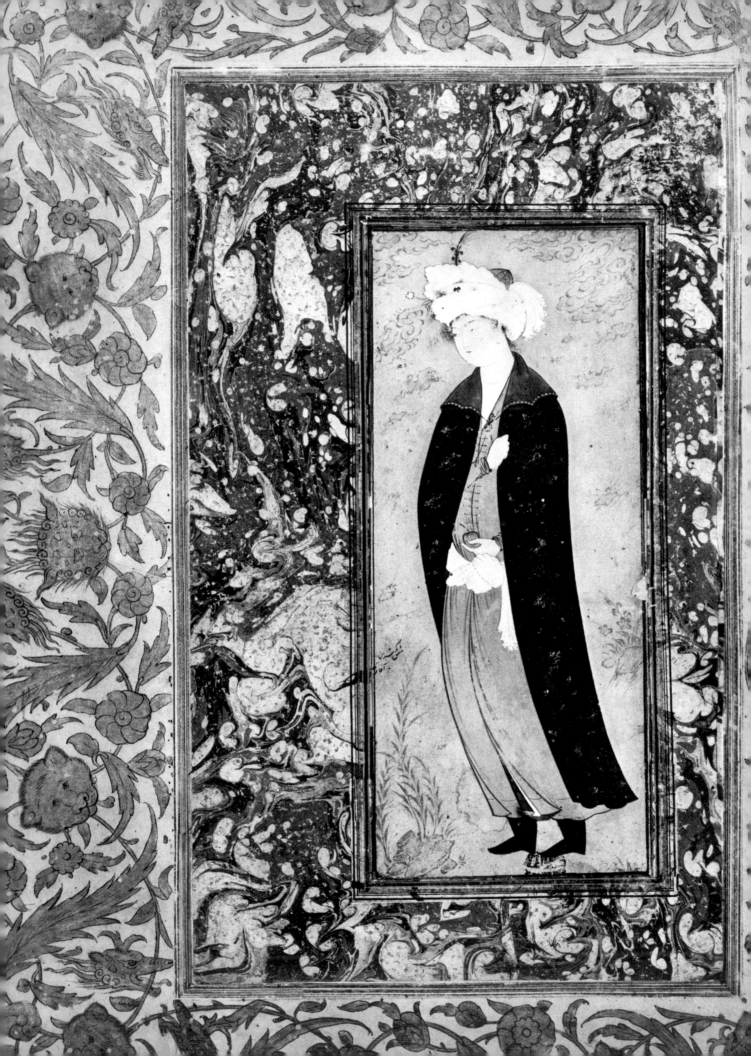

6. A Young Man in a Blue Cloak. Riza. H. 13⅝ in., W. 8¾. *Opposite*

12. Portrait of Nashmi the Archer. Riza. H. 8⅞ in., W. 5¼ in.

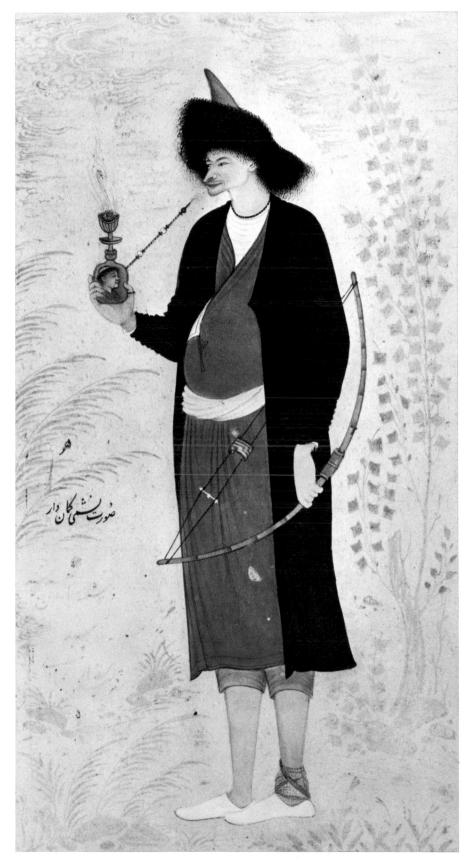

7. Daydreaming Youth. Riza. H. 5 in., W. 3 in. *Left*

10. A Monkey-trainer. Attributed to Riza. H. 4⅟₁₆ in., W. 4⅟₁₆ in. *Right*

9. A Woman with Beads. Riza. H. 7½ in., W. 3⅜ in. *Opposite*

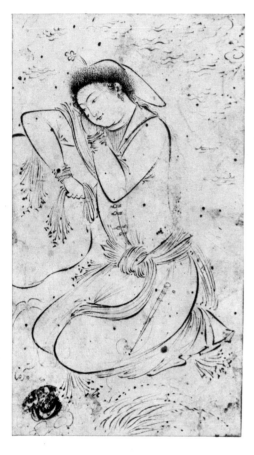

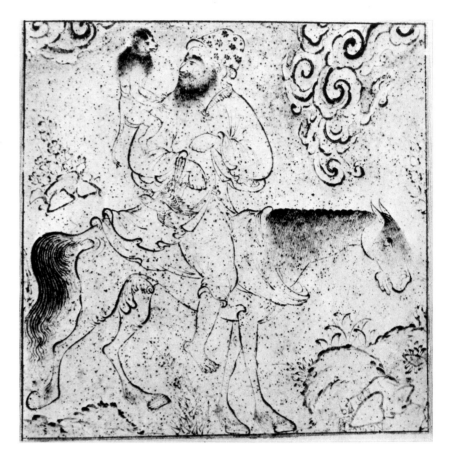

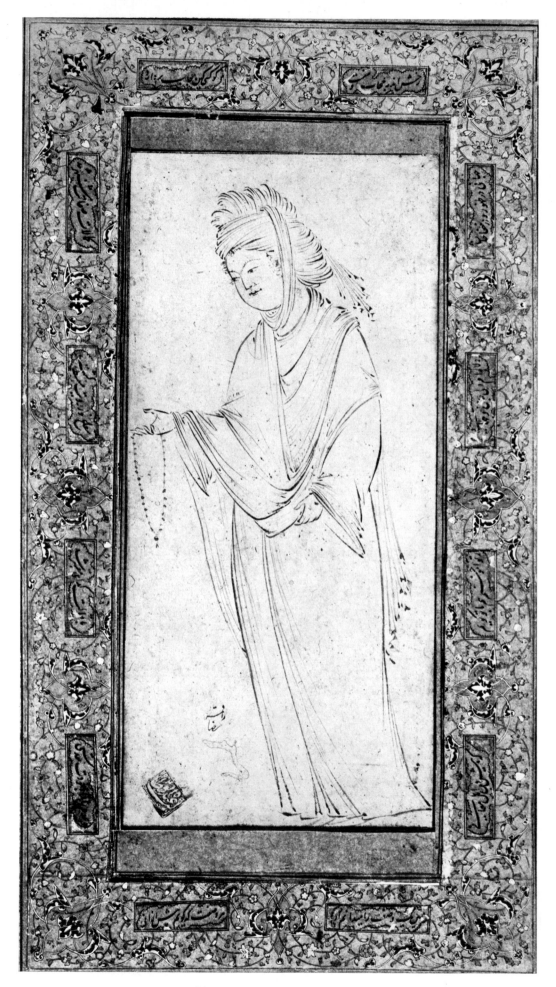

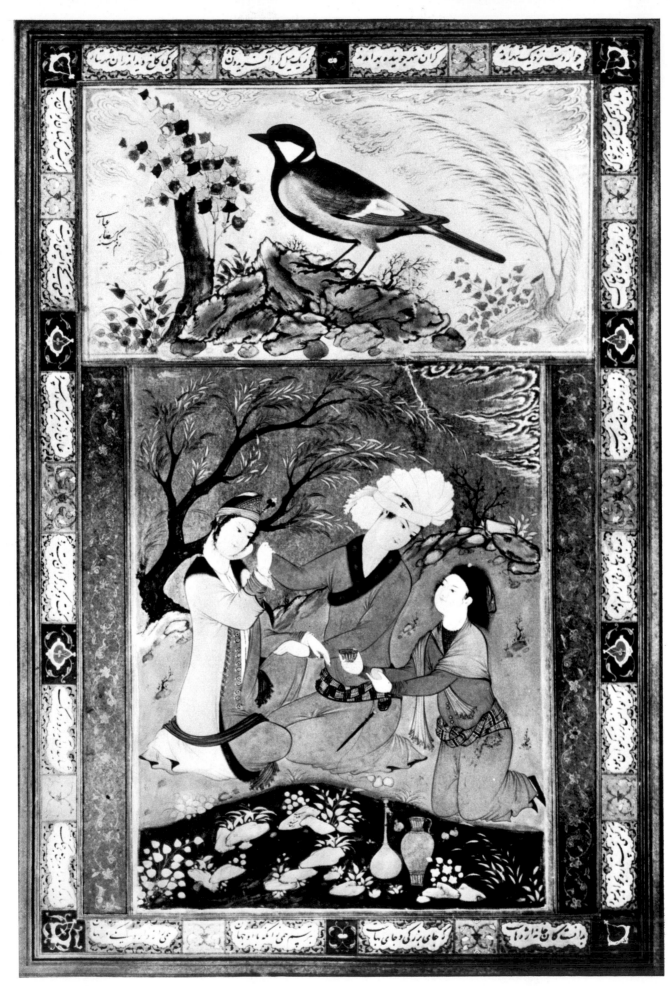

11. Lovers in a Landscape and Bird on a Branch. Riza. H. 13¼ in., W. 8¾ in. *Opposite*

14b. Rustam Killing the Dragon Arzhang (folio 138 from the *Shahnameh* of Firdausi). H. 14½ in., W. 8 in.

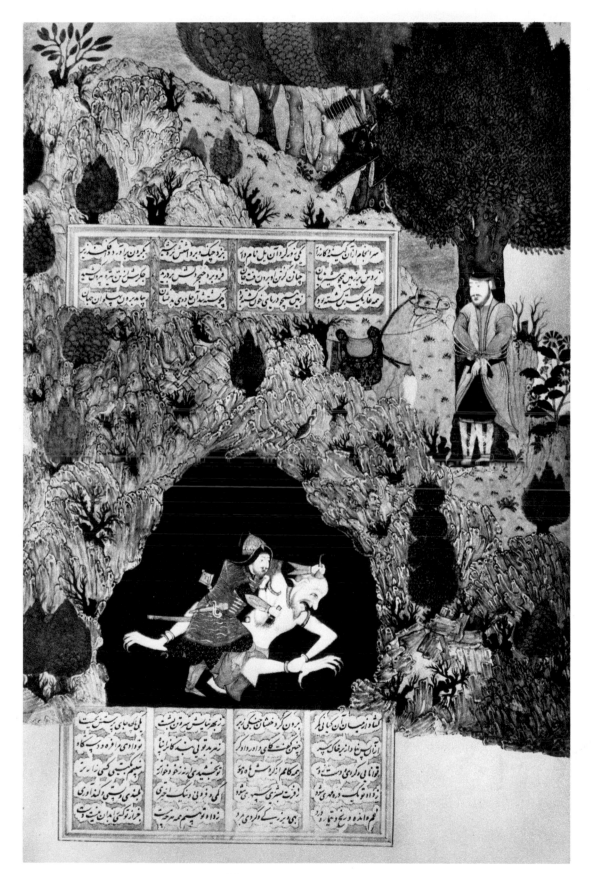

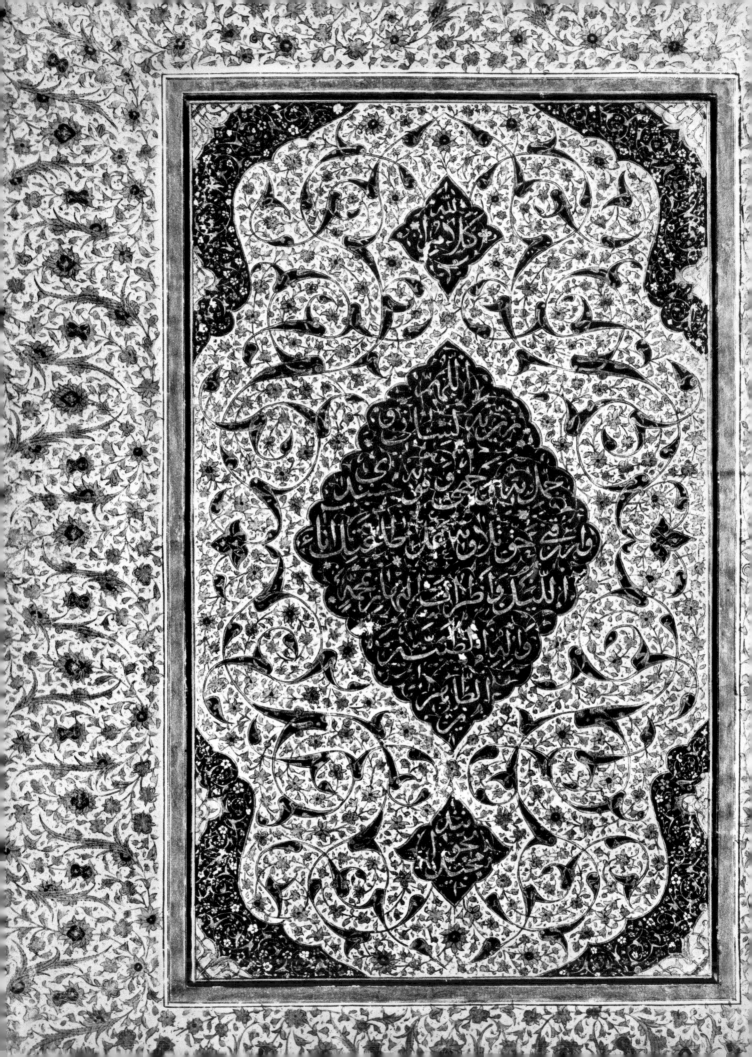

18. Dedicatory Page from a *Qur'an*. H. 11⅞ in., W. 7½ in. *Opposite*

16. Calligraphy. Attributed to Mir 'Imad. H. 10¾ in., W. 5¼ in.

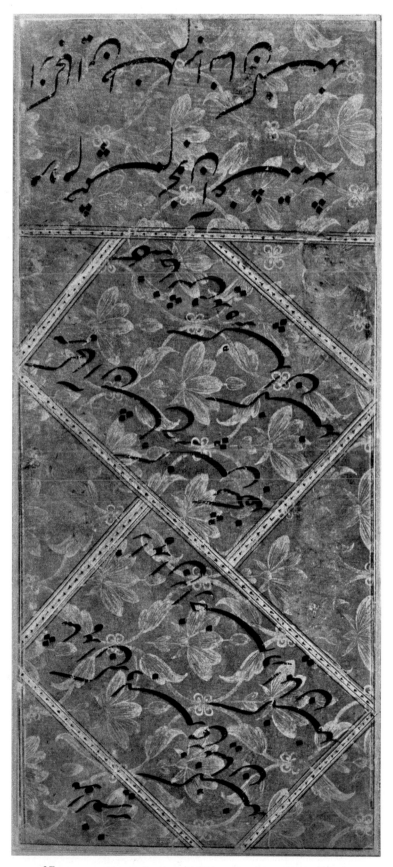

19. Boats at Sea. Double cloth. L. 8⅝ in., W. 5¾ in. (Both sides are illustrated.)

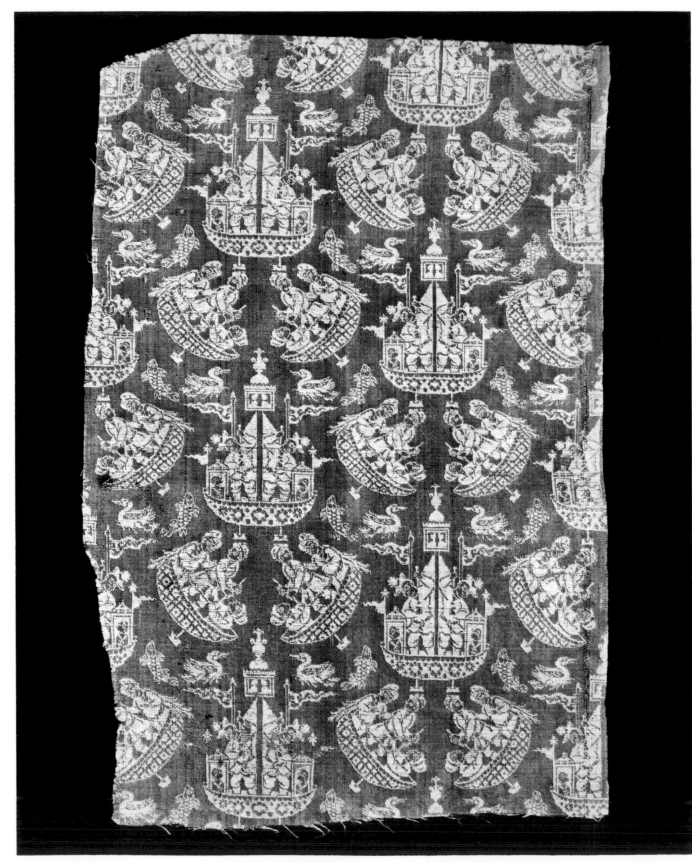

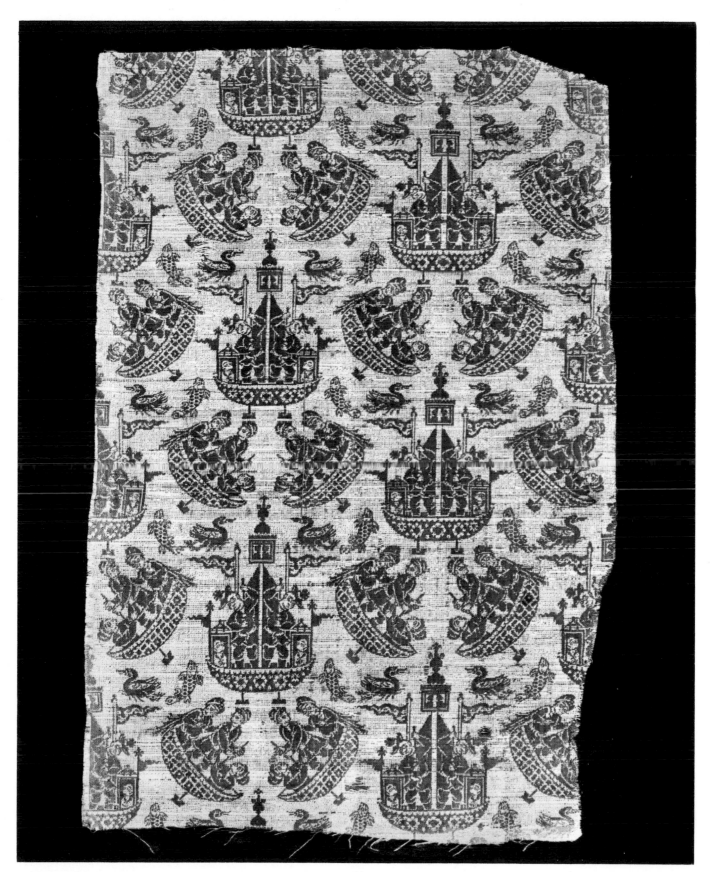

24. Prayer Cloth. L. 57 in., W. 38½ in.

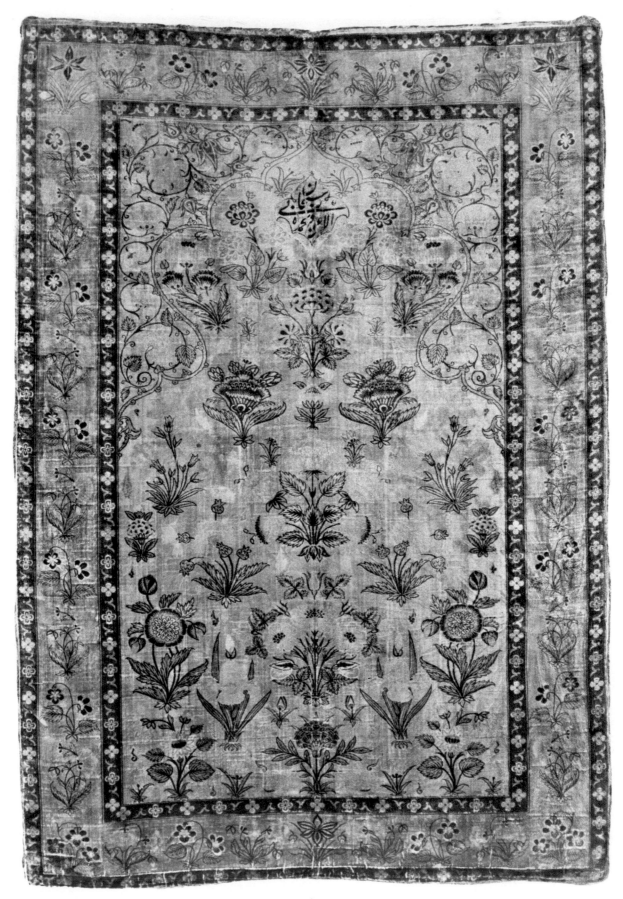

26. Silk Kilim or Tapestry Rug. L. 7 ft., 5½ in.; W. 4 ft., 3½ in.

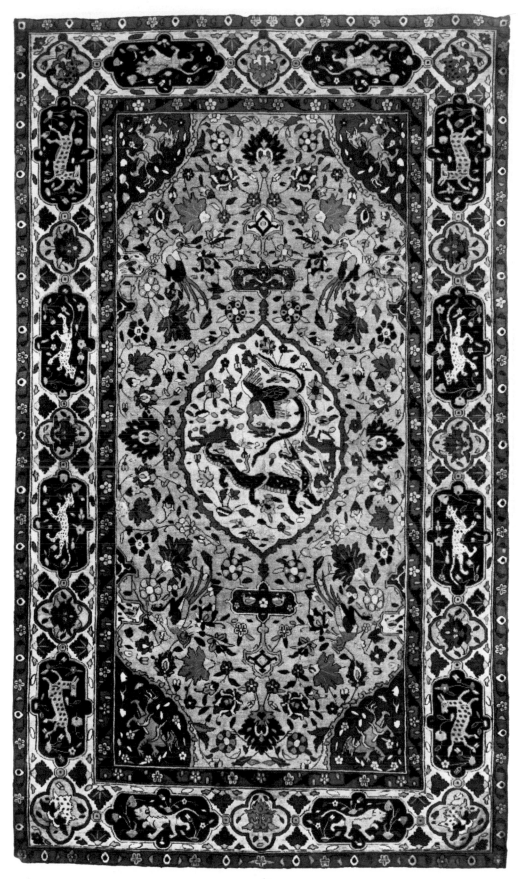

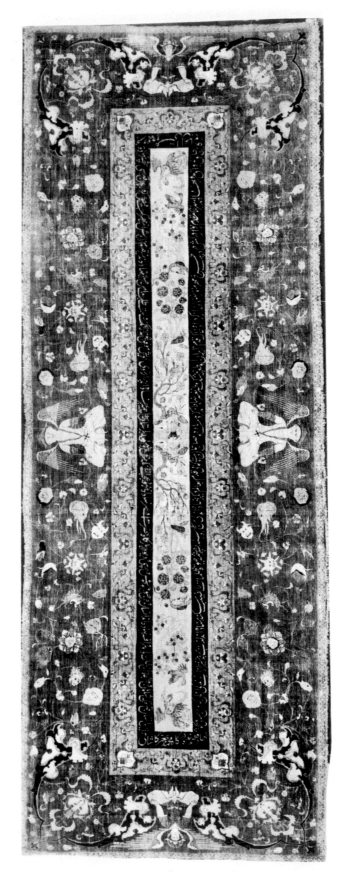

28. "Shah 'Abbas" Carpet. L. 13 ft., 2½ in.; W. 5 ft., 8½ in.

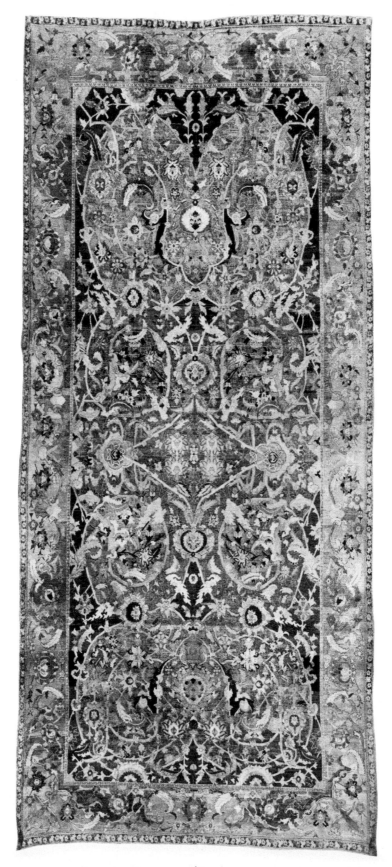

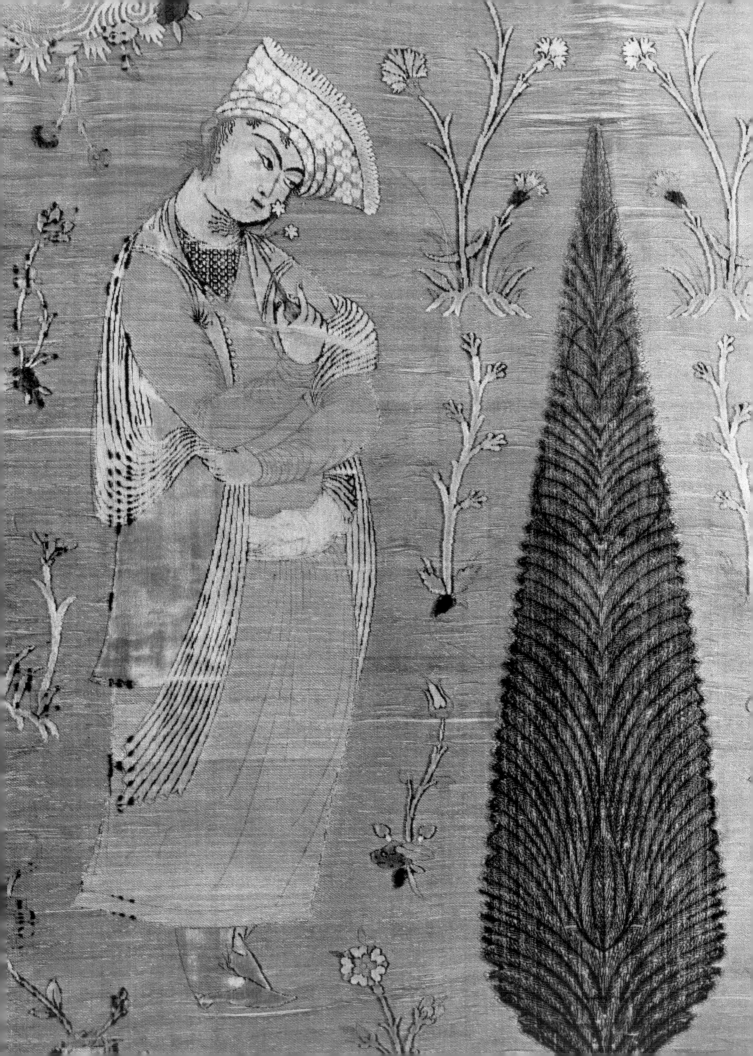

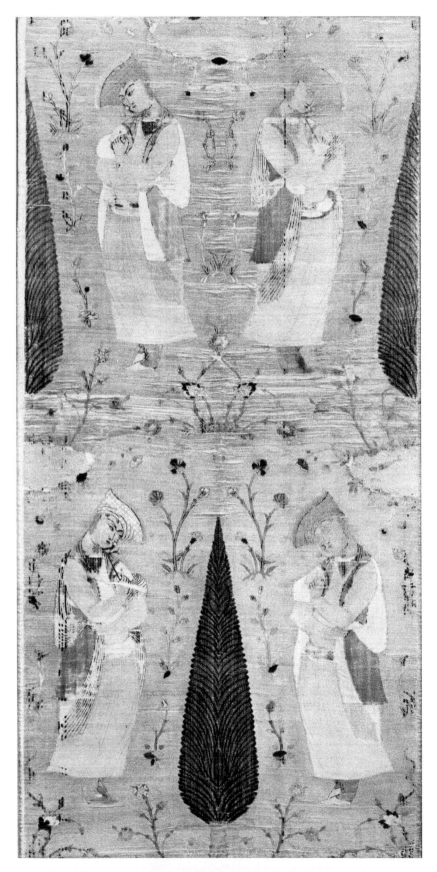

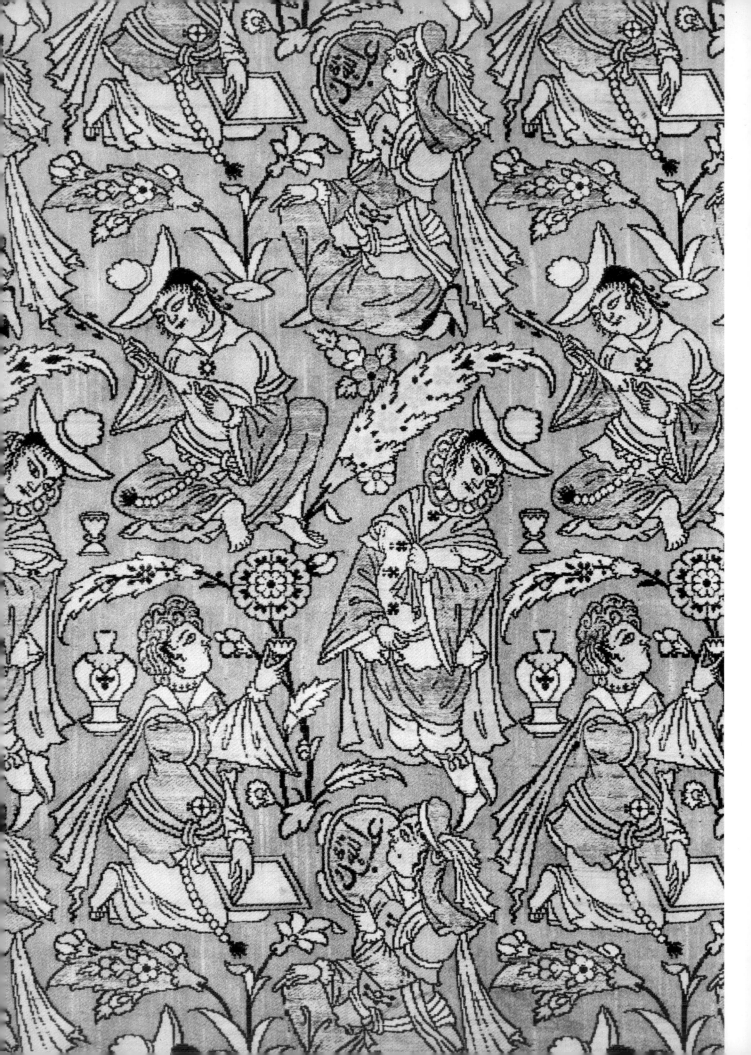

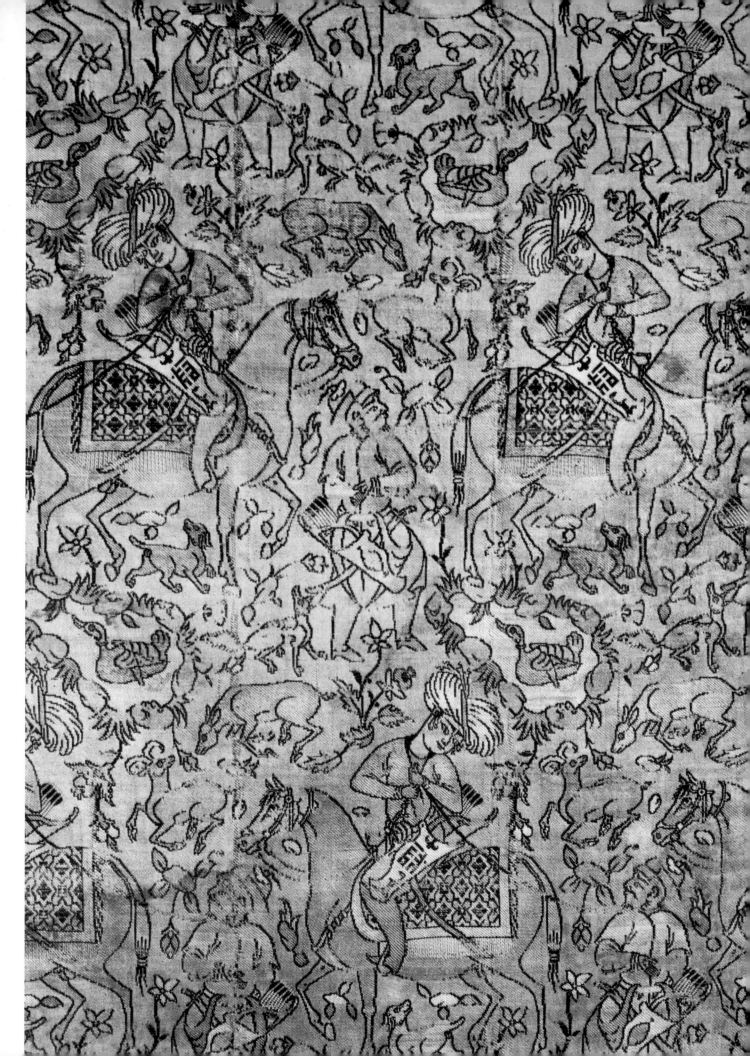

27. Fragment of an Arabesque Carpet. L. 4 ft., 6 in.; W. 4 ft., 5½ in.

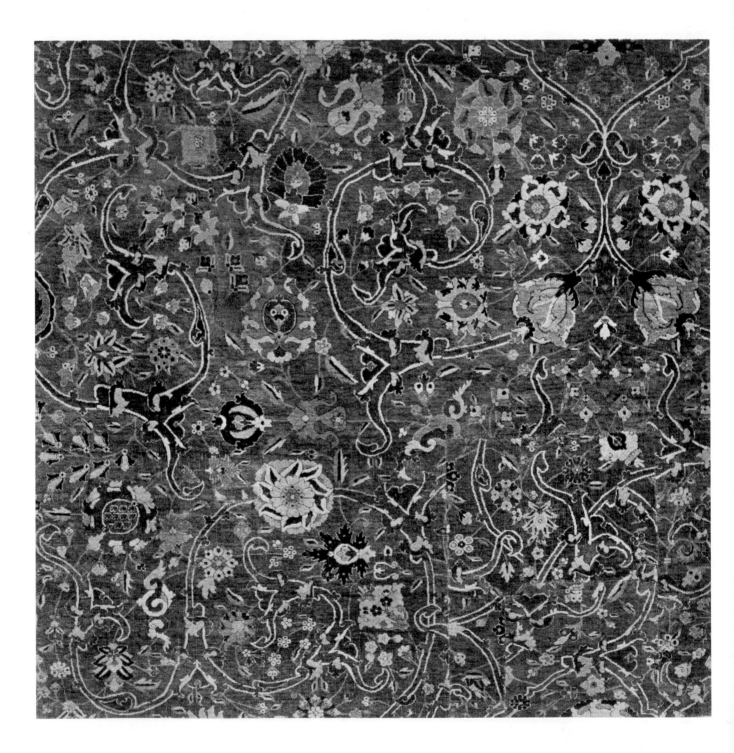

29. "Vase" Carpet. L. 21 ft., 8½ in.; W. 8 ft., 3 in.

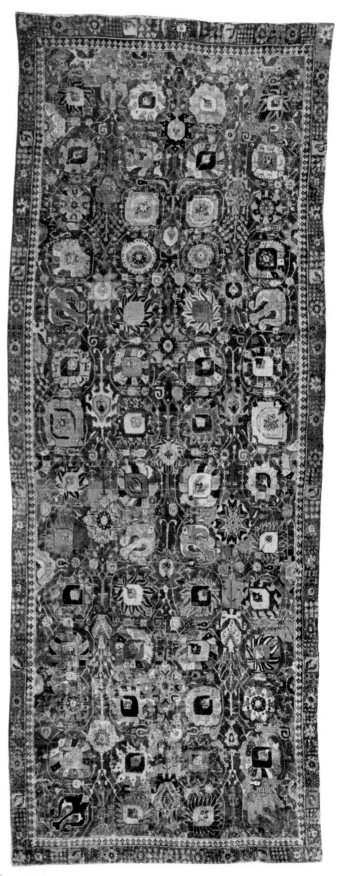

32. "Kubachi" Plate. Diam. 13 in. *Above*

31. "Kubachi" Polychrome Plate. Diam. 16⅝ in. *Left*

33. "Kubachi" Blue and Buff Plate. Diam. 14 in. *Right*

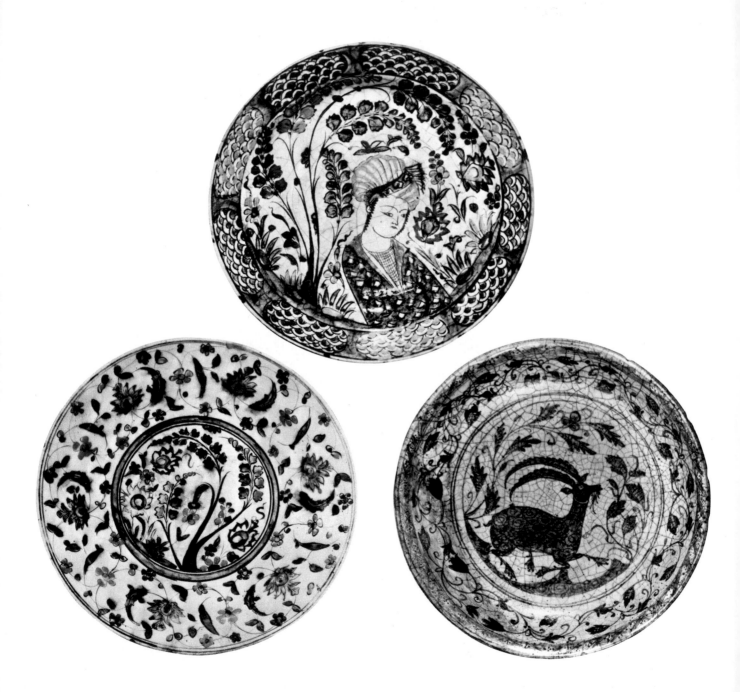

34. "Celadon" Flower Vase. H. 14⅞ in.

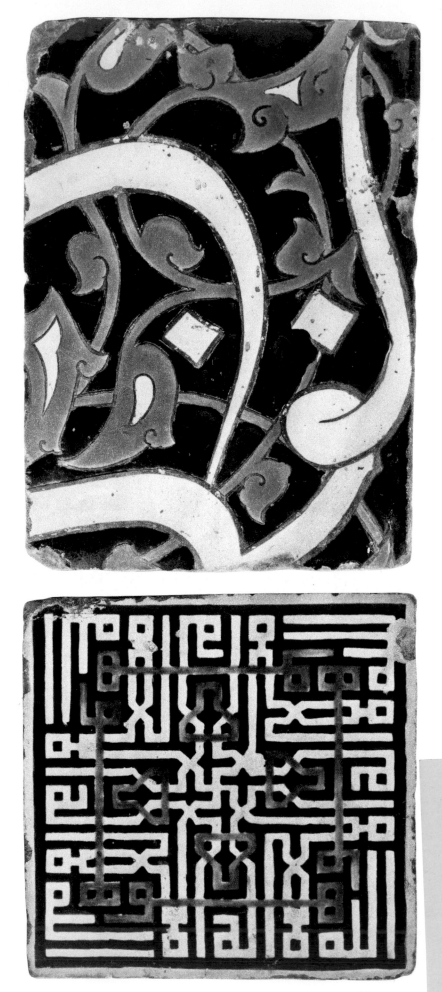

35. Calligraphic Tile Fragment. H. 10½ in., W. 15 in. *Opposite above*

36. Calligraphic Tile. H. 14 in., W. 14 in. *Opposite below*

40. Copper Disk from an Astronomical Instrument. Diam. 31½ in.

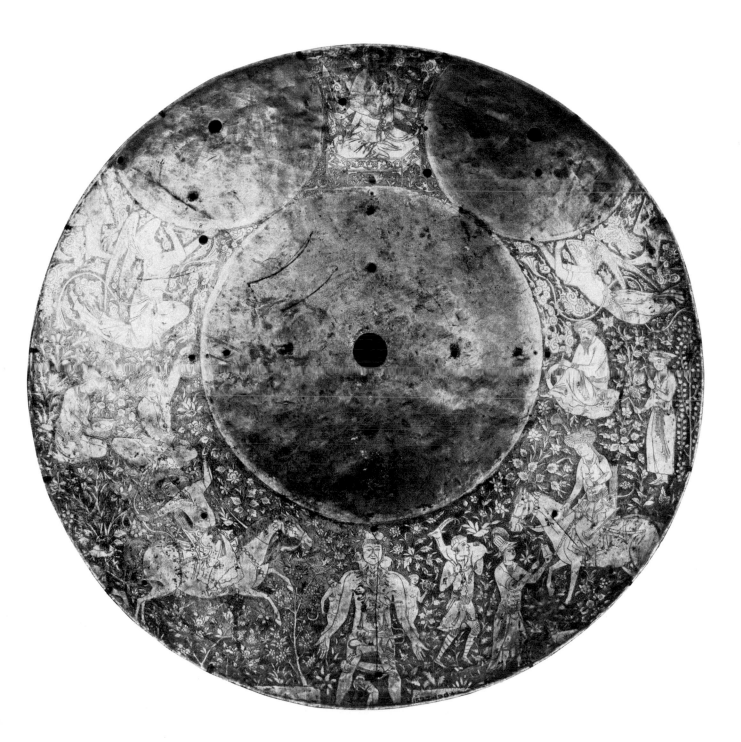

37. Two Polychrome Tiles. H. 17½ in., W. 9¼ in.

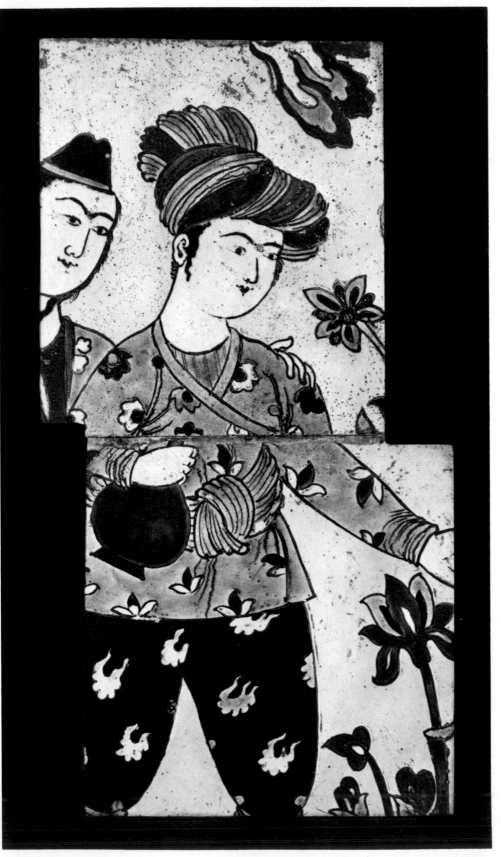

38. Tile Panel. H. 36⅝ in., W. 44¾ in.

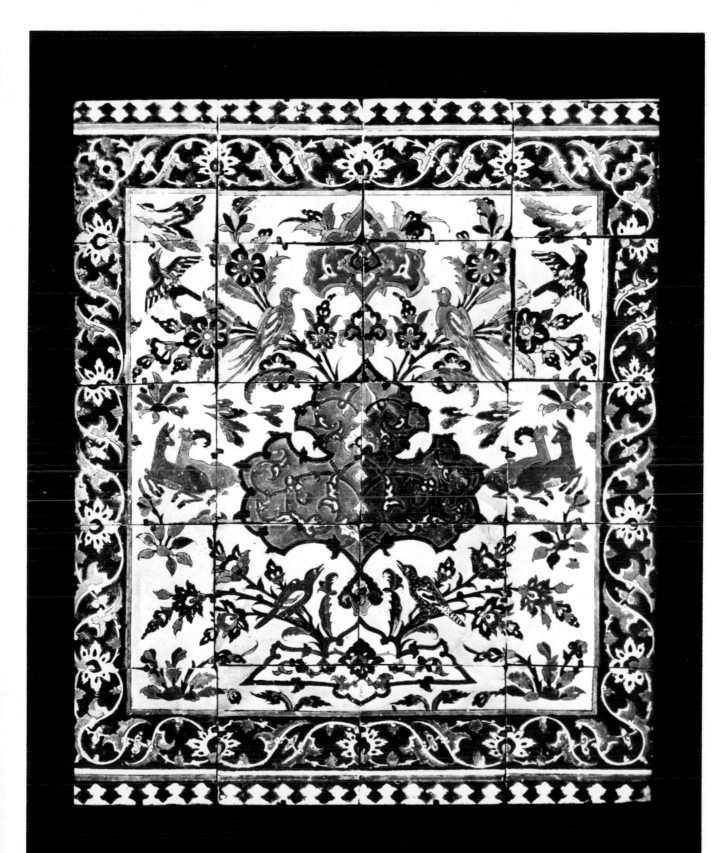

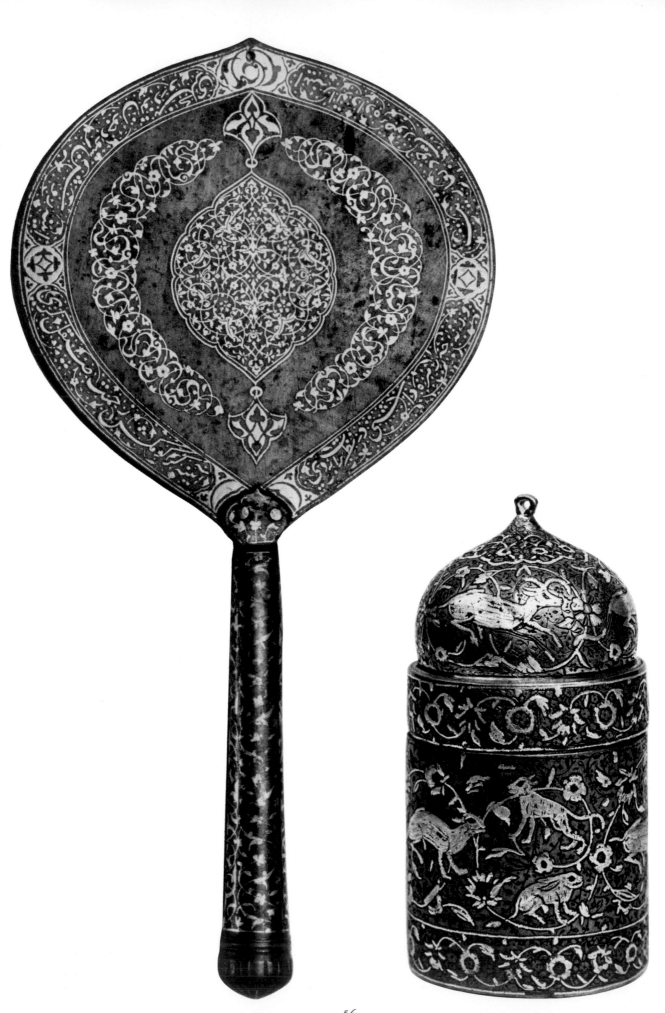

44. Steel Mirror Inlaid with Gold. H. 10½ in., W. 5⅜ in. *Opposite left*

39. Brass Inkwell with Silver Inlay. H. 3⅝ in. *Opposite right*

43. Brass Candlestick. H. 12⅜ in. *Below*

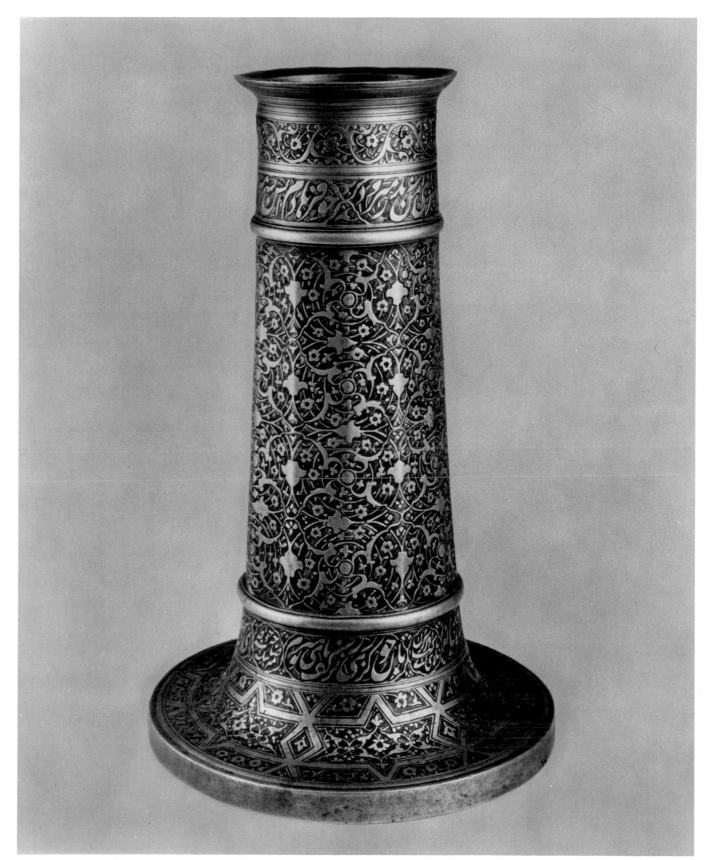

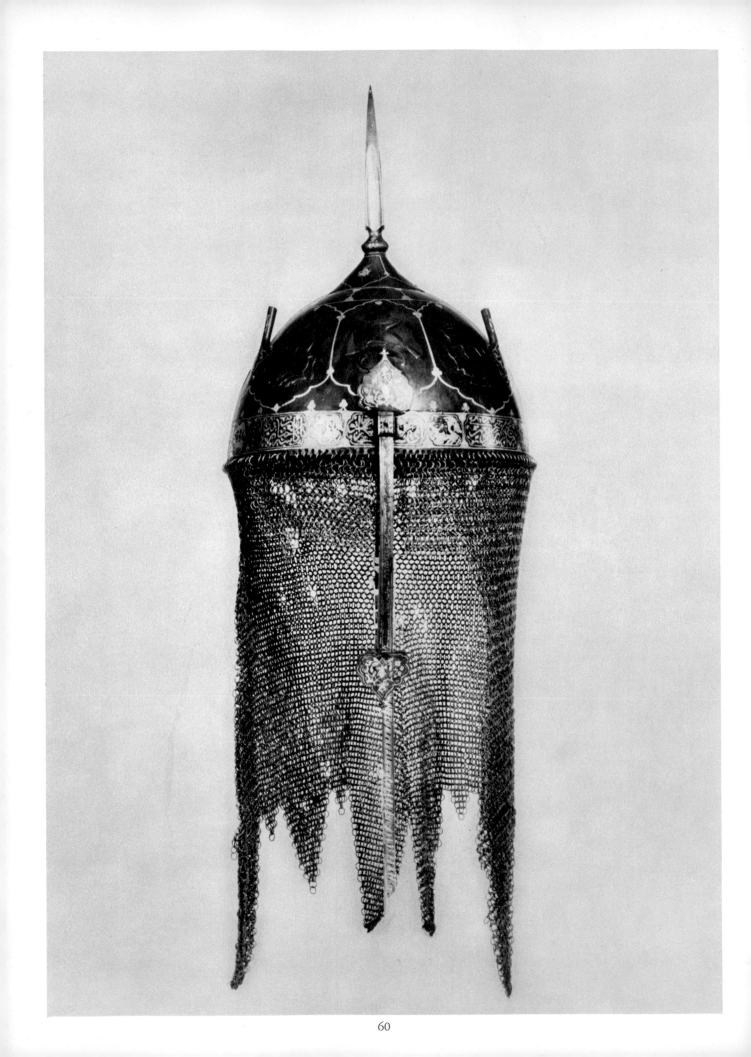

60

46. Gilded Steel Helmet Decorated with Hunting Scenes. H. 10¼ in.,; Diam. 8 in. *Opposite*

45. Sword of Shah 'Abbas I. L. 40½ in.

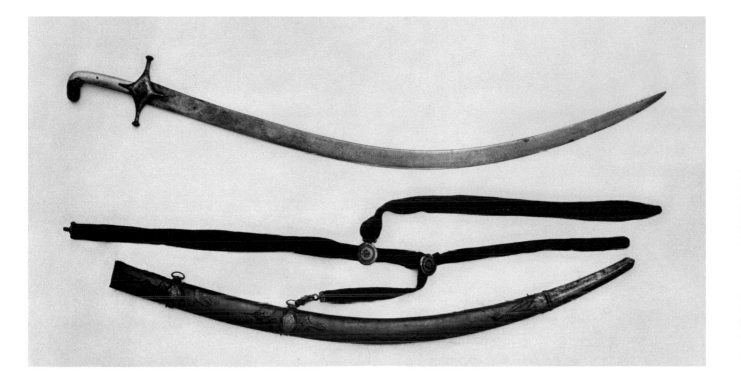

47. Two Archers' Rings. a. Red and white agate. b. Yellow and white agate. Diam. 1½ in. *Above*

48. Steel Lance Point with Gold Damascened Decoration. L. 16½ in., W. 1½ in. *Center*

49. Steel Dagger. L. 13½ in., W. 1⁵⁄₁₆ in. *Below*

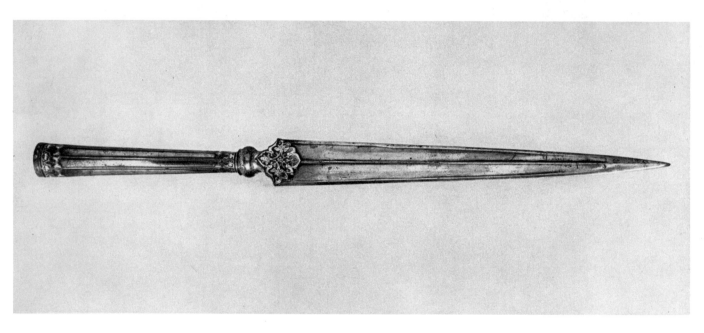

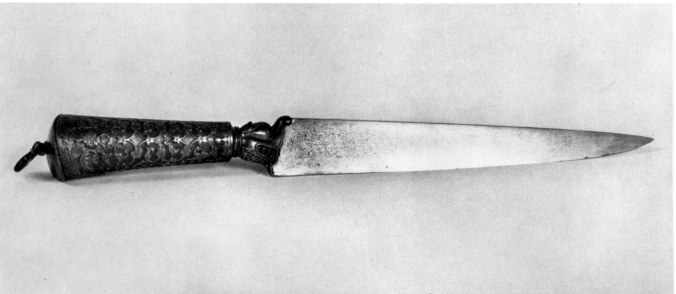

1. Seated Princess
Sadiqi Bek
Ca. 1575
H. 13⁹⁄₁₆ in., W. 8⅞ in.
Private Collection

The drawing is lightly tinted. The princess' mouth, sash, handkerchief, and undergarment are all colored a delicate red. The long, thin cloth curving from her headpiece behind her back and through her sash is an equally delicate light blue. But the line is hard, almost brittle, with little of the sensuous sweep so characteristic of late Qazvin draftsmanship. Sadiqi's work is almost emotionless; it is a cool and cerebral rendering of the classical traditions of Iranian painting.

This small ink drawing was certainly completed at least twenty years before the capital was transferred from Qazvin to Isfahan. It is bordered by blue marbleizing and the outer margins of the page are illuminated in gold with flying simurghs, foxes, flowers, and clouds. The inscription above the drawing is a mystical quatrain of unidentified authorship, definitely not in the prevailing Safavi literary mode of the *Sabkh-i Hindi*, and in style most similar to the quatrains of Abu Sa'id Abu'l Khair. It is a fine poem glorifying God:

No living being has ever found your favor disappointing,
For he whom you accept enjoys nothing but good fortune.
And any particle joined to your favor for even one instant
Glows with a brightness greater than one thousand suns.

The calligraphy is signed by "the humble Mir Husain al-Sahvi al-Tabrizi," a gifted calligrapher who, like many other Iranian scribes, emigrated to India in the late sixteenth century.

The miniature is signed in the lower right "The work of Sadiq." Sadiqi signs himself either Sadiq or Sadiqi.

Publ.: L. Binyon, J.V.S. Wilkinson, and B. Gray, *Persian Miniature Painting* (London, 1933), no. 302.
For biographical information regarding Sadiqi Bek see Appendix A, page 147.

2. Seated Man
Sadiqi Bek
Ca. 1595
H. 4 in., W. 7 in.
Museum of Fine Arts, Boston

Sadiqi's previous drawing accurately reflects some of the main currents of Qazvin period drawing and painting. This drawing fits into another category, a transitional one bridging the gap between Qazvin and Isfahan painting. The atmosphere around the seated princess has a chilly ambiance; here the air is charged with electric energy. Line flows far more freely. It widens from thin to thick and back again, and its expansion is gauged by no logical measure. Instead, line has become a living and often writhing rhythm, more sensuously expressive than in the previous drawing and indicative of the fluid, calligraphic quality of line and contour in the late sixteenth century.

The person portrayed is unidentified, but by the time he was drawn the young artist Riza was firmly established at the royal court, and it is likely that the highly innovative work of this prodigious talent provided the impetus for Sadiqi's most original and daring drawing.

Publ.: A. Coomaraswamy, *Les miniatures orientales de la collection Goloubew au Museum of Fine Arts de Boston, Ars Asiatica* 13 (Paris and Brussels, 1929), no. 75.

3. Lion Tamer
Attributed to Sadiqi Bek
Ca. 1605
H. 5¾ in., W. 9¼ in.
Fogg Art Museum; purchase, Alpheus Hyatt Purchasing Fund

Since Sadiqi died about 1612, this powerful *siyah qalam* (black pen) drawing should number among his last works. It can be confidently attributed to his hand; the drawing has the stark calculation and almost chilly ambiance we have already noted in this master's work. Its taut, cerebral rhythms, partially independent of the very forms they delineate, underline the movement toward abstraction we have found consistent in his art.

The lion was the symbol of the imperial throne. Tame and even trained lions performed a vital role in the royal ceremonials and must have been a common sight in Isfahan. Some seventy years later Mu'in Musavvir recorded a less controlled animal (No. 75).

On the reverse of this page, which was formerly in an album, are five inscriptions. Four are in Arabic and are written in the stately thuluth script: at the top a proverb; in the center an involved blessing; at the left a few words from the *Qur'an* under which are written the words "He is the dear one," which apply to God; and, at the bottom of the page, one of the Hadith (traditional sayings) of the Prophet. At the right is a Persian verse, probably by Hafiz and written in the agitated shikasteh script popular in the seventeenth and eighteenth centuries:

Those who with their looks can change dust into gold,
Can they possibly favor us with a glance?

It is signed by Muhammad Riza, a celebrated seventeenth-century calligrapher.

4. Different Kinds of Spirit
Ascribed to Muhammadi
Ca. 1575
H. 8⅜ in., W. 5⅜ in.
Museum of Fine Arts, Boston

More in subject matter than in style, Muhammadi's work is a prelude to Isfahan painting. He is a genre painter, specializing in scenes of nomadic camp life, of simple peasant living, of darvishes. Although he is not the first painter to diverge from the more heroic themes of earlier Iranian painting, he is a major influence on early Isfahan painters, especially Riza.

This particular tinted drawing is centered on an elaborate conceit—the different varieties of intoxication, a frequent subject of Iranian mystical poetry, particularly that of Hafiz. Outside two ethereal cities and in front of a subtly hued but very vital tree some darvishes meditate, while others engage in lively discussion. A central, bare-chested man leans over either in stupor or spiritual bliss, and all of the rest resort to less sublime but more accessible spirits.

Next to nothing is known about the painter's life, and though a large body of work bears his name, many of these "signatures" are questionable. Much of this ascribed work is also not of the highest quality, but some, such as this present drawing, are clearly masterpieces of late-sixteenth-century art in Iran.

His work consists of single-page drawings and paintings, intended most likely for inclusion in albums of assorted, diverse pictures. The art of the precious book—the fine, illustrated manuscript—which had played so large a role in earlier

Islamic painting was, in the course of the seventeenth century, gradually supplanted by this less unified but more varied art form.

Publ.: Coomaraswamy, *Collection Goloubew,* p. 35, no. 48, pl. 26; B. Gray, *Persian Painting* (Lausanne, 1961), p. 157 (color).

5. Youth in Red Shoes
Attributed to Mirza 'Ali
C. 1590
H. 4½ in., W. 2⅜ in.
Private Collection

This young aristocrat's attentuated pose, stretched almost to the limit of refinement, is the sophisticated precursor of one of the major modes of the Isfahan school. But in Mirza 'Ali's versatile hands this subject never becomes a type, nor does it ever diverge from the impeccable standards of subtle and elegant taste set by this master. His influence is wide but is nowhere richer than in the painting of Riza, and it is clear that the two masters—Riza two generations younger than the older artist—were closely associated at the end of the sixteenth century.

Publ.: E. Grube, *Muslim Miniature Painting* (Venice, 1962), no 93.

6. A Young Man in a Blue Cloak
Riza
Ca. 1587
H. 13⅝ in., W. 8¾ in.
Fogg Art Museum; Sarah C. Sears Collection

The painting bears Riza's signature at the left: "Exercise of the most humble Aqa Riza." The last letter of Riza's name was lost when the page was trimmed for mounting in its contemporary marbleized and gilded borders. Under the youth's feet is the monarch's seal: " 'Abbas, the servant of the King of Holiness, 995." The "King of Holiness" is, of course, 'Ali, and we find the same inscription on 'Abbas' sword in this exhibition (No. 45), as well as on his firman (No. 17). The date on the seal does not refer to the date of the painting but rather to the year of 'Abbas' accession to the throne.

The image of the solitary youth—standing or sitting, drinking or day-dreaming—gained currency in the late sixteenth century, particularly in the art of Mirza 'Ali (No. 5), the master of this genre to whom Riza is most indebted. But while Riza continues the melodic line and rich color of the earlier master, he adds to his svelte youths a far stronger accent of luxurious sweetness and soft detachment. The subject itself, the refined, aristocratic youth elegantly dressed and graciously posed, is to become one of the stock images of the Isfahan school, though never again treated as brilliantly as here in one of Riza's earliest known works.

Publ.: E. Schroeder, *Persian Miniatures in the Fogg Museum of Art* (Cambridge, Mass., 1942), pp. 116-134, pl. 21; Gray, *Persian Painting,* p. 161.
For biographical information regarding Aqa Riza see Appendix B, page 147.

7. Daydreaming Youth
Riza
Ca. 1590
H. 5 in., W 3 in.
Fogg Art Museum; purchase, Alpheus Hyatt Purchasing Fund

In this drawing, Riza's linear mastery creates a sure sense of refined elegance and soft, well-rounded volumes. But his line is also characterized by a frequent nervous "splutter," particularly at the ends of the young man's sash and kerchief. This new, more "agitated" and "aggressive" line is one of Riza's major innovations.

Riza's name is written at the left, in front of the youth's knees.

8. Man with a Ram
Riza
Ca. 1590
H. 5⅞ in., W. 8⅞ in.
Fogg Art Museum; purchase, Francis H. Burr Memorial Fund

The young master's signature appears beneath the forelegs of the ram. The animal is a pet, pampered and fattened for the main course of the spring New Year's feast, and Schroeder says: ". . . the hilt of a large knife, showing behind the man's back, suggests that the subject of our drawing may indeed be the hour of parting." (*Bulletin of the Fogg Art Museum* 11,2 [1950], p. 72.)

9. A Woman with Beads
Riza
Ca. 1595
H. 7½ in., W. 3⅜ in.
Museum of Fine Arts, Boston

In the lower left of this ink drawing is a short inscription, saying that Riza drew it. At the bottom left is an eighteenth-century owner's seal. The twelve inscriptions in the margin are verses of a mystical poem.

Riza's mastery of clothing is complete. He creates smooth falling folds and abrupt edges with equal ease. Short, staccato dabs and fluid curves blend to form natural volumes and diaphanous silks. His line never becomes abstracted from the form it delineates. His rhythms never abandon observable detail.

Publ.: Coomaraswamy, *Collection Goloubew,* no. 80 (transl. of verses); Schroeder, *Persian Miniatures,* p. 124; Grube, *Muslim Miniature Painting,* no. 100; I. Stchoukine, *Les peintures des manuscrits de Shah 'Abbas I à la fin des Safavis* (Paris, 1964), p. 106.

10. A Monkey-trainer
Attributed to Riza
Ca. 1595-1600
H. 4¹/₁₆ in., W. 4¹/₁₆ in.
Private Collection

The *qarrad,* or monkey-trainer, was a common wandering entertainer in earlier times as well as in Safavi Iran. The monkey would perform before crowds and would mimic drunks, aged crones, lascivious old men, and mincing women. But a subject which in the hands of a lesser artist would not have gone beyond the bounds of charming genre becomes here a profound vision of life. The well-fed trainer rides heavily on an emaciated, nearly foundered horse. The image of the careworn and saddlesore nag is a frequent one in both Safavi and Mughal painting and often symbolizes the troubles and transience of mortal existence. But the strivings of the soul are not to be found in the *qarrad's* face: it is more simian than that of his monkey, whose knowing visage hints at a wisdom his master can never attain. And is the bird, caught in the fleshy man's hand and destined to be his next meal, a symbol of the soul, striving to be free?

Few works of this period carry such profound implica-

tions. The drawing's tapering line, suggesting nuances of light and shade and subtly making contours real and volumes full, could only be by Riza. A quick comparison with Nos. 7, 8, 9 in this exhibition confirms this attribution. The drawing is the work of the virtuoso draftsman we already know, but it reveals a spirit more profound than we had suspected.

Publ.: A. Sakisian, *La miniature persane* (Paris and Brussels, 1929), fig. 107.

11. Lovers in a Landscape and Bird on a Branch
Two paintings mounted as an album leaf
Riza
Ca. 1610
H. 13¼ in., W. 8¾ in.
Seattle Art Museum

Though his hand is chucking the young woman under her chin, the languorous young man in green seems equally interested in his younger male attendant. Sexual dipolarity, quite overt in Safavi Iran and favored by Shah 'Abbas I himself (to the immense horror of resident European missionaries), was a not uncommon subject of late Safavi literature and art. Both paintings are signed.

Publ.: B.W. Robinson, *Persian Drawings* (New York, 1965), no. 60 (color).

12. Portrait of Nashmi the Archer
Riza
Dated 1031 H. (1621/22)
H. 8⅞ in., W. 5¼ in.
Fogg Art Museum; bequest, Estate of Abby Aldrich Rockefeller

The title, as rendered above, is written at the left in black ink. Nashmi is a Turcoman name, and this rather slipshod hero was perhaps a member of the new imperial army 'Abbas assembled. If he was typical, we can only marvel at the successes of the Shah's soldiery. Nashmi has gone out wearing his slippers, has forgotten one sock and allowed the other to fall around his ankle, and is smoking a mixture which, one suspects, contains more than tobacco.

Below the title, in faint, badly abraded gold, are written three additional lines: "Saturday, the fourth day of the month of Rabi' al-akhir in the year 1031 it was finished. The most humble Riza-yi 'Abbasi drew it." This very decided caricature is a superb example of the biting wit often found in Riza's later work.

13. Leather Book Binding
Illustrated p. 146
Early 17th century
H. 11 in., W. 6¾ in.
Fogg Art Museum; gift of Mr. S. Cary Welch, Jr.

The exterior is of dark brown leather with gilded, stamped panels, cartouches, and medallions. Between the gilded areas in the central rectangle is gilded filigree, raised against blue and red backgrounds.

On the inside, dark blue areas are highlighted with gold decoupage, while the gold interior contrasts with brown leather arabesques, enlivened by touches of dark blue, green, and orange.

The binding is unsigned and undated, but its quality rivals that of the 1632 *Khusrau and Shirin* binding (No. 51). The latter is the work of the binder Muhammad Muhsin Tabrizi, and we may well be dealing here with another masterpiece from his hands.

14. The Shahnameh of Firdausi
613 folios, measuring 14½ in. by 8 in., with 44 miniatures
Dated 1023 H. (1614)
a. Zahhak being nailed to Mount Demavand (folio 38); illustrated
b. Rustam Killing the Dragon Arzhang (folio 138); illustrated
The New York Public Library; Spencer Collection

This manuscript's final page states that the book was ordered by Shah 'Abbas I who assigned its actual production to the supervision of his vizier Mirza Muhammad Sharif. It is clear evidence that, though the Shah was the patron, he was not interested, as Tahmasp would have been, in the day-by-day efforts of the artists working on the book. Yet it is not to be doubted that its general character—the brilliant re-working of Timurid styles and motifs from the great 1430 *Shahnameh* of Tamerlane's son Baysunghur—is due to the Shah's own directive. In this period 'Abbas' inclination toward Timurid models was pronounced, the two other most prominent examples being the refurbishing (ca. 1608) of the manuscript of 'Attar's *Mantiq al Tair,* now in the Metropolitan Museum, and the Royal Mosque in Isfahan (1612-1638). It is an aesthetic direction far removed from that of 'Abbas' earlier great *Shahnameh* of ca. 1587 in the Beatty Library, which, while it engaged the formidable talents of Riza, remained a brilliant but traditional statement.

Whether Riza worked on this 1614 *Shahnameh* is not known. There are no signatures in the book. This period of Timurid revival may have been profoundly to his distaste and, being a highly individual artist, he may well have withdrawn from court circles at this time, devoting himself, as accounts disapprovingly tell us, to wrestling and low living. Perhaps the direction and much of the illustration of the book was left up to Habibullah of Sayeh, an artist highly favored by the Shah and the painter responsible for the most impressive of the Timurid revival pictures of the *Mantiq al-Tair.* But whoever the artists were, they were obviously masters of high skill, for, despite its derivative character, the manuscript displays impressive powers of invention and design.

Publ.: R. Gottheil, "An Illuminated Manuscript in the Spencer Collection," *Bulletin of the New York Public Library* 36 (1932), pp. 543-554; Grube, *Muslim Miniature Painting,* no. 105.

15. Calligraphy
Attributed to 'Ali Riza 'Abbasi
Early 17th century
H. 6¼ in., W. 9¾ in.
Fogg Art Museum; purchase, Alpheus Hyatt Purchasing Fund

The margins are decorated with marbleizing in two shades of blue sprinkled with gold. A highly calculated and hardly haphazard technique, marbleizing was especially favored in the Safavi period.

The four unsigned lines of superb nasta'liq script are very likely the work of 'Ali Riza 'Abbasi, a calligrapher who first rose to fame in Qazvin, whose congregational mosque he supplied with several inscriptions. In the beginning of the reign of Shah 'Abbas he served with the monarch's chief general, Farhad Khan, but the Shah, hearing of the scribe's ability, commanded his general to send 'Ali Riza to the court. The calligrapher began his service under 'Abbas in 1592/93 and outlived his master.

A fiercely ambitious man, he was at first simply the head calligrapher. Before long he succeeded in deposing Sadiqi Bek,

who held the post of Director of the Royal Library. Despite the latter's understandable hostility and the threatening rivalry of his equal in calligraphy, Mir 'Imad, 'Ali Riza maintained his new position of power within the royal artistic hierarchy. In fact, the Shah's "love and affection for this artistic man was so great that he would sometimes sit on his throne of heroes and hold a candle in his hand so that 'Ali Riza could write in its light."[1]

'Abbas, a gifted connoisseur of calligraphy, considered 'Ali Riza the equal of Mir 'Ali al-Haravi, the celebrated master whose role as "supreme calligrapher" is comparable to that of Bihzad's as "supreme painter" in Iranian art history. The Shah favored 'Ali Riza with the choicest of public commissions; 'Ali Riza designed the great calligraphic inscription on the drum of the Shaikh Lotfallah mosque in Isfahan, as well as on that of the Royal Mosque itself. In 1601/02 the Shah paid him the signal honor of ordering him to design calligraphic tiles for the tomb of the Imam Riza in Meshhed.

Although the calligraphy here is of unquestionable excellence, the quatrain by an unidentified poet is not:

O, most high! On the slate of the world
Is written nothing save the word of your generosity.
The smallest beggar on your road
Is no less great than the Emperor of Rome.

The poem is most likely addressed to a patron. It would have been a fitting sample of his work for 'Ali Riza to present to 'Abbas.

1. N. Falsafi, *Zindigani Shah 'Abbas Awwal* [The Life of Shah 'Abbas I], vol. 2 (Tehran, 1965), pp. 53-56, provides a useful short biography of 'Ali Riza 'Abbasi.

16. Calligraphy
Attributed to Mir 'Imad
Early 17th century
H. 10¾ in., W. 5¼ in.
Fogg Art Museum; gift of John Goelet

The seven lines of fine nasta'liq script are written on a light blue paper decorated with delicate gold flowers. Although the scribe has not signed his name, the page can be securely attributed to the hand of Mir 'Imad. A lifelong rivalry existed between him and 'Ali Riza; both were singularly gifted and singularly favored by Shah 'Abbas I, an avid patron of calligraphy. Mir 'Imad was apparently not as skilled at in-fighting as was 'Ali Riza: the latter is said to have arranged Mir 'Imad's assassination in order to have the monarch's affections solely for himself.

The first line in the upper right is a frequent beginning for a calligraphy: "He is the dear one." It can refer to both the earthly and the divine beloved. The poem itself is by Hafiz, and its meaning can similarly be understood on these two levels:

When my beloved flirts in such a way,
Even a holy man's belief would break.

Wherever that narcissus shows its bloom,
The eyes of beauties offer it their soil.

My eyes are blood-red from my tears.
O, this injustice has no equal in the world.

A closely similar page, dated 1017 H. (1608/09) and signed by Mir 'Imad, is in the Indo-Iranian album in the Institute of the Peoples of Asia, Leningrad; see A. A. Ivanov, T. B. Grek, and O. F. Akimushkin, *Album indiskikh i persidskikh miniatur XVI-XVIII v.* [Album of Indian and Persian Minia-

tures, 16th-18th centuries] (Moscow, 1962), pls. 6, 104-111. For an excellent biography of Mir 'Imad, see M. Bayani, *Khushnevisan* [Calligraphers] (Tehran, 1966), pp. 518-538.

17. Firman from Shah 'Abbas I to King Charles I of England
Ca. 1625-1629
H. 20⅜ in., W. 10⅞ in.
Collection of Prince Sadruddin Aga Khan

This royal epistle, or firman, was composed by an unidentified royal scribe in an elegant nasta'liq script. Though somewhat worn along two folds, the page is in excellent condition. Written in a necessarily very official and formal Persian, the letter is filled with elaborate compliments and intricate, diplomatic niceties, which cannot be adequately or clearly translated into twentieth century English. But the import of the firman, summarized here, makes its purpose clear and indicates that it undoubtedly accompanied an Iranian ambassador from Shah 'Abbas to the court of Charles I:

We have always offered full assistance and hospitality to all of your merchants in Iran. Therefore we hope that you will issue royal orders so that our merchants traveling in your kingdom will be afforded similar treatment. We hope you will insure that our merchants in your kingdom are offered every help and assistance.

The firman is addressed to Charles, King of the Franks, the latter designation being the common one in Iran for Europeans. During Shah 'Abbas' reign of forty-two years only two monarchs named Charles ruled in Europe: Charles I of England (1625-1649) and Charles IX of Sweden (1604-1611). Trade between Iran and Sweden was minor, if, indeed, it existed at all, while England, since the reign of Elizabeth I, had actively sought good commercial relations with Iran. Certainly 'Abbas must have been addressing the English king in his epistle, which in style and content is strikingly similar to the letters which the English military adviser and confidant of Shah 'Abbas, Anthony Sherley, brought with him when he returned from Iran to England as the Shah's ambassador and commercial representative.

On the reverse side of the royal epistle is stamped Shah 'Abbas' seal which reads: "The servant of the king of holiness, 'Abbas." The epithet "king of holiness" refers to 'Ali, the Prophet Muhammad's son-in-law and the special subject of veneration for Shi'a Muslims. 'Abbas was notably proud of his dynasty's descent from 'Ali, and we find two other objects in this exhibition which bear the identical inscription: No. 6 (Aqa Riza's "Young Man in a Blue Cloak") and No. 45 (Shah 'Abbas' sword).

18. Dedicatory Page from a Qur'an
Early 17th century
H. 11⅞ in., W. 7½ in.
Fogg Art Museum

The lush, dense arabesque in the margins of this page presents a largely gold complexity with only the flowers' centers in dark blue. The internal rectangle displays a more lavish use of blue. This was once the first page in a *Qur'an*, and it offers in Arabic the following prayer for the scribe who wrote the holy book:

I who write this book beg God to beautify my tongue, illumine my face, kill my envy, and nourish me with divine obedience both day and night through the greatness of Muhammad and his family.

The reverse of the folio contains the *Sura al-Fatihah,* the first chapter of the *Qur'an,* its Arabic written in black ink with an interlinear Persian translation penned in a minute and very faint red script. The illumination around it is less restrained in color: red, orange, lapis, gold, and green are used in dense ornamental combinations.

There is no mention of the scribe's name. The arabesque is a close cousin to that seen on the steel mirror (No. 44).

19. Boats at Sea
Double cloth in red and white silk with silver strips
Late 16th century
L. 8⅝ in., W. 5¾ in.
The Detroit Institute of Arts

The design on one side of the cloth is in white on a ground of red silk and silver; on the reverse it appears equally clearly, in red on the white and silver ground. The sailing ships appear to be manned by Europeans.

See: N.A. Reath and E.B. Sachs, *Persian Textiles* (New Haven, Conn., 1937), p. 89 (example 33). Other fragments of this cloth are in the Textile Museum, Washington, D.C.; The Metropolitan Museum of Art; and the Museum of Fine Arts, Boston.

20. Prayer Cloth
Silk and metal thread
Early 17th century
L. 49 in., W. 33 in.
Cincinnati Art Museum *Frontispiece*

The inscription, repeated three times at the top of the cloth, reads: "There is no God but God, and He is one, and He has no partner." It is one of the basic statements of Muslim belief.

This textile is said to have been the prayer cloth of Shah 'Abbas himself, though there is no specific mention of the monarch on it. Stylistically it clearly belongs to the early seventeenth century and was very likely produced in an Isfahan workshop.

The ground is a rich orange. The flowers of the central plant and the ground of the border contain silver thread. In the border are orange, yellow, blue, and white blossoms on light green stems.

Publ.: *Archives of Asian Art* 21 (1967-68), p. 77; *Cincinnati Art Museum Bulletin* 9, 1-2 (June, 1971), p. 57.

21. Four Young Men Smelling Flowers
Cut, voided, satin velvet with gold and silver thread brocade
Early 17th century
L. 60¼ in., W. 28½ in.
The Art Institute of Chicago; gift of John R. Thompson

The whole cloth, of which this large piece is a fragment, was originally in the Jaipur State Treasury and almost certainly came to India as one of the vast number of seventeenth-century textiles imported from Iran. The large scale of the figures suggests that the weaving was intended to be used as a hanging.

The ground is gold. Each youth wears a white tunic, red coat, and yellow scarf.

See: Reath and Sachs, *Persian Textiles,* pp. 130, 131 (example 89), where a fragment of the same textile in the Cleveland Museum of Art is analyzed.

22. Entertainment for a European
Satin with brocaded details
Early 17th century
L. 34½ in., W. 20½ in.
The Cleveland Museum of Art; purchase from the J. H. Wade Fund

The European is poised on one foot, as if either dancing to the music of the 'ud and the tambourine or running away from it. A youth kneels in front of him beside a huge flower and offers a cup of wine. The ground is golden yellow, and the brocading is in silver thread, now tarnished black.

Exotic in costume and manner, Europeans are frequently depicted in Safavi and Mughal painting. This is one of the few known representations in textiles. On the tambourine is written the name 'Abdullah, which may or may not be the name of the textile designer or weaver.

Publ.: F. Sarre and F. Martin, *Meisterwerke Muhammedanischer Kunst,* vol. 3 (Munich, 1910), no. 2380; A.U. Pope and P. Ackerman, eds., *A Survey of Persian Art,* 6 vols. (Oxford, 1938); reprint ed. (Tokyo, 1964) in 12 vols.: vol. 12, pl. 1044/B. (Pope and Ackerman volume citations herein from reprint edition; page and plate numbers identical in both editions.)

23. Safavi Warrior and Prisoner
Compound satin
Early 17th century
L. 29 in., W. 26 in.
Textile Museum Collection, Washington, D.C.

The ground of the fabric is a pale, gray blue, and the design is in light yellow, pale pink, black, and white. The motif of a Safavi youth leading a bound prisoner may well refer to Shah 'Abbas' successful campaigns against the Uzbeks on Iran's northeastern borders. The rider's quiver bears the name 'Abdullah, written in an archaic Kufic script. Fragments from the same textile are in the Yale University Art Gallery and the Art Institute of Chicago.

Publ.: Pope and Ackerman, *Survey,* vol. 12, pl. 1044/A.

24. Prayer Cloth
Cut, solid, satin velvet
Early 17th century
L. 57 in., W. 38½ in.
Cincinnati Art Museum

The inscription in the medallion at the top of the cloth reads: "Pure is my Lord God, and He is exalted." The ground of the central field is cream-colored. Tulips, roses, carnations, and iris are woven in red, pink, blue, and white. The border has a light green ground against which blue and white violets and pink and yellow anemones move delicately as if stirred by a gentle breeze.

This textile has been attributed to a Yazd workshop.

Publ.: Reath and Sachs, *Persian Textiles,* p. 121 (example 79); Pope and Ackerman, *Survey,* vol. 5, pp. 2070 and 2138, vol. 11, pl. 1081; *Archives of Asian Art* 21, p. 96.

25. Silk Tomb Cover from the Shrine of the Imam Riza
Late 16th century
L. 10 ft.; W. 3 ft., 6 in.
Cincinnati Art Museum

This large and very impressive woven covering, with a red background and animal, human, and supernatural heads curving over its surface in a colorful arabesque, is a problematic

but fascinating piece. The key to its history lies in the bold nasta'liq inscription in the inner border:

This holy threshold on whose dust
The most glorious kings have put their heads and crowns.[1]

Men and jinn, birds and beasts, angels and demons,
Have bowed their heads in his exalted court.[2]

It is no wonder that they have shown obedience and
* servitude*
To the threshold of the Dearest of the Prophet.[3]

To be more blessed the holy angels have put their wings
Beneath the feet of his pilgrims.
That they have built these nine, pure, round vaults.

It is due to the existence of the House of the Robe[4]

For honoring the advent of the pilgrims to his threshold
They have placed the shining sun in the hand of the sky.[5]

From the dust of the road and the dirt of their feet
Its pilgrims have made rivals to musk and ambergris.[6]

From the wine of union with the beauty of the Beloved[7]
They will become drunk, as if they had entered the other
* world.*

Painlessly they reach the source of the water of life
And let Iskandar's fate be the obscurity and darkness.[8]

Those who have put their hope in the cupbearer of
* Kauthar[9]*
Will enjoy the water of life.

[By] the servant of this threshold Muhammad Ja'far
* Kashani.*

As a work of literature the poem is not strong, but its expression of Shi'a belief is passionate and intense. Stylistically, it is clearly a Safavi poem. Of Muhammad, Ja'far Kashani, whose signature appears at the end of the inscription, nothing is known: he may have been solely the calligrapher; but, since Kashan was a major textile center under 'Abbas' patronage, he may have also designed the whole tomb cover.

But the rich decoration does not fit the accepted categories of late-sixteenth- and seventeenth-century textiles and carpets.[10] While the innermost rectangle—the pond and birds—could be reasonably assigned to this period, the outer margin's many-headed arabesque, four angels, and pendulous leaf forms owe more to Timurid and early Safavi decoration.

The inscription locates the carpet almost certainly in the tomb of the Imam Riza. Meshhed and its holy shrine had suffered greatly at the hands of the Sunni Uzbeks who had seized Meshhed early in 'Aḥbas' reign, and in 1601 the Shah began a major program of reconstruction which included sending 'Ali Riza 'Abbasi, his chief calligrapher, to Meshhed to provide inscriptions for the Shrine and design new tiles for the Imam's tomb. Perhaps at this same time he commissioned a new tomb cover. In style it does not conform to the recognized products of the royal workshops in central Iran, and the cover may well have been made in Khorasan itself. Timurid design of this sort seems to have survived in Khorasan in Safavi times, and this may be the explanation for the archaistic flavor of the piece.

But whatever questions we raise about the creation of the tomb cover, we can only marvel at its fine workmanship and superb design.

1. Since the Shrine of the Imam Riza in Meshhed was the principal pilgrimage place of Iranian Shi'a Muslims and was a special object of veneration for the Safavi monarchs, this would almost certainly be the "threshold" to which the verse refers.

2. Here a direct reference is apparently being made to the decoration of the tomb cover itself.

3. The "Dearest of the Prophet" is an epithet given to 'Ali, for Shi'a Muslims the closest associate of the Prophet, his rightful successor as leader of Islam, and the ancestor of the martyred Imam Riza.

4. "Al-i 'aba'" (The House—or family—of the Robe) is an expression referring to the Prophet's immediate family—'Ali, Fatima, Husain, and Hasan—and the twelve imams. As the Shi'a royal family, they are ultimately responsible for the creation of the Shrine. The "nine, pure, round vaults" may well be a specific architectural reference to the Tomb complex itself.
 These two key words might also be read "Al-i 'Abba(s), with the final letter of the monarch's name omitted. In the other reading the final letter (Hamzeh) is also left out. It is quite conceivable that the inscription intends a double meaning: either the "House of the Robe" or the "House of 'Abbas."

5. The "sun" may refer to both the real sun in the sky and the great golden eyvan (vault) constructed by Mir 'Ali Shir Nawa'i in the late fifteenth century as part of the Shrine. One of the principal approaches to the Imam's shrine passed through it.

6. In this verse, in the Persian original, there occurs a significant orthographical and metric error.

7. I.e., the mystical union with God.

8. Iskandar (Alexander the Great) sought in vain the water of immortality.

9. 'Ali is the cupbearer of Kauthar, the river in Paradise from which all other rivers flow.

10. There is a very small group of these silk weaves: Pope and Ackerman, *Survey*, vol. 11, pls. 1172, 1173; Gulbenkian Foundation, *Oriental Islamic Art, a Catalogue of the Collection of the Calouste Gulbenkian Foundation* (Lisbon, 1963), no. 69. Both texts suggest an early-sixteenth-century date. For a similar fragment K. Erdmann suggests a sixteenth- or seventeenth-century origin in India (*Seven Hundred Years of Oriental Carpets*, [Berkeley and Los Angeles, 1970], p. 178, fig. 222).

26. Silk Kilim or Tapestry Rug

Warp in yellow silk; weft in red, blue, yellow, green, orange, black, tan, brown; silver and gilt threads
Kashan, early 17th century
L. 7 ft., 5½ in.; W. 4 ft., 3½ in.
Textile Museum Collection, Washington, D.C.

This is a flat-woven rather than a knotted carpet. Its intricate, vibrant pattern is a masterpiece of technical, as well as visual, virtuosity. Rugs of this type were frequently objects of trade with Europe, but this example is clearly a royal carpet, a product of the imperial workshops in Kashan and perhaps intended for Shah 'Abbas I himself.

The animals depicted in the carpet are, for the most part, ultimately derived from Chinese prototypes. The phoenix, a symbol both of mystical wisdom and of royal power, is battling a dragon—in Iran, unlike in China, generally considered to be an evil force. Other animals are references to royalty as well: the birds of paradise, the lions, the leopards. The royal iconography of this carpet is developed by R. Ettinghausen in the catalogue cited below. A companion piece to this carpet is in the Berlin Museum.

Publ.: Reath and Sachs, *Persian Textiles*, p. 72, (example 11); Pope and Ackerman, *Survey*, vol. 6, p. 2404, vol. 11, pl. 1267/A; The Asia Society, *Masterpieces of Asian Art in American Collections* (New York, 1970), p. 39, pl. 8; R. Ettinghausen, *From Persia's Ancient Looms* (Washington, D.C., 1972), fig. 7.

27. Fragment of an Arabesque Carpet

Isfahan, early 17th century
L. 4 ft., 6 in.; W. 4 ft., 5½ in.
The Metropolitan Museum of Art; gift of Joseph V. McMullan

No complete rugs of this type are known, and it is apparent that they were produced in relatively small numbers, almost certainly in or very near Isfahan and in workshops under the

royal aegis. That so few pieces of this rare but obviously major type survived is surely one of the tragedies of Safavi history. This magnificent fragment alone is evidence enough that these were carpets of the highest aesthetic order.

Publ.: Joseph V. McMullan, *Islamic Carpets* (New York, 1965), no. 21.

28. "Shah 'Abbas" Carpet
Silk enriched with silver and gilt silver thread
Ca. 1620
L. 13 ft., 2½ in.; W. 5 ft., 8½ in.
The National Gallery of Art; Widener Collection

This shimmering carpet displays a rich variety of delicate colors—light greens, reds, browns, and blues; dark blue and brown; and white. All "Shah 'Abbas" carpets are knotted in silk, but most are less dense than their sixteenth-century prototypes. They rely heavily on surface effects: silver and gold brocading; deep, shaggy pile; and sweeping, energetic designs.
 Probably produced by several workshops under Shah 'Abbas' patronage, these rugs dazzled contemporary European visitors. Considerable numbers were exported to Europe, some as royal gifts, others, apparently, as objects of trade.

Publ.: Pope and Ackerman, *Survey,* vol. 11, pl. 1247.

29. "Vase" Carpet with Blue Background
Cotton warp and wool pile
Late 16th—early 17th century
L. 21 ft., 8½ in.; W. 8 ft., 3 in.
Cincinnati Art Museum, gift of the Duke and Duchess of Talleyrand-Perigord

The composition is clear and ordered, and the progress from one stylized blossom to another is steady and controlled. The classical calm of the design is enhanced by the cool richness of the blue ground. This type of carpet is generally attributed to southern Iran.

30. "Vase" Carpet with a Red Background
Silk warp and wool weft; Sehna knot
17th century
L. 8 ft., 9 in.; W. 6 ft., 3½ in.
Corcoran Gallery of Art; W. A. Clark Collection

The fiery red ground, brilliant color, and swirling palmettes make this carpet far less controlled and much more intense in design than No. 29. But beneath its surface turbulence lies a tight balance and a near symmetry, all the more powerful for being partially concealed.

Publ.: Pope and Ackerman, *Survey,* vol. 11, pl. 1234; K. Erdmann, *Oriental Carpets* (London, 1960), p. 44, fig. 85; Ettinghausen, *Ancient Looms,* Fig. 6.

31. "Kubachi" Polychrome Plate
Late 16th century
Diam. 16⅝ in.
The Metropolitan Museum of Art; Mr. and Mrs. Isaac D. Fletcher Collection

It has not been possible to locate precisely the production center responsible for this ware, most of which was discovered in the Daghestani village of Kubachi at the end of the last century. But it seems clear that the ceramics were made in northwestern Iran, a location which may account for the definite Turkish "Iznik" flavor of the floral design on the rim.

32. "Kubachi" Plate
Early 17th century
Diam. 13 in.
Cincinnati Art Museum

The color scheme of this polychrome plate is related to that of the more splendid so-called "Iznik" pottery produced in sixteenth-century Turkey under Ottoman patronage. The scale-pattern borders are probably derived from the same source. The single male figure, however, is a definite "Isfahan" type, also found in painting, while the sinuous branches and cluttering flowers behind him are wholly Iranian in flavor.

33. "Kubachi" Blue and Buff Plate
Early 17th century
Diam. 14 in.
The Fine Arts Gallery of San Diego

Despite a large repair in the lower left, this is a splendid plate of simple and powerful design. The ware itself is less than fine and has the porous, rather brittle composition and thin, crackled glaze characteristic of Kubachi ceramics.

34. "Celadon" Flower Vase
17th century
H. 14⅞ in.
Yale University Art Gallery; Hobart Moore Memorial Collection, gift of Mrs. William H. Moore

Chinese celadon had been imported into Iran since the ninth century, but it was not until the sixteenth century that Iranian imitations of this Chinese ware reached a high level of sophistication. Yet even this similarity is more a matter of surface than of depth. Iranian potters never achieved true porcelain, and their glazes were fired at lower temperatures than were the Chinese. As a result, the greenish "celadon" glazes tend to be softer than the Chinese originals, they scratch more easily, and develop more extensive crackle. Still, though the composition and glaze may have been imitated, Iranian potters exercised their own ingenuity in creating monochrome ware of different colors as well as in decorating the surfaces of the vessels with lively designs. This rich green vase has been painted in white touched with drops of blue enamel.

35. Calligraphic Tile Fragment
Early 17th century
H. 10½ in., W. 15 in.
The Art Institute of Chicago;
Mary Jane Gunsaulus Collection

Delicate, white nasta'liq letters, only a portion of a word, curl over a dark blue background enlivened by turquoise arabesque tendrils. The slightly convex tile, originally probably part of an inscription on the exterior of a dome, is proof of the high degree of technical proficiency in painted ceramic which Safavi craftsmen had attained.

36. Calligraphic Tile
Early 17th century
H. 14 in., W. 14 in.
The Art Institute of Chicago; Logan-Patten-Ryerson Collection

This single tile is said to have come from the Royal Mosque in Isfahan. The intertwining, archaistic Kufic script forms a design of the utmost complexity, relying on the color scheme

to separate two related messages. In turquoise blue we read: "He is God." White lettering expresses the Muslim profession of faith: "There is no God but Allah." The visual intricacy of the composition is not simply aesthetic inventiveness; instead, it is a vivid metaphor of the diversity, interconnectedness, and fundamental unity of God.

Publ.: Pope and Ackerman, *Survey,* vol. 9, pl. 528/B.

37. Two Polychrome Tiles
Ca. 1625
H. 17½ in., W. 9¼ in.
The Cleveland Museum of Art; gift of the John Huntington Art and Polytechnic Trust

Originally part of a larger composition, this young man and woman were most likely represented as participants in an outdoor entertainment. The color scheme is the same as that in the larger *haft rangi* (seven-color) tile (No. 38).

Publ.: C.K. Wilkinson, *Iranian Ceramics* (New York, 1963), pl. 88.

38. Tile Panel
17th century
H. 36⅝ in., W. 44¾ in.
Seattle Art Museum; Eugene Fuller Memorial Collection

This large wall panel, composed of polychrome tiles nine inches square, is said to have come from the former royal palace of the Haft Dasht, a seventeenth-century building located in the great gardens of Sa'adatabad on the south side of the Zayendeh Rud. Its seven-color design of animals and birds sporting amid stilted vegetation against a yellow background is typical of seventeenth-century tile work, and similar amiable compositions are still to be found in the interior tile surfaces of both the Royal Mosque and the Armenian Cathedral of the Redeemer in Julfa. The finer mosaic ceramic work of the Timurid period has been abandoned in favor of the swifter, cheaper, and more flexible technique of painted ceramic tiles.

39. Brass Inkwell with Silver Inlay
Late 16th century
H. 3⅝ in.
The Metropolitan Museum of Art

40. Copper Disk from an Astronomical Instrument
Ca. 1600
Diam. 31½ in.
Victoria & Albert Museum

The disk must once have been part of an astronomical instrument, but its function is unclear. Twelve figures, engraved and gilded, decorate the surface, and the portions of figures behind the angels in the upper left and right indicate that the metal area originally surrounding the disk was also decorated in a similar way. The nude figure in the lower center supports the signs of the zodiac.

Publ.: Pope and Ackerman, *Survey,* vol. 12, pl. 1404.

41. Gilded and Silvered Cut Steel Kashkul
Dated 1015 H. (1606/07)
H. 3¼ in., L. 8½ in.
Collection of Prince Sadruddin Aga Khan

Cut steel work represents one of the high points of Safavi metal technique, and this sabot-shaped *kashkul* (beggar's bowl) is one of the finest known examples. On the bottom and top of the vessel are intricate arabesques, while around the side runs a silvered inscription enclosed within a gilded band, itself chased with a delicate arabesque design.

The inscription is extremely complex, metrically intricate and considerably condensed, so that sometimes a letter which occurs several times within a line is written only once. As a result, it has been necessary in many instances to reconstruct entire lines. The longer panels contain a six-line poem:

The Spring of Khizr dried up. When someone desires something like it, you are [that Spring].

Or, one can say that you resemble the Cup of Jamshid, which wants to be in the hands of those who resemble Iskandar.

Today this kashkul has received a new, enduring engraving. You are the greatest of all kings; you are a jewel cut out of a mine of jewels.

This steel kashkul will convey this news to everyone who wants it.

You are fit to be the Khaqan of China and the golden Emperor of Rome.

The smaller medallions contain more prosaic information:

Made by the most humble Hajji 'Abbas, the son of the late Aqa Rahim Yaraqasaz [an armorer or ornamental metal specialist], in the year 1015 H.

Although the person for whom the *kashkul* was made is not specifically identified, the laudatory tone and several references to monarchs make it quite possible that the vessel was intended for Shah 'Abbas himself. The metaphors could not be more complimentary. The "Spring of Khizr" refers to the waters of immortality which Alexander the Great sought in vain, according to Iranian legend. Jamshid's cup reflected the entire world to those who looked in it, and for Iran, situated between the two great cultures of China and Rome, the rulers of both civilizations represented pinnacles of power.

Hajji 'Abbas is a well known metalworker (see Pope and Ackerman, *Survey,* vol. 12, pl. 1393), but this is the only dated example of his art. It places him securely as a craftsman at the court of Shah 'Abbas I, rather than as an early eighteenth-century master as had previously been supposed.

42. Copper Kashkul
Early 17th century
H. 7 in., L. 19¼ in.
Collection of Edwin Binney, 3rd

The long, heavy bowl ends dramatically in two dragonheads, forms deriving (originally) from Chinese art but with a long history in Iranian painting and metalwork. The inscription filling the broad band below the rim contains the full names of all the twelve imams, while two short bands below the inscription read: "The owner is Darvish Amir 'Abbasi."

It was certainly not a poor man who ordered this sumptuous and superbly worked vessel. Many of the darvish orders in Safavi times were rich and powerful organizations, though their role as props of the Safavi royal house was somewhat reduced by Shah 'Abbas. The high quality of this bowl, like No. 41, as well as its excellent condition, would indicate that it was not part of the paraphernalia of a wandering holy man. In seventeenth-century Iranian painting the darvish image

(see Nos. 4 and 60) occupies a significant role as a symbol of piety and is evidence of the Shi'a inclination toward cult images.

Publ.: Pope and Ackerman, *Survey,* vol. 12, pl. 1386/A.

43. Brass Candlestick
Early 17th century
H. 12⅜ in.
The St. Louis Art Museum

A crisp arabesque, similar to that of the steel mirror (No. 44), decorates the broad middle band of the candlestick. Above it are four cartouches, containing a quatrain from Sa'di's *Bustan:*

> [The candle] said: "O, my poor admirer,
> The honey which is my sweet beloved is burning down.
> When I see that the sweetness departs from me,
> Like Farhad, the fire flames from my head."

The admirer is, of course, the moth: the image of the moth destroying itself in the fire of its love is one of the most powerful, recurrent images of Persian mystical love poetry. The honey refers to the beeswax of the candle, but its sweetness is the beloved. Farhad was the lover of Shirin, whose name in Persian means "sweet."

The second inscription, written around the candlestick's base, is of unknown authorship but is clearly based on Sa'di's verses:

> Like an ant I will build a house on your path.
> Like pure gold I wish to die under your feet.
> O, candle, like a moth I will die for your sake.
> I will offer myself as a sacrifice and die at your feet.

Between each of the four lines of this poem are small medallions containing a less passionate message which invokes divine protection for the owner and informs us of his name and that of the candlestickmaker:

> O, God, may I die as a good man.
> Drive away the sudden calamity.
> The owner is Khwajeh Amir Bek.
> [The maker is] Khwajeh Ibn Mahmud.

Publ.: Pope and Ackerman, *Survey,* vol. 12, pl. 1384/B.

44. Steel Mirror Inlaid with Gold
Early 17th century
H. 10½ in., W. 5⅜ in.
Nelson-Atkins Gallery of Art, Kansas City, Mo.; Nelson Fund

The clear, restrained quality of the arabesque on this mirror parallels architectural arabesques on the Masjid-i Shah and on the fine spandrel from the portal of the Royal Bazaar now in the Nelson-Atkins Gallery of Art. The nasta'liq inscription in the outer band is a poem in the elaborate and rather contorted *Sabkh-i Hindi,* or Indian mode, favored by Safavi patrons:

> Tell the mirror-maker: "Don't bother polishing it."
> The mirror will become unclouded when you look in it.
> You have loaned your face to the mirror.
> How else could it show your visage?

Publ.: Pope and Ackerman, *Survey,* vol. 6, p. 2516, fig. 839.

45. Sword of Shah 'Abbas I
Early 17th century
L. 40½ in.
The Metropolitan Museum of Art; bequest of George C. Stone, 1936

The hilt is composed of ivory plaques riveted to both sides of the tang. On the steel pommel is a rather crudely cut flower design, while the cross-guard is ornamented on each side with a cartouche enclosing an Arabic inscription: one one side the bismillah, the opening words of the *Qur'an,* "In the name of God, the Beneficent, the Merciful"; and on the other side, "I give you victory," a reference to the sword's function.

The single-edged blade is of watered, or damascened, steel and is of superb quality. Near the hilt on one side are two gold-inlaid cartouches. The smaller inscription reads: "Made by Asadullah," while the larger cartouche contains the words: "'Abbas, the servant of the King of Holiness," the standard "signature" of the great Shah. Generally considered the finest of all Iranian swordsmiths, Asadullah apparently flourished near the end of the sixteenth century; there is no precise information about him in contemporary chronicles. Dated blades bearing his name range over an unlikely time span from 1408 to 1808, and we must conclude either that Asadullah was a name common among armorers or that many of these weapons are forgeries. In any case this particular blade is one of uncommonly high quality, and the authenticity of its two names—'Abbas and Asadullah—seems highly likely.

The scabbard of stamped, black leather over wood is less impressive than the blade. But the baldric, of brown leather with steel slides, is hooked to the scabbard by means of a simple, but whimsical, double-headed duck. The baldric's slides and the two steel clasps on the scabbard are engraved with the five verses of sura 105 of the *Qur'an,* a chapter describing the defeat of a Yemeni army which attacked Mecca in the year Muhammad was born.

See: L.A. Mayer, *Islamic Armourers and their Works* (Geneva, 1962), pp. 26-29.

Publ.: *Metropolitan Museum of Art Bulletin* (May, 1958), p. 251.

46. Gilded Steel Helmet Decorated with Hunting Scenes
17th century
H. 10¼ in., Diam. 8 in.
Fogg Art Museum; gift of John Goelet

47. Two Archer's Rings
17th century
a. Red and white agate
b. Yellow and white agate
Diam. 1½ in.
The Metropolitan Museum of Art; bequest of George C. Stone

48. Steel Lance Point with Gold Damascened Decoration
Early 17th century
L. 16½ in., W. 1½ in.
The St. Louis Art Museum

Publ.: Pope and Ackerman, *Survey,* vol. 12, pl. 1429/E.

49. Steel Dagger
Early 17th century
L. 13½ in., W. 1⁵⁄₁₆ in.
The St. Louis Art Museum

The damascened blade is held in the mouth of a dragon. Above the carved steel arabesque of the handle is an inscription stating that the dagger was made for Mustafa Quli Khan, a chief of the Qashqai tribe which had entered Iran before the Safavi conquest of the country and which generally lived in southern Iran.

Publ.: Pope and Ackerman, *Survey,* vol. 12, pl. 1425/D.

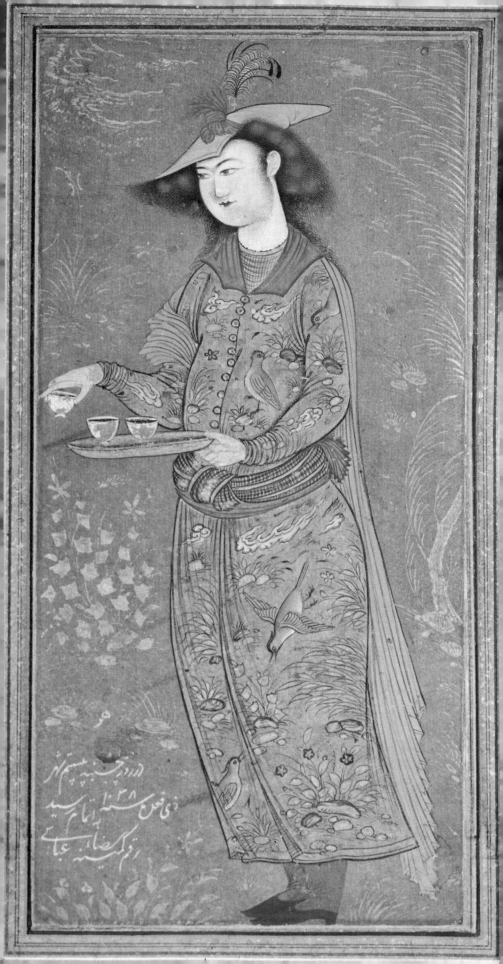

The Later Safavis · **Safi I** (1629-1642)

We have devoted much attention to the greatest of the Safavis because his reign requires it; the rule of his successors does not. The Isfahan period is dominated by one giant figure, Shah 'Abbas I, and the city in its entirety—its glistening architecture, its superb design, its abundant refulgent arts, even its smoothly decaying history—is like a marvelously set gem, brilliant but immobile. The patterns that 'Abbas created before his death in 1629 were not altered for ninety-three years. The centralized bureaucracy he created continued to administer, though with failing initiative and increasing corruption, until it shattered in 1722 under the attack of an ill-prepared and haphazard Afghan army. Few great buildings were constructed after his reign; indeed, he had built so many that there was little need for more. Chardin reports that Isfahan in 1666 contained 162 mosques, 48 medressehs (religious schools), 182 caravanserais, and 273 public baths, almost all of them put up by the great Shah himself. In a way, by having done so much—by having built so avidly; by having established so firmly an effective system of state arts; by having transformed Iran from an unstable feudal monarchy into a centralized autocracy—'Abbas bequeathed too much to his descendants. He left them little room for innovation, even had they possessed the energy to try. The order he created was too complete, and the strait jacket he tried to put on history only withered those who had to exist within it.

Still, the King, himself, did not feel the security which he achieved for his whole country. Having come of age far from his family, having been nearly executed by his mad uncle Isma'il II, and having finally come to the throne by overthrowing his father, 'Abbas was profoundly mistrustful of both his attendant lords and his potential heirs. Soon after his accession in 1587 he had blinded and incarcerated his father and two brothers. Later he executed his eldest son Safi on a trumped-up charge of treason. A second son he blinded and propelled toward suicide, and a third son, briefly designated heir-apparent during the Shah's serious illness of 1620, was blinded when 'Abbas recovered. The aging monarch is reported to have suffered bitter remorse over his want of paternal trust. Having eliminated all his own sons, he was eventually succeeded by his seventeen-year-old grandson Safi I.

Shah 'Abbas' paranoia reached deep, setting a pattern for the rest of the dynasty's checkered history. Due to his grandfather's exaggerated fears of overthrow, Safi had been brought up in the imperial harem, educated by eunuchs, and excluded from the rigorous training in statecraft, military tactics, and the arts which his predecessors had experienced. It was a deliberate and eventually fatal negligence, and one which he and his successors also perpetuated.

Safi was in every way unfit to rule, and his reign of thirteen years was chiefly distinguished by the fact that he was seldom sober. His continuous mental and physical instability compelled him to savage cruelties. The principal European commentator of the time, Ambassador Adam Olearius of Holstein, has described the king in 1637:

> He was about seven and twenty years of age, handsome bodied, having a graceful aspect, and of a clear and smooth complexion, somewhat hawk-nosed as most of the Persians are, and he had a little black hair upon the upper lip.

His appearance was misleading. Erratic purges and wholesale executions decimated the military and the aristocracy, and according to Olearius, Safi took deliberate pleasure in his indiscriminate rages:

> When he intended any execution, he was ordinarily clad in scarlet, or some red stuff, so that all trembled when he put on anything of that color.

He was only barely interested in architecture; the Royal Mosque was brought to completion during his reign but little else. We cannot doubt that the well-ordered workshops of 'Abbas continued to function under Safi without his overt guidance. Riza kept on painting, both miniatures (No. 50) and manuscripts (No. 51), until his death in 1635, and the greatest of the Safavi astronomical manuscripts (No. 52) was completed near the outset of his rule. But in all the arts—textiles, carpets, ceramics, metal, and books—there were no new directions. His was a reign living off the carefully accumulated capital of his predecessor.

50. Young Man with Three Cups. Riza. H. 6⅞ in., W. 3¾ in. *Opposite*

51. Khusrau Spies Shirin Bathing (folio 47R from the *Khusrau and Shirin* of Nizami). Riza. H. 9¾ in. W. 5½ in. *Opposite*
(Binding illustrated below.)

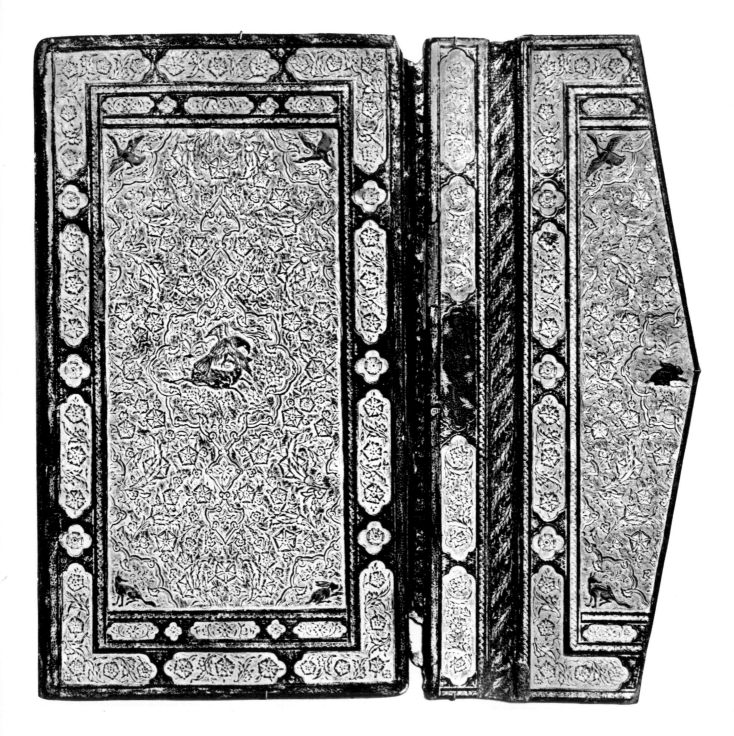

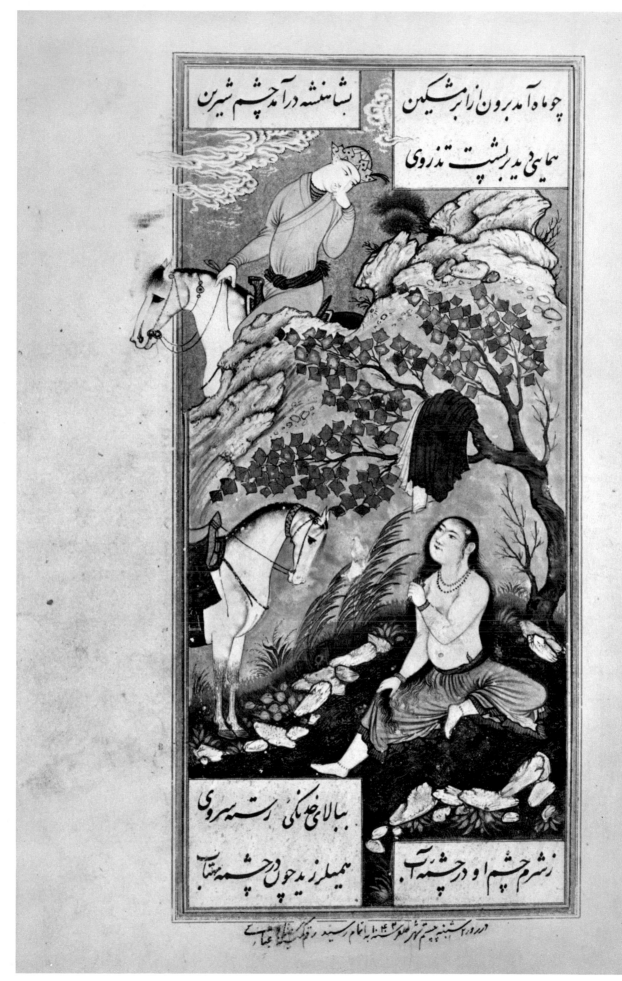

52a. The Constellation of the Camel (folio 42R from the *Book of Fixed Stars* of 'Abd al-Rahman al-Sufi). H. 15⅝ in., W. 9⅜ in.

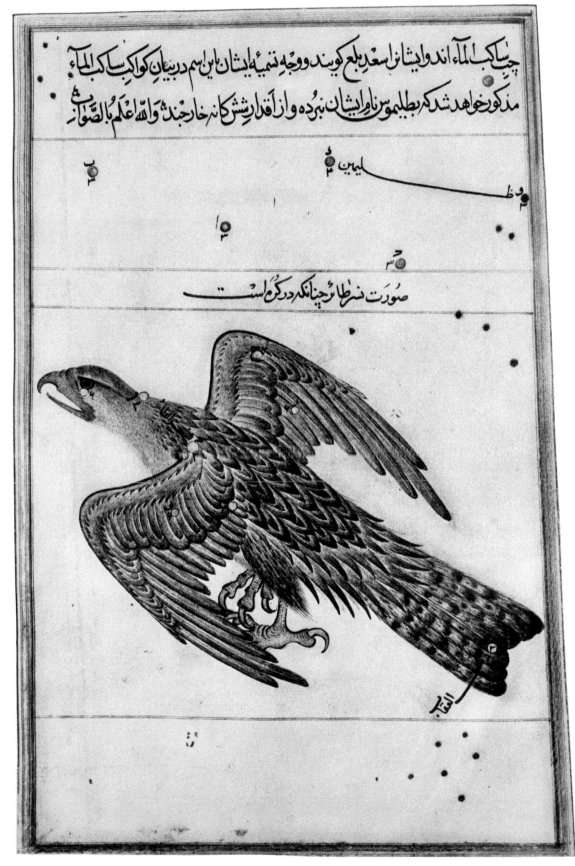

53b. Calligraphy. Muhammad Riza. H. 7¾ in., W. 4⁵⁄₁₆ in.

54. Flowering Plant beside a Pond. Textile. L. 45⁷⁄₁₆ in., W. 26¾ in. *Opposite*

55. Large Jar with Metal Cover. H. 11 in. (with cover).

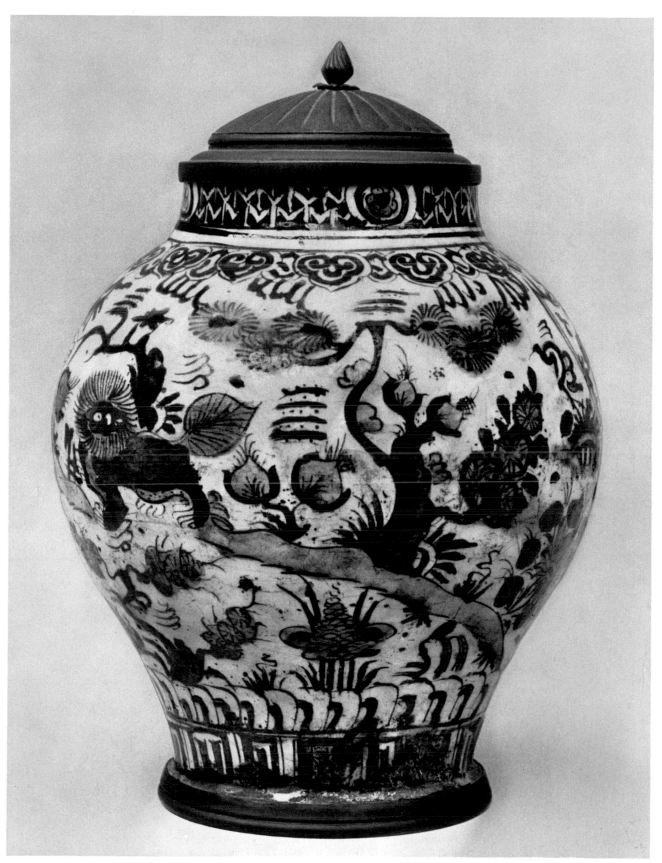

50. Young Man with Three Cups
Riza
Dated 1038 H. (1629)
H. 6⅞ in., W. 3¾ in.
Collection of Prince Sadruddin Aga Khan

The white inscription in the lower left area of the painting reads: "Thursday, the 20th of the month of Dhu'l-Qa'da in the year 1038, it was finished. The work of the most humble Riza-yi 'Abbasi." (The date corresponds to 12 July, 1629.) Despite some minor abrasions the painting conveys a dazzling tactile exquisiteness. Linear richness in Riza's earlier work has here been partially transmuted into sumptuous patterns and sensuous textures. The supremely refined aristocrat of No. 6 has become softer and plumper; his body's form—hesitating between mere decadence and gross decline—is as overripe as his lush fur hat. Like his garment, he is a paradigm of luxury.

The variations on the svelte and the powerful, the mystical and the sublime, which we find in Riza's youthful work for Shah 'Abbas, change in the painter's old age. He plays instead on less polished themes: the erotic, the decadent, the caricatural, and the coarse.

51. The Khusrau and Shirin of Nizami
18 miniatures by Riza
Dated 1041 H. (1631/32)
Khusrau Spies Shirin Bathing (folio 47r); illustrated
H. 9¾ in., W. 5½ in.
Victoria & Albert Museum

This text was copied in 1041 H. (1631/32) by 'Abd al-Jabbar, according to the colophon, and during the course of the following year Riza must have completed the eighteen miniatures which illustrate the text, for one of them (shown here) is dated Monday, 6th Safar 1042 H. (23 August, 1632). All of the miniatures are signed Riza-yi 'Abbasi. The manuscript is bound in a seventeenth-century binding of the highest quality, the work of Muhammad Muhsin Tabrizi.

Though his colors are rich, Riza's power as a manuscript illustrator has clearly ebbed from the level it attained in his earlier work, principally the fragmentary *Shahnameh* in the Chester Beatty Library (no. 277) for which Riza supplied five miniatures; and the ca. 1595 *Qisas al-Anbiya* in the Bibliothèque Nationale, Paris (Sup. pers. 1313). One suspects he was a mercurial artist, working erratically and hardly able to keep up the sustained effort necessary for the production of an entire book. His effort in this copy of Nizami's great love story is uneven. All but the dated picture show hasty, unimaginative landscapes, and many of the figures, though graceful in their sway-backed way, are stock types, technically fine but monotonous. They pale in comparison with his single-page figures.

We have seen that Riza's later art turns toward caricature, ribald humor, and luxury (see Appendix B). Logically, it also explores the erotic, and folio 211 of this manuscript depicts with graphic exactness Khusrau and Shirin consummating their marriage.

Publ.: T.W. Arnold, "The Riza 'Abbasi Manuscript in the Victoria & Albert Museum," *Burlington Magazine* 37 (1921); T.W. Arnold and A. Grohmann, *The Islamic Book* (Paris, 1929), pls. 71-74; B.W. Robinson, *Persian Miniature Painting* (London, 1967), no. 71.

52. The Book of Fixed Stars of 'Abd al-Rahman al-Sufi
188 folios, measuring 15⅝ in. by 9⅜ in., with 71 illustrations
Dated 1042 H. (1632)
a. The Constellation of the Camel (folio 42r); illustrated
b. The Constellation of Aquila (folio 59r); illustrated
The New York Public Library; Spencer Collection

Al-Sufi's *Kitab al-Kawakib al-Thabitah,* one of the basic astronomical texts of Islam, was often illustrated, but no other known copy rivals this one in quality and scope. Many of the illustrations occupy two pages, while a few are on silk fold-outs of impressive size. Altogether these are the largest known manuscript paintings of the Isfahan period.

The text was written in a fine Naskhi hand by Muhammad Baqir, one of the most celebrated late Safavi masters. The illustrations are unsigned and clearly the work of several masters, and if Riza was not actually one of them, it is clear that they were all painters trained by him. The manuscript is one of the few important books to have been produced at the court ateliers during the reign of Shah Safi.

Publ.: Grube, *Muslim Miniature Painting,* no. 111.

53. Two Pages of Calligraphy
Muhammad Riza
Late 17th century
a. H. 7⅝ in., W. 4 in.; b. H. 7¾ in., W. 4⁵⁄₁₆ in.
Museum of Fine Arts, Boston

Muhammad Riza, one of the most celebrated calligraphers in the first half of the seventeenth century, provided important inscriptions both on the Royal Mosque in Isfahan and on the great iwan added to the Shrine of the Imam Riza in Meshhed by Shah 'Abbas II.

The slightly smaller page (a) is a Safavi devotional poem largely in Arabic about 'Ali and his family, who receive special veneration in Shi'a countries. It is in six parts:

1. To the Arab Prophet and the civilized Messenger (of God). And to his "brother" Asadullah, called 'Ali.[1] And to Zahra, the Pure, and to her Mother and sons. To their family and their tribe and their virtuous house.[2]

2. To Saijad, to Baqir, to Sadiq, truly be greetings. And to Musa and 'Ali and Taqi and Naqi.[3]

3. And to Dhi'l-'Askar and Hayyat-i Qa'im, who strikes with his sword by the order of Eternal God, truly be greetings.[4]

4. To them all be my greetings and praises a thousand times in the morning, in the evening, and both day and night.

5. To them all be my greetings and praises in the morning, in the evening, and both day and night.

6. [By] the most humble servant born in your house, Muhammad Riza.

The larger page (b) is an "amulet" in Persian and Arabic invoking divine assistance and protection against evil. It is in four parts, the first two in Arabic and the last two in Persian:

1. He gives honor:
Take away my calamity, O 'Ali, who are the revealer of wonders. One finds protection through you against one's difficulties. Through your saintliness make all my worries and sorrows scatter, O 'Ali, O 'Ali, O 'Ali.

2. He gives honor:
The praise is yours, O you who have generosity and glory and
majesty. Be proud, for it befits you.

3. O you, who are the protection of everyman who is in misery.
Your generosity is the excuse of everyman's sins. The dust
on the shoes of those who follow your Path is an honorable
ornament on the bejeweled buttons on everyman's hat. If you
favor me with the honor of your acceptance, I feel like an
angel. If with the whip of disfavor you drive me away from
yourself, I feel like a devil.

4. [By] the most humble servant born in your house,
Muhammad Riza.

(Shown only at the Fogg Art Museum.)

1. The "Arab Prophet and Messenger" is, of course, Muhammad. "Asadullah" (God's sword) is one of the titles of 'Ali, the Prophet's son-in-law and the first Shi'a imam.

2. Zahra is one of the names of Fatima, the Prophet's daughter and the wife of 'Ali.

3. All are Shi'a imams.

4. Dhi'l-'Askar is one of the Shi'a imams. Hayyat-i Qa'im (the witness of God) refers to the twelfth (and last) imam who, though absent from this earth, still lives and will return to punish sinners and bring justice to the world.

54. Flowering Plant beside a Pond
Cut, voided, satin velvet, brocaded
First half of the 17th century
L. 45⁷⁄₁₆ in., W. 26¾ in.
Worcester Art Museum; Jerome Wheelock Fund

The rippling, S-curved water of each small, silver pond sustains a large, flowering plant and a smaller, tulip-like blossom, while a small cloud floats in the space between each plant. Despite the worn condition of the fabric, the gently undulating design conveys great subtlety and grace.

See: Reath and Sachs, *Persian Textiles*, pp. 131, 132 (example 90). Other fragments of this textile are in The Metropolitan Museum of Art, the Gulbenkian Foundation, the Textile Museum, and the Victoria & Albert Museum.

55. Large Jar with Metal Cover
Ca. 1730
H. 11 in. (with cover)
The Metropolitan Museum of Art; Theodore M. Davis Collection, bequest of Theodore M. Davis, 1914

In this black and white painted jar, derived from Chinese types, a sense of ordered space has been discarded in favor of whimsical ambiguity. The cross-eyed and dandelion-headed lion is in humorous counterpoint to the ponderous respectability of the form.

63. Shah 'Abbas II Receiving the Mughal Ambassador. Attributed to Muhammad Zaman. H. 8 in., W. 12½ in.

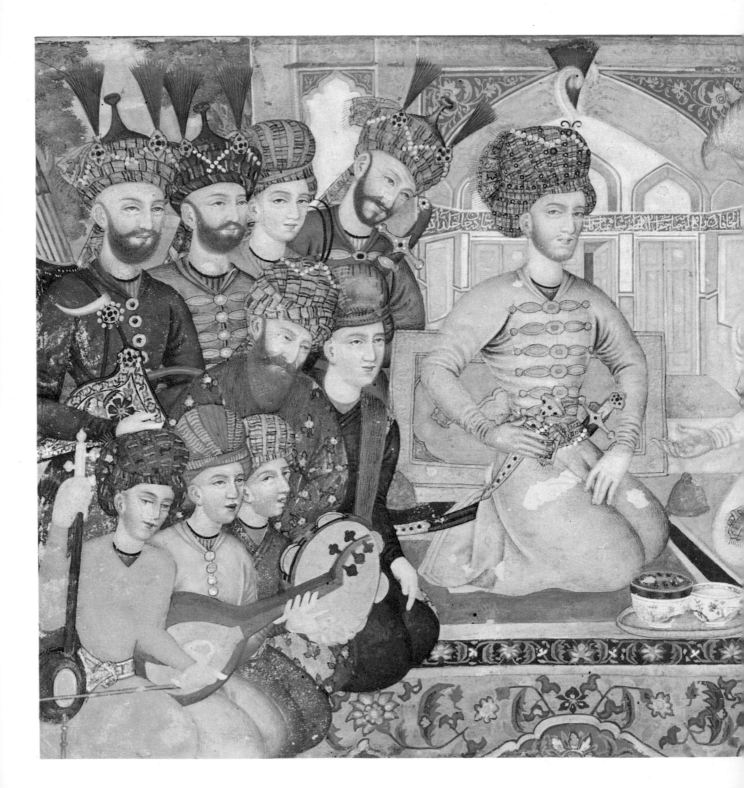

Shah 'Abbas II (1642-1666)

Of the later Safavis only 'Abbas II, the great-grandson of his namesake, interrupted the steady decline of the dynasty. Although inclined to lose control under the influence of alcohol and narcotics, he was more stable and gifted than any other descendants of 'Abbas, and history records him as a careful, just ruler and an intelligent patron. During his twenty-four years as king he built important mosques, medressehs, caravanserais, and bridges, both within Isfahan and in the rest of the country. He made splendid additions to the great Shi'a shrine of the Imam Riza in Meshhed and restored some of Isfahan's older monuments. He was a patron of the book as well, and made rich use of the well trained painters he had "inherited" from Riza's atelier. The latter's son Shafi' developed a new genre in painting—voluptuous still-life studies of flowers (No. 58)—and became one of the court's chief textile designers, while Riza's most prolific student, Mu'in, produced some of the seventeenth century's finest illustrated manuscripts (Nos. 56, 57).

Three Muhammads—Muhammad Qasim (Nos. 60, 61), Muhammad Yusuf, and Muhammad 'Ali—worked under his patronage, and a fourth, Muhammad Zaman, was, according to one scholarly interpretation, sent by the Shah to Italy to master the European techniques which the monarch admired (Nos. 63, 71, 72). The hypercritical traveling French jeweler, Tavernier[1], even reports that the Dutch East India Company sent two European painters to Isfahan to teach the Shah drawing. In keeping with this new fascination with exotica the European painter later known as 'Ali Quli Jabbehdar (see Nos. 73, 74, 86) arrived in Isfahan and secured employment at the royal court, while, among the Iranians, an unnamed artist who may well be the youthful Muhammad Zaman brought together both European and Indian influences to leave us a rough but splendid portrait of the Shah himself (No. 63).

1. J. B. Tavernier, *Les dix voyages de M. J. B. Tavernier en Turquie, en Perse, et aux Indes* (Paris, 1713).

57. Rustam in Combat with Puladwand and His Demons (folio 163 from Volume I of the *Shahnemah* of Firdausi). H. 14¾ in., W. 9⁷⁄₁₆ in.

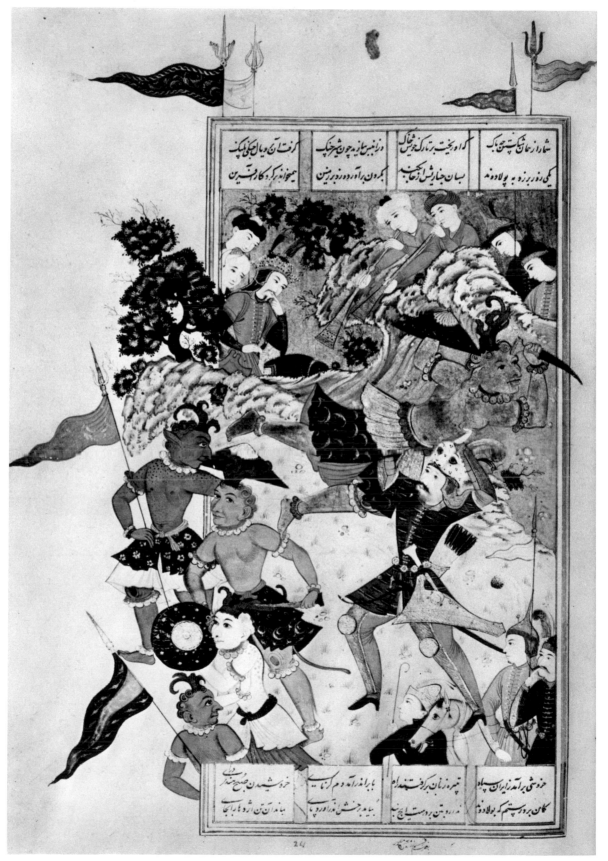

60. Red Darvish. Attributed to Muhammad Qasim. H. 7½ in., W. 4⅛ in. *Opposite*

61. Two Lovers. Attributed to Muhammad Qasim. H. 8⅛ in., W. 4⅜ in.

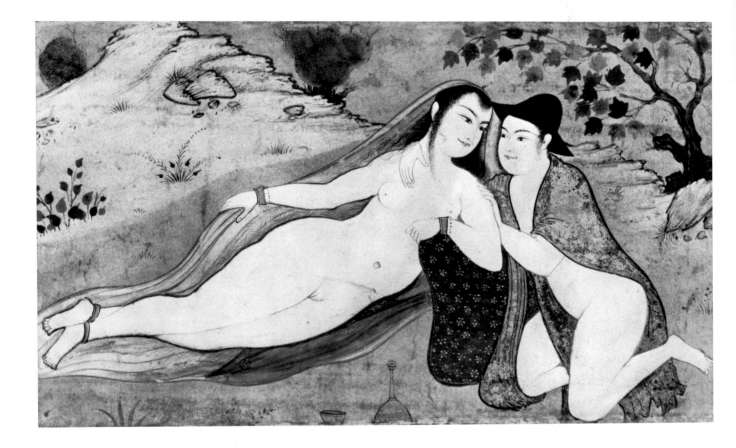

64. Strawberry Plants and Butterflies. Textile. L. 57½ in., W. 28⅝ in.

58. Bird, Butterflies, and Blossoms. Shafiʻ ʻAbbasi. H. 6⅜ in., W. 9¹³⁄₁₆ in. *Opposite*

59. Mystical Journey. H. 9¾ in., W. 4¹⁵⁄₁₆ in. *Detail opposite*

65. Archer in a Tree. Textile. L. 53¾ in., W. 29 in. *Opposite*

66. Golden Flowers. Textile. L. 27½ in., W. 28 in.

67. Steel Dagger with Bone Handle and Gold Inlay. L. 14¼ in., W. 1½ in. *Above*

68. Gilded Steel Powderhorn. L. 6 in., W. 1½ in. *Below*

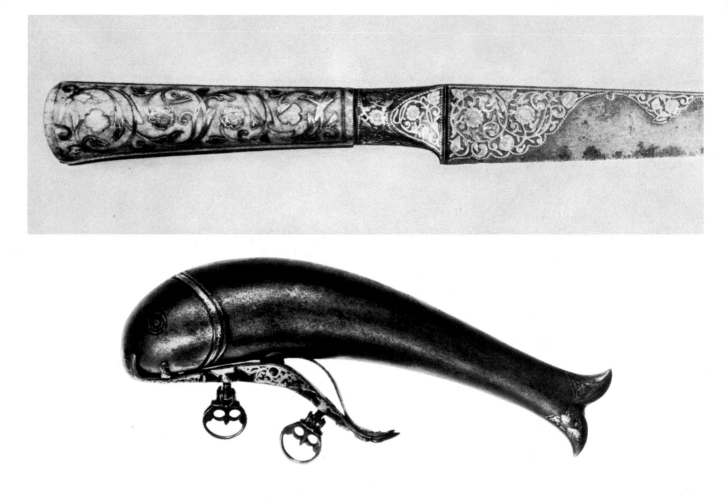

69. Blue and White Bottle. H. 10⅛ in., Diam. 6⅝ in.

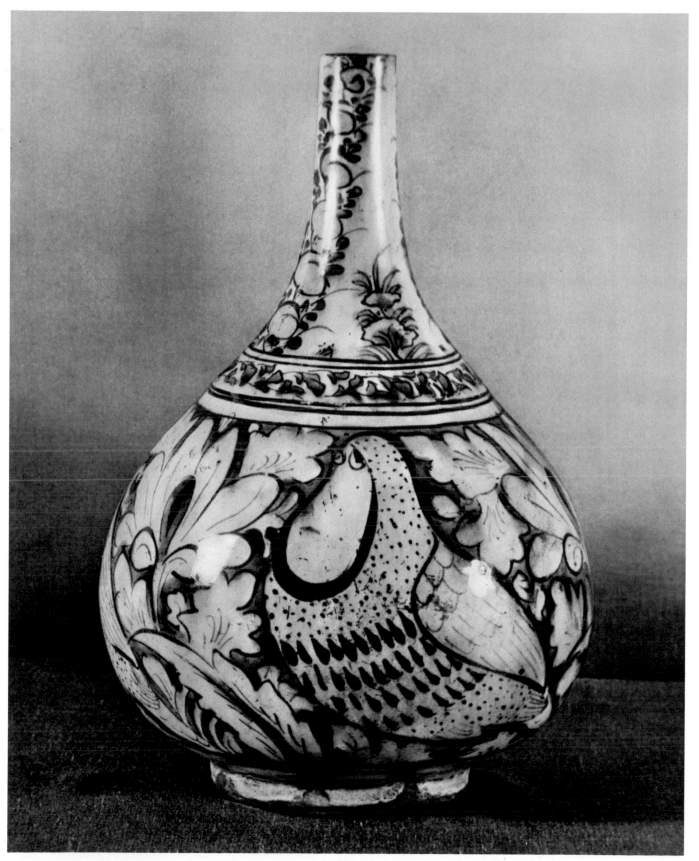

56. Isfandiyar Traps the Simurgh
Mu'in Musavvir
Ca. 1650
H. 13½ in., W. 8⅞ in.
Private Collection

Shah 'Abbas II must have been a keen connoisseur of painting, for he almost certainly commissioned two manuscripts of the *Shahnameh,* both illustrated by Mu'in Musavvir (see no. 57). One of these great manuscripts was dismantled, and this page and others are now dispersed in various collections in Europe and North America, among them The British Museum; Fogg Art Museum; Worcester Art Museum; A. Hyatt Mayor Collection; Prince Sadruddin Aga Khan Collection.

In Mu'in's other single miniatures and drawings in this exhibition he presents us with his humor, his respect for his master Riza's work, and his attention to the world around him. Here, however, he reveals himself as an artist of enormous power and vision, who, while working on traditional scenes of Iranian painting, enlivens them with rich, bold color and daring line.

For biographical information regarding Mu'in Musavvir see Appendix C, page 147.

57. Volume I of the Shahnameh of Firdausi
243 leaves with text and miniatures measuring 14¾ in. by 9⁷⁄₁₆ in.
Mu'in Musavvir
Dated 1064 H. (1654)
Rustam in Combat with Puladwand and His Demons (folio 163); illustrated
Collection of Prince Sadruddin Aga Khan

The text is written in a fine nasta'liq script in four columns of 25 lines each. The volume is bound in an early-nineteenth-century morocco Indian binding. The second volume of this manuscript of the *Shahnameh,* similarly bound, is in the Chester Beatty Library in Dublin (see M. Minovi, B. W. Robinson, J.V.S. Wilkinson, and E. Blochet, *The Chester Beatty Library, A Catalogue of the Persian Manuscripts and Miniatures* [Dublin, 1959-1962], no. 270). The colophon of volume I gives no mention of the scribe except to say that the book was completed in Jumada 2 1064 H. (April-May, 1654). Of twenty-nine full-page miniatures and a double-page frontispiece in volume I all but one bear Mu'in's name written at the bottom of the page. All of the twenty-one miniatures in volume II are signed by him.

Several of Mu'in's illustrations are dated and cover a span of three years from 1065 to 1067 H. (1654-1657). He was, therefore, already a mature artist in his late thirties, working under the patronage of Shah 'Abbas II for whom he almost certainly prepared these illustrations. It was a prolific period during which he also completed miniatures for a now-dispersed *Shahnameh,* of which No. 56 in this exhibition is a fine example.

Publ.: *Catalogue of Persian, Turkish, and Arabic Mss. and Indian and Persian Miniatures,* Sotheby & Co., sale catalogue (London, November 25, 1968), lot. 179.

58. Bird, Butterflies, and Blossoms
Shafi' 'Abbasi
Dated 1062 H. (1651/52)
H. 6⅜ in., W. 9¹³⁄₁₆ in.
The Cleveland Museum of Art; purchase, Andrew R. and Martha Holden Jennings Fund

It is very likely that Shafi' 'Abbasi was the son of Riza-yi 'Abbasi, though the honorific *nisbah* " 'Abbasi" was not inherited but instead given to him by Shah 'Abbas II, the great-grandson of 'Abbas I, patron of Riza. He was trained by his father, as a drawing in the celebrated Sarre album in the Freer Gallery of Art clearly indicates (see F. Sarre and E. Mittwoch, *Die Zeichnungen von Riza 'Abbasi* [Munich, 1914], p. 13). He was also an important textile designer, and some of his floral designs have fortunately survived (see Pope and Ackerman, *Survey,* vol. 12, pl. 1056/C). It is very possible that textile No. 64 in this exhibition was based on one of his designs.

Safavi painters in the late seventeenth century developed a striking new painting genre—flower studies, influenced perhaps in equal measure by European and Indian paintings of the same subjects; many undoubtedly formed the basis for textile designs. It was to be more fully developed by Qajar painters in the nineteenth century. Of the painters in this exhibition, Muhammad Zaman was also especially celebrated for his floral studies.

This example of Shafi' 'Abbasi's work ranks with the very best of Muhammad Zaman, and its sensuous volumes and subtle colors may even surpass his. It was painted for a patron of high rank, though the inscription indicates that it was apparently not for Shah 'Abbas II himself: "For the successful nawab, the most honorable, most holy, and most high, [who is] of exalted position, it was drawn by the qalam of the humble Shafi' 'Abbasi in the year 1062 H. [1651/52]."

59. Mystical Journey
Ca. 1650.
H. 9¾ in., W. 4¹⁵⁄₁₆ in.
Fogg Art Museum

In its swirling patterns this ecstatic tinted drawing approximates most closely the partly spontaneous, partly calculated rhythms of some of the striking marbleized borders favored by illuminators in Isfahan (see Nos. 6, 15). But its energetic curves reveal the unity and diversity of all life as well: darvishes pray, dance, meditate, and apparently transcend their earthly existences; insects, fish, fowl, and mammals mingle, merge, and prey on one another. The entire "electric" composition focuses on the simurgh (the mythical bird who is the symbol of mystical awareness in Iranian literature and art) whose composite body is made up of abstract lines, and includes a passionate darvish, birds, fish, a tiger's tail, and an elephant.

Certain elements of costume in this drawing may imply a Turkish rather than Iranian origin. But if it was produced under Ottoman auspices, it seems clearly to be the work of an artist trained in the Isfahan school. Preeminently it is a visionary's journey, a visual rendering of profound spiritual experience, akin to that great work of mystical literature, the *Conference of the Birds* of Farid al-Din 'Attar.

60. Red Darvish
Attributed to Muhammad Qasim
Ca. 1660
H. 7½ in., W. 4⅛ in.
Private Collection

Three of Riza's later seventeenth-century followers—Muhammad Qasim, Muhammad Yusuf, and Muhammad 'Ali—were celebrated draftsmen who developed in parallel directions,

apparently during the reigns of Shah 'Abbas II and Shah Sulaiman. All "students" of Riza, they cultivated a mannered style based upon his innovations. In their drawings we usually find fluid, almost flaccid rocks in sparse landscapes and rounded figures in easy poses. The subjects are most often single figures, generally sensuous young men and women or older darvishes.

Of the three artists, Muhammad Qasim, also an accomplished manuscript painter, is the most imaginative. This cunning, knowing darvish is endowed with a personality as vital and convincing as any in Riza's work, and the almost liquid linear rhythms of his garment rival those of the earlier master.

61. Two Lovers
Attributed to Muhammad Qasim
Ca. 1660
H. 8⅛ in., W. 4⅜ in.
Fogg Art Museum; purchase, Grace Nicols Strong, Francis H. Burr, and Friends of the Fogg Art Museum Funds

Muhammad Qasim was trained by Riza during that master's later years and "inherited" from his mentor an inclination for almost liquid line, bold coloring, and erotic subjects. All three qualities are amply demonstrated in this painting, one of the very few, fine representations of the nude in Islamic art.

Publ.: Grube, *Muslim Miniature Painting,* no. 122.

62. Shah 'Abbas II and the Mughal Ambassador
Shaikh 'Abbasi
Dated 1074 H. (1663/64)
H. 9 in., W. 5½ in.
Collection of Mehdi Mahboubian

Another meeting of the monarch and the ambassador (see No. 63) was recorded by Muhammad Zaman, an artist probably somewhat younger than Shaikh 'Abbasi. The fact that both artists are strongly influenced by European and Indian paintings indicates a likely association of the two men, both working under the patronage of 'Abbas II. Indeed, it seems quite possible that Muhammad Zaman may have been trained by Shaikh 'Abbasi. Although this painting ranks high in Shaikh 'Abbasi's limited oeuvre, the older master was soon surpassed by the more gifted younger painter.

Publ.: *Catalogue of Fine Indian and Persian Miniatures and a Manuscript,* Sotheby and Co., sale catalogue (London, 12th December, 1972), lot 202.

63. Shah 'Abbas II Receiving the Mughal Ambassador
Attributed to Muhammad Zaman
Ca. 1663
H. 8 in., W. 12½ in.
Collection of Prince Sadruddin Aga Khan

The ambassador sits at the Shah's left. An inscription in the architectural niche behind the Shah identifies the monarch by name but mentions neither painter nor date. However, a painting by Shaikh 'Abbasi, dated 1663 (No. 62), represents the same subject, and similarities of dress and features make it almost certain that this painting was done about the same time.

This group portrait is clearly derived from the formal *darbar* portraiture of the Mughal emperors, a genre which particularly flourished under Shah Jahan in India (1627-

1658). Artistic contacts between Iran and India had been rather one-sided in the past, when Iranian painters, calligraphers, and builders had emigrated to assume lucrative posts in the various Muslim kingdoms of India. Under the Mughals this lopsided influence was accelerated, but it had also a reverse current: the emperor Jahangir (1605-1627) sent his favored artist Bishindas to Isfahan to record exact likenesses of Shah 'Abbas I, and Indian paintings found their way as gifts to the Isfahan court.

They were admired, apparently, for Muhammad Zaman, a master who drew inspiration largely from European sources, must have borrowed his basic composition from the Mughal group portrait. His arrangement, however, is less rigid than the frozen *darbar* scenes Shah Jahan encouraged. Servants struggle manfully with trays of food through the packed crowd of courtiers, and their partially concealed, squinting faces are as humorously rendered as the rather dazed faces of the musicians. Nor are we dealing with idealized types in the principal portraits: the Shah's youthful face is intelligent, lively, even a little cruel, while the Mughal ambassador's expression is characterized by diplomatic respect and wise restraint.

Muhammad Zaman was in his early twenties in 1663 and since his first signed and dated work comes from the year 1675, this painting is the earliest work which we can attribute to him. The characteristics which mark his later work—almost overdone modeling of features and clothing, stippled beards and trees, and an ability to catch many levels of facial expressiveness—are already present here in the eclectic, rough, but powerful painting of a youthful master just finding his own direction.

For biographical information regarding Muhammad Zaman see Appendix D, page 148.

64. Strawberry Plants and Butterflies
Satin velvet, brocaded, cut, and voided, with silk and gilt-
 silver yarns
17th century
L. 57½ in., W. 28⅝ in.
Museum of Fine Arts, Boston

The repeat pattern is a marvel of clarity and stateliness. Two butterflies hover above each leaf, which forms the background for a strawberry plant with fruit and six blossoms. The gilt-silver thread (the metal wound around a silk core) is brocaded. The pile is made up of short velvet warps, a technique highly favored by seventeenth-century weavers.

See: Reath and Sachs, *Persian Textiles,* pp. 129, 130 (example 88). Fragments from this cloth are also in the University Museum, Philadelphia, and The Metropolitan Museum of Art.

65. Archer in a Tree
Plain, compound cloth with gold and silver brocade
Late 17th century
L. 53¾ in., W. 29 in.
The Metropolitan Museum of Art; purchase, Rogers Fund,
 1910

Having taken refuge in a tiny tree with huge pink and white fruits, an archer in a blue coat aims at a yellow lion clawing at the back of his horse. The white horse itself is busy fighting a second lion. The concentrated pattern is ordered on a strict horizontal and vertical basis and shows little of the sinuous diversity of No. 91.

The textile is made of silk, with gilt metal and silver strips used in the brocading.

Publ.: Reath and Sachs, *Persian Textiles,* pp. 83, 84 (example 26); Pope and Ackerman, *Survey,* vol. 5, p. 2125.

66. Golden Flowers
Red satin with stylized floral brocade in gilt and silver thread
17th century
L. 27½ in., W. 28 in.
The Metropolitan Museum of Art; gift of the Hajji Baba Club
in honor of Dr. M. S. Dimand, 1959

67. Steel Dagger with Bone Handle and Gold Inlay
17th century
L. 14¼ in., W. 1½ in.
Nelson-Atkins Gallery of Art, Kansas City, Mo.; Nelson Fund

Publ.: Pope and Ackerman, *Survey,* vol. 12, pl. 1425/C.

68. Gilded Steel Powderhorn
Mid-17th century
L. 6 in., W. 1½ in.
Collection of Mrs. Eric Schroeder

This whimsical powderhorn, in the shape of a fish, is made of fine, damascened steel. It is gilded around the head, tail, and movable handle, and delicate arabesques are incised under the gilding.

69. Blue and White Bottle
First half of the 17th century
H. 10⅛ in., Diam. 6⅝ in.
The Art Institute of Chicago; Mary Jane Gunsaulus Collection

The bottle probably once had a metal top, crowning the rotundity of the form. Despite the streaking of the blue under-glaze color, the decoration reveals a typically Iranian sensitivity to the relation of form and ornament: the vessel's weighty shape is humorously equated with the ponderous pot-belly of the self-conscious bird.

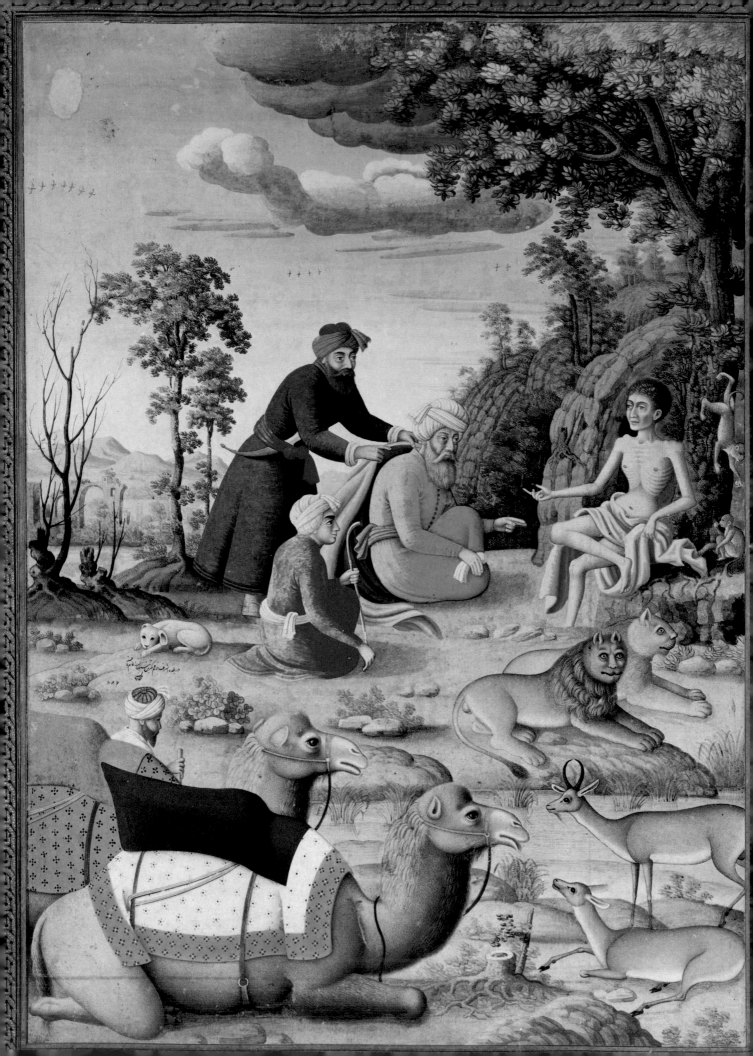

Sulaiman (1666-1694)

It is Sulaiman's court which has been most richly recorded for us by European sources. Chardin wrote a lengthy description of the Shah's second coronation and of his own less than easy years at the royal court. So, too, did Tavernier, whom very little seemed to please. There were others too, like Ambrosio Bembo (see No. 70), who were not permitted such intimate glimpses into court life but who left valuable accounts of the city itself.

The picture of Sulaiman's reign is far from wholesome. Harem-raised, the Shah virtually abdicated his power to the court eunuchs who embarked upon a wholesale execution of many of the country's most capable nobles. The calculated policy of official religious tolerance was abrogated, and the resultant persecution of Christians, Jews, and even Sunni Muslims robbed the state of its vitality and commercial well-being. There was little building, either in Isfahan or in the rest of Iran, and the economic arts so carefully nurtured by Shah 'Abbas I continued to utilize designs which had been vigorous half a century earlier but which now tended to look a little shopworn.

But the arts of the book—the preeminent interest of the private connoisseur in Iran—present a startling contrast to this rather dismal picture. And even if Sulaiman was less merciful in his justice than his father 'Abbas II had been, and shared the insobriety and sloth of his grandfather Safi, he apparently did possess a connoisseur's interest in painting of a high order. For it was almost certainly under his patronage that the three most considerable painters of the late seventeenth century—'Ali Quli Jabbehdar, Muhammad Zaman, and Mu'in Musavvir—created some of their most impressive work. Muhammad Zaman was even directed to refurbish and "improve upon" two of the previous century's most celebrated manuscripts. If we are correct in assuming that Sulaiman, as patron, was directly or indirectly involved in their work, then the duality of his taste—favoring both the traditional modes of Mu'in Musavvir and the new Europeanizing currents of 'Ali Quli Jabbehdar and Muhammad Zaman—is symptomatic of the precarious balance between old and new in late-seventeenth-century painting. Had the dynasty not been near its end, these two movements might well have merged into a rich and vital synthesis.

71. Majnun Visited in the Wilderness. Muhammad Zaman. H. 9¹³⁄₁₆ in., W. 6⅞ in. *Opposite*

70. The Palace of Mirrors or Ayineh Khaneh (folio 246 from *The Journal and Travels of Ambrosio Bembo in Asia*).
G. G. Grelot. H. 18 in., W. 13 in.

76. Portrait of Riza. Mu'in Musavvir. H. 7⅜ in., W. 4⅟₁₆ in. *Opposite*

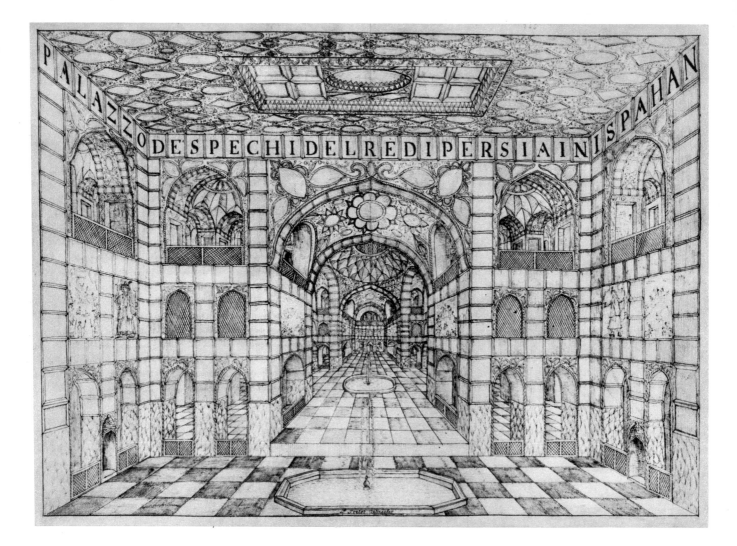

74. Woman at a Fountain. ʿAli Quli Jabbehdar. H. 6¹⁵⁄₁₆ in., W. 4⁷⁄₁₆ in. *Opposite*

73. Two Shepherds in Bucolic Landscape. ʿAli Quli Jabbehdar. H. 6½ in., W. 4¾ in.

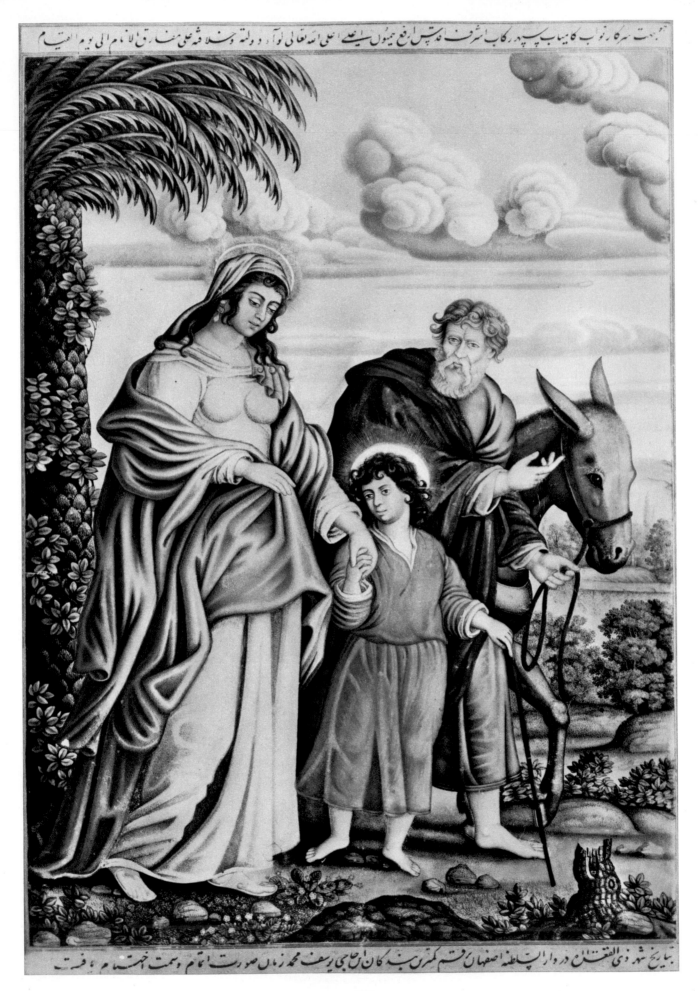

تاریخ شہر فرنگی القفیل اندر وارس سلطنہ اصفہان قسم گترس افغ کان این حاجی یوسف محمد زمان صورت اقتم ورسمت اخستم ام یوم القیم

108

72. **The Return from the Flight into Egypt.** Muhammad Zaman. H. 7¹³⁄₁₆ in., W. 5⁹⁄₁₆ in. *Opposite*

78. **Squatting Camel.** Mu'in Musavvir. H. 7¼ in., W. 5¹⁄₁₆ in. *Right*

79. **White Thrush.** Mu'in Musavvir. H. 7¼ in., W. 4⅝ in. *Below*

77. Four Lions. Muʻin Musavvir. H. 6³⁄₁₆ in., W. 4¹³⁄₁₆ in.

75. Lion Attacking a Youth. Mu'in Musavvir. H. 4 in., W. 7 in.

81. Blue and White Dish. Diam. 11⅞ in.

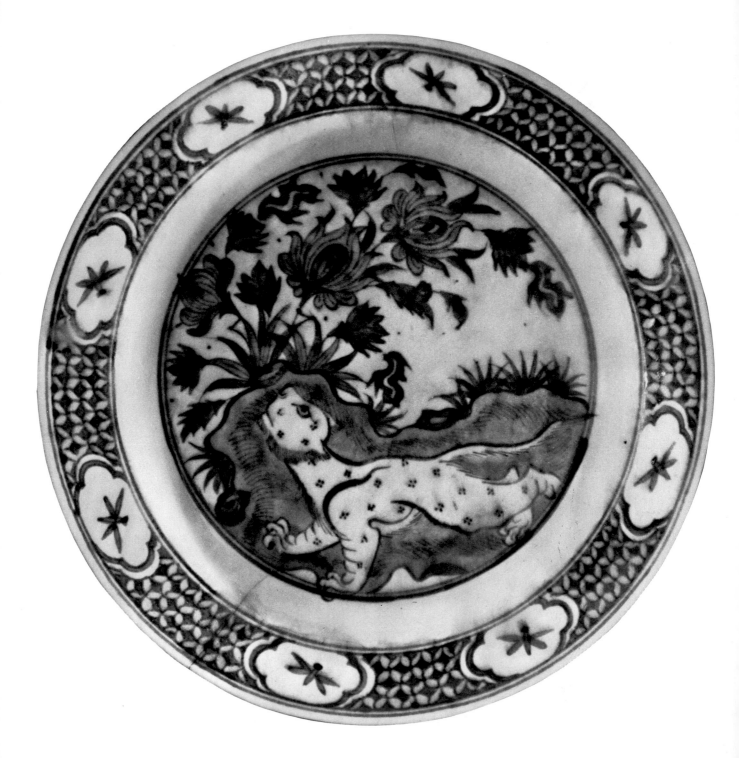

84. Deep, Golden-brown Luster Bowl. H. 3¼ in., Diam. 7½ in.

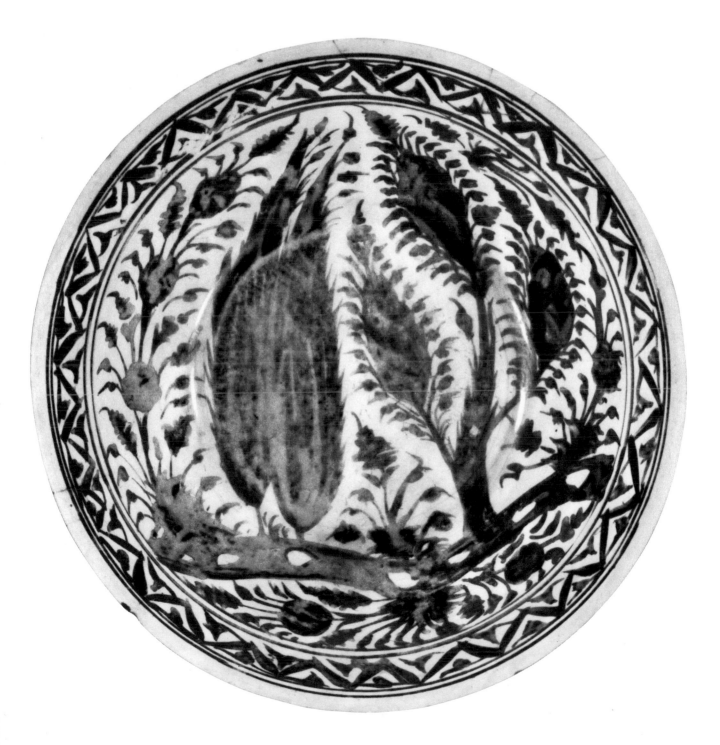

80. Large White Plate. Diam. 19⅛ in.

82. Qalian in the Form of an Elephant. H. 9⅛ in., W. 7⅛ in.

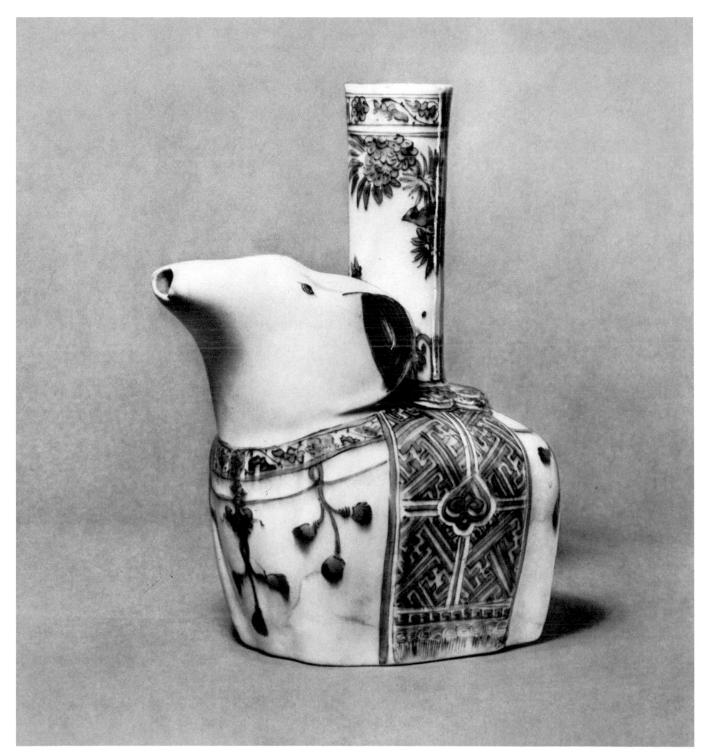

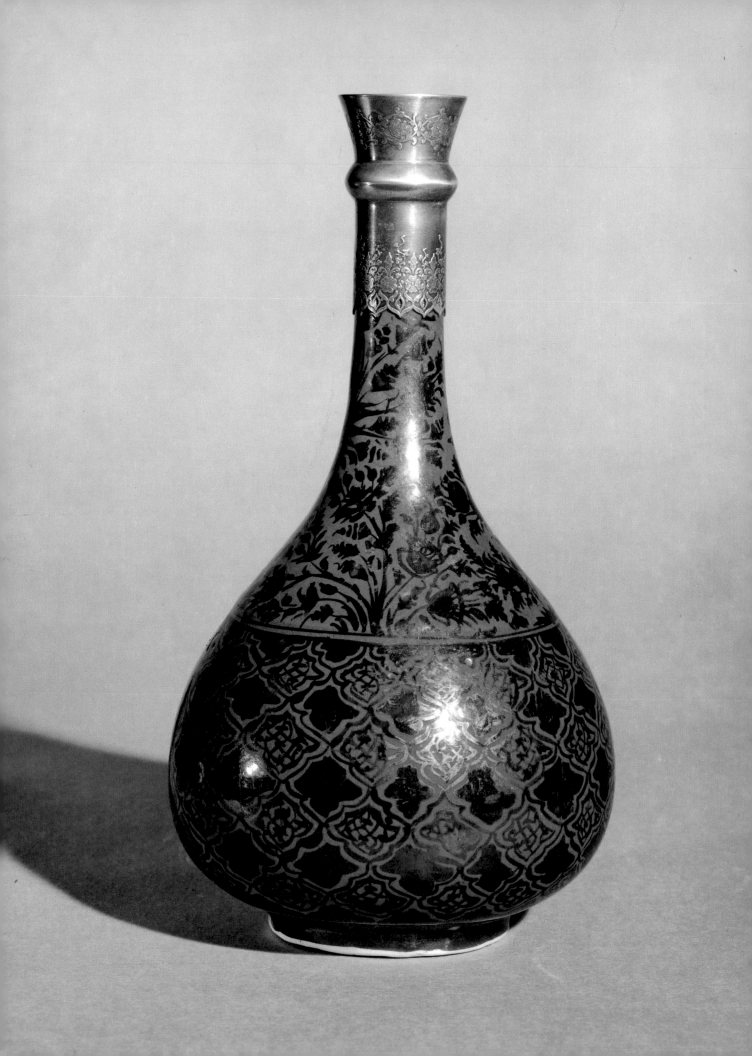

83. Blue and Brown Luster Bottle. H. 10⅞ in., Diam. 5¾ in.
Opposite

70. The Journal and Travels of Ambrosio Bembo in Asia
Italian manuscript of 315 pages with 47 illustrations by
 G. G. Grelot
1671-1675
The Palace of Mirrors or Ayineh Khaneh (folio 246);
 illustrated
H. 18 in., W. 13 in.
University of Minnesota, James Ford Bell Library

Two European travelers to Iran in the seventeenth century,
Chardin and Tavernier, are recognized as the richest Western
sources for knowledge of late Safavi Iran. But dozens of other
accounts by travelers from all nations of Europe have ap-
peared. This Italian manuscript, one of the most rewarding, is
only now in the process of being published.

Ambrosio Bembo arrived in Iran in June, 1674, after
having traveled in Ceylon and India for two years. During his
stay in Isfahan, he met the French painter G. G. Grelot, a
competent draftsman whom Chardin had hired to illustrate his
own travels in Iran. Despite his considerable ability as a
writer Chardin was not a good employer, and Grelot eagerly
entered Bembo's service.

Bembo's modest introduction to his book (whose full
title reads: *Travels and Journal through part of Asia, during
nearly four years, undertaken by me Ambrosio Bembo, a
Venetian Noble*) states his own purpose simply:

*In describing the various places I have related all that could
give a sufficient idea of them: and with respect to the
material part I have availed myself, at no inconsiderable
expense, of the talents of an ingenious Frenchman, who
accompanied me, and have endeavored as far as it has been
in my power to give satisfaction by introducing various
sketches of the Towns, and costumes of the various nations,
as well as of the celebrated monuments and rarities.*

Of the forty-seven illustrations in the *Journal*, seven were
used by Chardin in his own *Travels*. The other forty have
never been published. Their subjects range widely: Cyprus,
Aleppo, Baghdad, Persepolis, Isfahan, Bisitun, Taq-i Bustan,
and other smaller cities, as well as representations of peoples
and costumes encountered on the way. Eleven of Grelot's line-
drawings deal with Isfahan itself, and folio 246, illustrated
here, represents a celebrated pleasure palace of the later Safavi
Shahs (Sultan Husain was crowned there), which was de-
stroyed at the end of the last century. The author is aware of
no other contemporary representation of the building.

71. Majnun Visited in the Wilderness
Muhammad Zaman
1675/76
H. 9¹³⁄₁₆ in., W. 6⅞ in.
Collection of Edwin Binney, 3rd

This page once formed part of the *Khamseh* of Nizami which
was produced under the patronage of Shah Tahmasp between
the years 1539-1543. This book's original complement of illus-
trations consisted of four miniatures by Sultan Muhammad,
six by Aqa Mirak, two by Mirza 'Ali, one by Muzaffar 'Ali, and
five by Mir Sayyid 'Ali. In 1675/76, well over a hundred years
later, when the manuscript had certainly become somewhat
the worse for wear, many of its margins were refurbished. At
the same time Muhammad Zaman repainted some of the faces
in the work of Aqa Mirak, probably removed four of Mir
Sayyid 'Ali's miniatures, and completed four miniatures of his
own for inclusion in the book. The present painting was one

of the four new illustrations, but either was not added to the
book or was removed at a still later date. To the left is a
meticulous inscription: "In the service of the most honorable
it was finished by the humblest of servants Muhammad Zaman
in 1086 [1675/76]."

Nizami's tragic love story of Majnun and Laila partly
parallels that of Romeo and Juliet. Unable to marry his
beloved, Majnun retreats into the wilderness, not only in
sorrow but also in search of spiritual fulfillment. His time
there is spent in an increasingly mystical awareness of God.
One of his most poignant experiences of the oneness of life is
his friendship with the animals who inhabit his otherwise
barren world, and in this miniature the emaciated and ascetic
Majnun, surrounded by the animals who trust him, gently re-
jects the counsel of his worldly visitors who have come to
convince him to leave the "wilderness." Muhammad Zaman's
rendering of this complex subject with its several layers of
meaning is one of the most sensitive in the history of Iranian
painting and belies the commonly held opinion that seven-
teenth-century painting in Iran was completely devoid of
spiritual content.

The ruined buildings at the left, drawn in clear Euro-
pean perspective, echo the common Iranian motif of desola-
tion, as do the brittle and lifeless trees before them.
Muhammad Zaman's use of European and, more specifically,
Flemish motifs and techniques is always sensitive and never
mutely imitative.

72. The Return from the Flight into Egypt
Muhammad Zaman
Dated 1100 H. (1689)
H. 7¹³⁄₁₆ in., W. 5⁹⁄₁₆ in.
Fogg Art Museum; gift of John Goelet

This painting is based upon a mid-seventeenth century en-
graving by the Flemish master Lucas Vosterman, after Peter
Paul Rubens' *The Return from the Flight into Egypt*.
Muhammad Zaman's version is considerably smaller than
Vosterman's large engraving.

A lengthy inscription, written in a careful, excellent
nasta'liq, fills the top and bottom borders of the miniature:

*For his excellency the successful Lord, for whom the sky is
a stirrup, the most honorable, most holy, most high and
exalted 'Isa. May the most high God raise his flag and his
wealth and his caliphate above mankind until the Day of
Resurrection. [This painting] was finished by Ibn Hajji
Yusuf Muhammad Zaman in the month of Dhu'l-Qa'da
1100 [18 August-16 September, 1689] in the capital city of
Isfahan.*

Although Jesus ('Isa) is considered a great prophet in Islam,
it is highly unlikely that an inscription containing his name
in such laudatory terms would have been found on a painting
for a Muslim patron, and we can properly assume that Mu-
hammad Zaman was working here for a Christian patron,
very likely a highly placed Armenian in Julfa.

73. Two Shepherds in a Bucolic Landscape
'Ali Quli Jabbehdar
Ca. 1675
H. 6½ in., W. 4¾ in.
Collection of Prince Sadruddin Aga Khan

Spotty clusters of flowers and leaves are found in Iranian
painting, but their treatment here is far from that of Muham-
mad Zaman (see Appendix D), the European 'Ali Quli's

117

Iranian contemporary. Though the pot-bellied youth in blue, who languishes at the right, is a stock type in seventeenth-century painting, the rounded and archly posed flutist is not, nor do we find in traditional landscapes such deeply eroded ridges rich in grass, and trees that are too sharply highlighted against a blue-streaked sky.

It is quite likely that 'Ali Quli, the convert to Islam, and Muhammad Zaman knew each other's work. Each makes concessions to the other's culture but still remains clearly within his own tradition.

Publ.: A. Welch, *Catalogue of the Collection of Islamic Art of Prince Sadruddin Aga Khan,* 2 vols. (Geneva, 1972), Ir. M. 42 (color).

For biographical information regarding 'Ali Quli Jabbehdar see Appendix E, page 148.

74. Woman at a Fountain
'Ali Quli Jabbehdar
Ca. 1675
H. 6¹⁵⁄₁₆ in., W. 4⁷⁄₁₆ in.
Collection of Edwin Binney, 3rd

The forms of this rocky landscape as well as the color scheme reflect the influence of contemporary Iranian painting on 'Ali Quli's work. In the upper right is a worn but still legible rendition of his name. The treatment of the central figure—her rounded body, flowing skirts, and costume—lends credence to the suggested European origin of the artist.

The painting bears striking similarity to a painting of a woman and two attendants in the Leningrad album (see Appendix E).

75. Lion Attacking a Youth
Mu'in Musavvir
Dated 1082 H. (1672)
H. 4 in., W. 7 in.
Museum of Fine Arts, Boston

The drawing is in brown ink with a light red tint on the lion and on the hats of three of the men who are trying to restrain the animal. The inscription is the longest and most fascinating of any in Mu'in's work:

It was Monday, the feast of the blessed Ramazan in the year 1082, when the ambassador from Bukhara brought a lion and a rhinoceros as gifts to Shah Sulaiman. At the gates of the palace the lion attacked the son of a grocer, a boy of about fifteen or sixteen years, and tore half of his face away. He died on the spot. The same year snow fell from the beginning of the month of Sha'ban [January, 1672] into the month of Shawwal [February]. As a result, there were great losses for many people: the price of all food rose, and that for wood in an extraordinary way. It was colder than anyone could remember it had ever been before. Communications are interrupted, and as the snow falls and I am confined to my house, I am going to draw this to distract myself. Work of Mu'in Musavvir. Written Saturday, the 3rd of the month of Shawwal 1082 . . .[1]

Publ.: Coomaraswamy, *Collection Goloubew,* no. 84 (pl. 67); E. Kühnel, "Der Maler Mu'in," *Pantheon* 29 (1942), p. 114; Schroeder, *Persian Miniatures,* p. 149; Grube, *Muslim Miniature Painting,* no. 117; Stchoukine, *Manuscrits de Shah 'Abbas,* p. 67.

1. Translation from Grube, *Muslim Miniature Painting.*

76. Portrait of Riza
Mu'in Musavvir
Begun in 1044 H. (1635) and finished in 1084 H. (1673)
H. 7⅜ in., W. 4¹⁄₁₆ in.
Princeton University Library; Garrett Collection

Mu'in's sensitive and respectful portrait of his aged master was apparently largely finished in the year of Riza's death in 1635, when, judging from our sources and from his appearance here, Riza must have been about seventy years old. The gentle, light red of his garment is admirably balanced with the light blue of his turban and cloak. Holding his brush in his right hand and a small cup of color in his left, Riza is painting the portrait of a European.

The inscription in Mu'in's hand in the upper left reads:

The portrait of my late master who has gone to his [eternal] rest, May God have mercy on him, Riza-yi Musavvir 'Abbasi, known by the name of Riza-yi 'Abbasi Asghar. It was painted in the month of Shawwal 1044 [20 March-17 April, 1635]. In the month of Dhu'l-Qa'da of the same year [18 April-17 May], he passed from this transient life to the eternal life. And this portrait was finished forty years later on the 14th of the month of Ramazan of the year 1084 [24 December, 1673], in order to conform to the wishes of my son Muhammad Nasira. [By] Mu'in Musavvir. May his sins be forgiven him.

It seems clear that the portrait, left unfinished due to the unexpected death of Riza, was finished when Mu'in himself was close to Riza's age. It is one of the few known portraits of an Iranian painter at work. In 1676 Mu'in completed another, very similar, portrait of Riza painting an Iranian (Pope and Ackerman, *Survey,* vol. 9, pl. 921/B).

Publ.: Arnold and Grohmann, *Islamic Book,* pl. 75; M.E. Moghadan and Y. Armajani, *Descriptive Catalogue of the Garrett Collection of Persian, Turkish, and Indian Manuscripts, Including some Miniatures* (Princeton, N.J., 1939), no. 200; Kühnel, "Mu'in," fig. 2; Grube, *Muslim Miniature Painting,* no. 118; Stchoukine, *Manuscrits de Shah 'Abbas,* pp. 88, 89.

77. Four Lions
Mu'in Musavvir
1088 H. (1677)
H. 6³⁄₁₆ in., W. 4¹³⁄₁₆ in.
Collection of Edwin Binney, 3rd

This line drawing of four lions, whose bodies are joined to one head, is a brilliant variation on the illusionistic themes which appear occasionally in Iranian art. Again, the inscription is precise and informative:

On Saturday night, the 7th of month of Shawwal in the year 1088 [3 December, 1677] in my home with the Messiah of the era Hakim Muhammad Sayyid Amun. May he be blessed. The pen of Mu'in Musavvir.

Publ.: Stchoukine, *Manuscrits de Shah 'Abbas,* p. 68.

78. Squatting Camel
Mu'in Musavvir
Dated 1089 H. (1678)
H. 7¼ in., W. 5¹⁄₁₆ in.
Private Collection

The inscription is partly enlightening, partly confusing. It reads: "In the night of Wednesday the 28th of the month of Shawwal 1089 [13 December, 1678] in the honor and fortune

of these two lines designed by the late master Bihzad Sultani, may God bless his soul. By Mu'in Musavvir." This translation was made by S.H. Nasr and is quoted in Grube, *Muslim Miniature Painting,* no. 120.

The enigmatic mention of "these two lines" has been explained either as a reference to a famous drawing of two camels by Bihzad, reproduced in Binyon, Wilkinson, and Gray, *Persian Miniature Painting,* pl. 87-A, or, as Grube suggests, to two lines of calligraphy which were originally mounted next to the drawing. In any case the drawing stands as a superb example of Mu'in's mature work, combining mellifluous line, meticulous observation, and a whimsical, homey sense of humor.

Publ.: Pope and Ackerman, *Survey,* vol. 9, pl. 924; Kühnel, "Mu'in," fig. 7; Stchoukine, *Manuscrits de Shah 'Abbas,* pp. 68, 69; Robinson, *Persian Drawings,* pl. 66.

79. White Thrush
Mu'in Musavvir
Dated 1100 H. (1689/90)
H. 7¼ in., W. 4⅝ in.
Museum of Fine Arts, Boston

Careful observation and depiction of natural life can be noted in the first half of the sixteenth century in the work of Bihzad and Mir Sayyid 'Ali, two of the leading early-Safavi painters, but their representations of animal life were small details of larger compositions. By the beginning of the next century animal study had developed into a full-fledged genre of its own, in both India and Iran. Whether Mu'in was influenced by his more celebrated Mughal predecessor, Mansur, is a moot point: the often cited "naturalism" of Mughal painting finds a simultaneous, though less vital, development in Iranian painting. Fully characteristic of Mu'in's hand is the bold, even startling use of color. He seems to delight in pressing color contrasts to the brink of gaudiness, though carefully refraining from passing the limits of good taste.

80. Large White Plate
Second half of the 17th century
Diam. 19⅛ in.
Museum of Fine Arts, Boston

This very large plate has been glazed white over a pale celadon slip, lending a delicate, translucent hue to the incised lotus blossom design.

81. Blue and White Dish
Late 17th century
Diam. 11⅞ in.
Museum of Fine Arts, Boston

The pure white body bears a blue and white design modeled on Chinese export ware, though with a more decorative bent. These pseudo-Chinese wares, traditionally attributed to Meshhed, were probably produced in a number of Iranian cities to supply the large market, both Iranian and foreign for Chinoiserie.

82. Qalian in the Form of an Elephant
Late 17th century
H. 9⅛ in., W. 7⅛ in.
The Metropolitan Museum of Art; purchase, the Friends of the Islamic Department Fund, 1968

Iranian *qalians* (water pipes), derived from types of Chinese drinking vessels, occur in the forms not only of this supercilious blue and white elephant but also of lions, toads, phoenixes, and ducks. The design has been outlined in black, and the blue underglaze painting has run in some places.

83. Blue and Brown Luster Bottle
Second half of the 17th century
H. 10⅞ in., Diam. 5¾ in.
The Metropolitan Museum of Art; Theodore M. Davis Collection, bequest of Theodore M. Davis, 1915

The glaze of this pear-shaped bottle with a silver top has been stained dark blue to provide a rich background for the design. Its dark brown luster painting shows the same vivacious sense of decoration and rather hasty execution as No. 84.

84. Deep, Golden-brown Luster Bowl
Second half of the 17th century
H. 3¼ in., Diam. 7½ in.
Cincinnati Art Museum

Luster painting, one of the most striking techniques of earlier Iranian ceramics, underwent a revival in the seventeenth century. It has not yet been possible to determine the precise centers of manufacture, and the less-than-careful painting of many of the pieces suggests that they may not have been made for the most exacting buyers. The designs avoid the strong Chinese influence we find in the blue and white ware of the same period, and though the painting of details may appear to be hasty, the over-all composition of the best examples has a striking rhythm and vitality, not unlike that of the polychrome Kubachi wares which they also resemble in their often illogical natural "clutter."

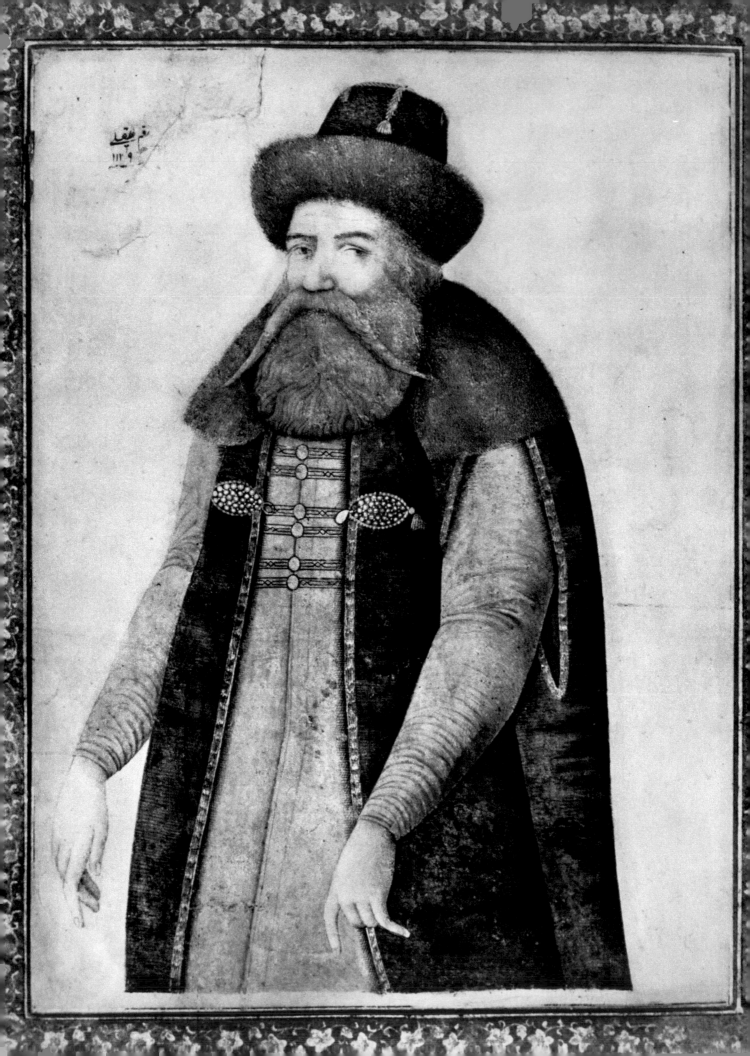

Sultan Husain (1694-1722)

Among the few distinctions of Sultan Husain's thirty-year reign is the last great Safavi building, the splendid mosque and medresseh on the Chahar Bagh, Isfahan's principal avenue. But it was not constructed under the Shah's patronage; his mother supplied the funds. Despite a painstakingly pious manner, the Shah expended his own efforts in increasing the number and size of his palaces and in extending his harem to what must have been exhausting proportions.

The royal workshops continued to be productive, and many of Iran's few surviving Safavi garments come from his reign (Nos. 92, 93, 94). Chinese models still provided the stimulus for a large portion of Iranian pottery (No. 89), while one of the finest Safavi scientific instruments was very likely made at the royal court (No. 95). 'Ali Quli Jabbehdar was still painting (No. 86), though undoubtedly well advanced in years, and a latter-day namesake of 'Ali Riza was enlivening the sententious verses of Sana'i (No. 87). With royal initiative in the arts almost wholly lacking, Iranians were still producing impressive, if rather dry, objects, as the dynasty ground to a halt.

Of course, the state structure continued to function, in society at large as well as in the arts, but it had ossified. The timid and retiring Shah withdrew both from the business of government and from those he governed, and passed most of his long reign in the harem where he had spent his formative years. Like his predecessor he handed over responsibilities to the court eunuchs, a few of them capable but most not, and he let the politic tolerance instituted by 'Abbas I lapse into often savage bigotry which only succeeded in driving away foreigners and weakening Iran's fragile economic base still further. The few energetic men of the time were mistrusted, hounded, and even executed, so that by 1720, when the Afghan tribes who had long suffered under Safavi domination began tentatively encroaching on Safavi territory, there was little capable leadership or effective resistance. 'Abbas' great creation collapsed quickly and ignominiously before its surprised attackers, and Isfahan itself, after a devastating siege in which the inhabitants were reduced to cannibalism, fell in 1722.

It was the end of the city's 125 years of greatness. Though the Safavi dynasty continued for many years, "ruling" or claiming rule as puppets (bearing illustrious but hollow names like Tahmasp II, 'Abbas III, and Isma'il III) in the hands of aspiring strongmen, the glory of the former Safavi capital was never reestablished. It was a poignant epilogue to the history of the city which had once been "half the world."

86. Portrait of a Russian Ambassador. 'Ali Quli Jabbehdar. H. 12 in., W. 8 in. *Opposite*

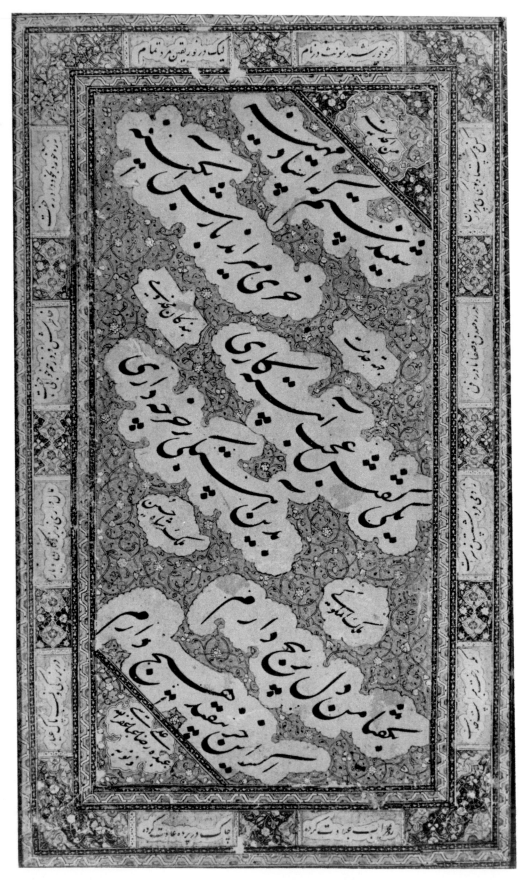

85. Portrait of Shah 'Abbas I and a Page. Attributed to Mu'in Musavvir. H. 10 in., W. 5⅞ in.

88. *Qur'an* **with Red and Gold Lacquer Binding.** Inscription on binding signed by 'Ali Riza 'Abbasi. H. 11¹³⁄₁₆ in., W. 8¹⁄₁₆ in. *Following pages*

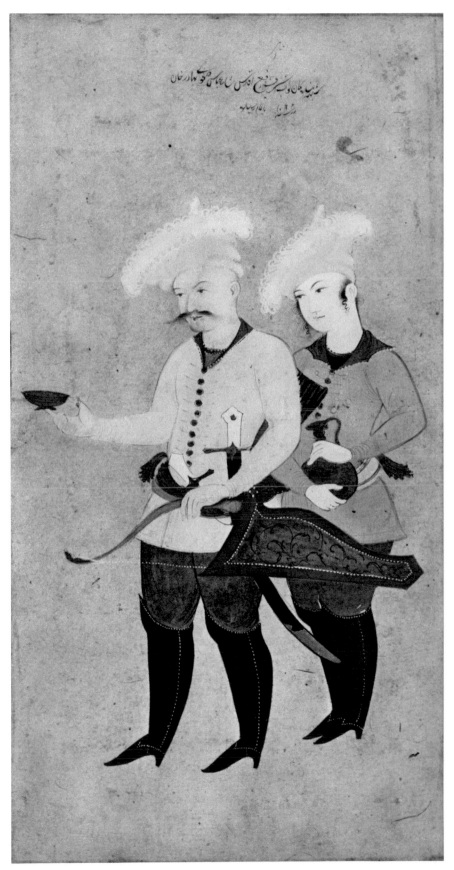

مارد لا يسمعون إلى الملأ الأعلى ويقذفون من كل جانب

دحورا ولهم عذاب واصب إلا من خطف الخطفة فأتبعه

شهاب ثاقب فاستفتهم أهم أشد خلقا أم من خلقنا إنا

خلقناهم من طين لازب بل عجبت ويسخرون وإذا ذكروا

لا يذكرون وإذا رأوا آية يستسخرون وقالوا إن هذا

إلا سحر مبين أإذا متنا وكنا ترابا وعظاما أإنا لمبعوثون

أو آباؤنا الأولون قل نعم وأنتم داخرون فإنما هي

زجرة واحدة فإذا هم ينظرون وقالوا يا ويلنا هذا يوم

الدين هذا يوم الفصل الذي كنتم به تكذبون

احشروا الذين ظلموا وأزواجهم وما كانوا يعبدون

من دون الله فاهدوهم إلى صراط الجحيم وقفوهم إنهم

مسؤولون ما لكم لا تناصرون بل هم اليوم مستسلمون

خصيم مبين ۞ وضرب لنا مثلا ونسي خلقه قال من يحيي

العظام وهي رميم ۞ قل يحييها الذي انشاها اول مرة وهو بكل

خلق عليم ۞ الذي جعل لكم من الشجر الاخضر نارا فاذا انتم منه

توقدون ۞ اوليس الذي خلق السموات والارض بقادر على

ان يخلق مثلهم بلى وهو الخلاق العليم ۞ انما امره اذا اراد

شيئا ان يقول له كن فيكون ۞ فسبحان الذي بيده ملكوت

كل شيء و
اليه ترجعون
سورة الصافات

بسم الله الرحمن الرحيم

والصافات صفا فالزاجرات زجرا فالتاليات ذكرا ۞ ان الهكم

لواحد رب السموات والارض وما بينهما ورب المشارق

انا زينا السماء الدنيا بزينة الكواكب وحفظا من كل شيطان

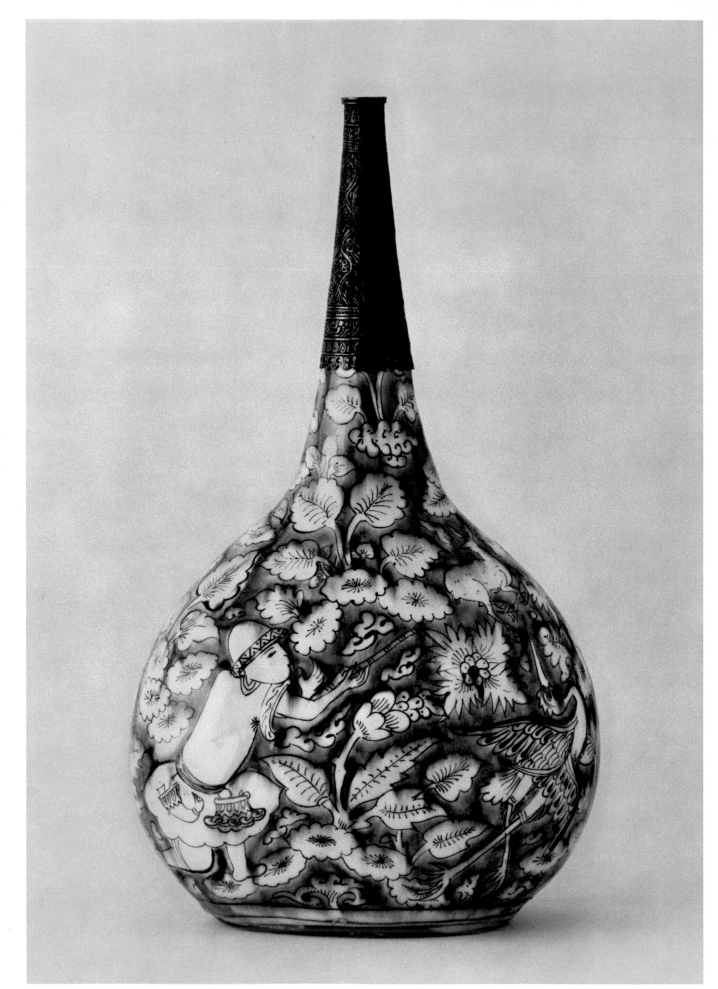

89. Blue and White Flask with a Silver Top. H. 14⅝ in., Diam. 7⅞ in. *Opposite*

96. Carnelian and Silver Oval Seal. H. 1½ in., W. 1⅝ in.

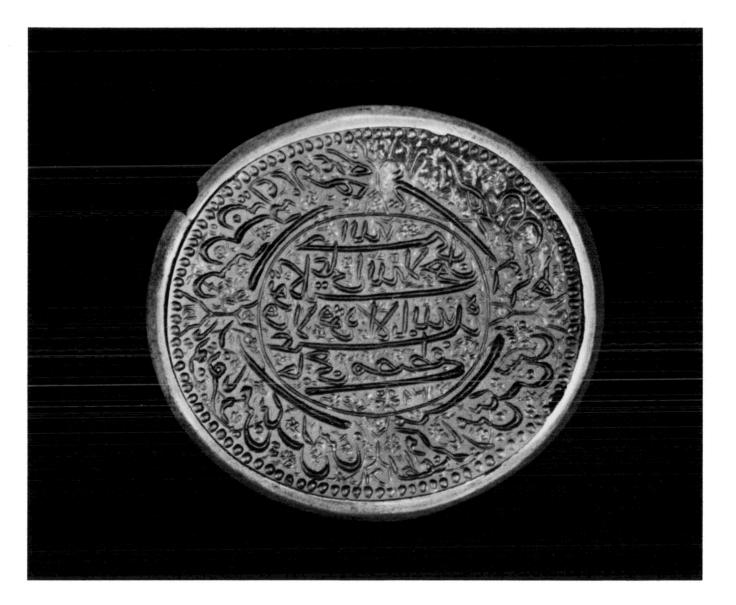

90. Blue Floral Ikat. Textile. L. 16 in., W. 10½ in.

91. Deer, Tigers, and Birds. Textile. L. 25 in., W. 12½ in. *Opposite*

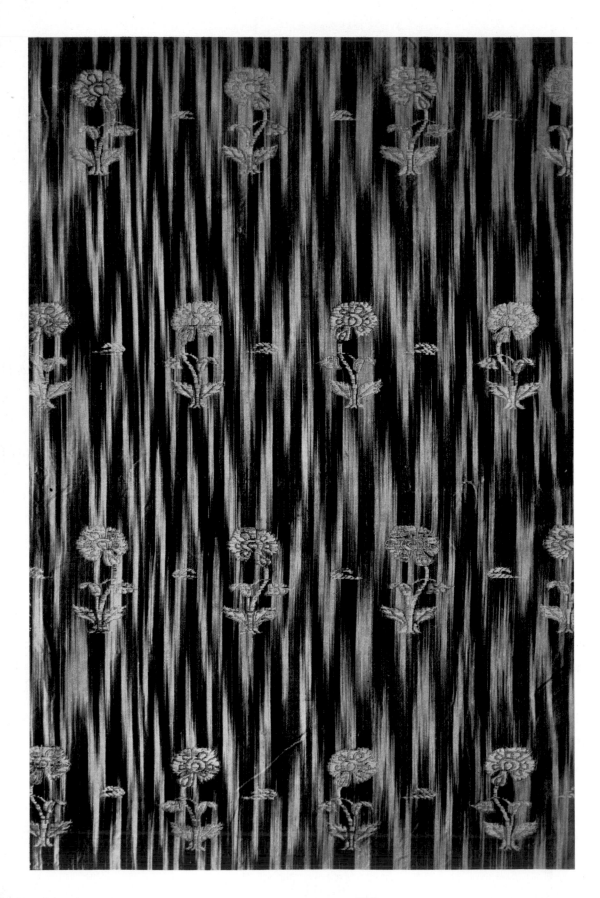

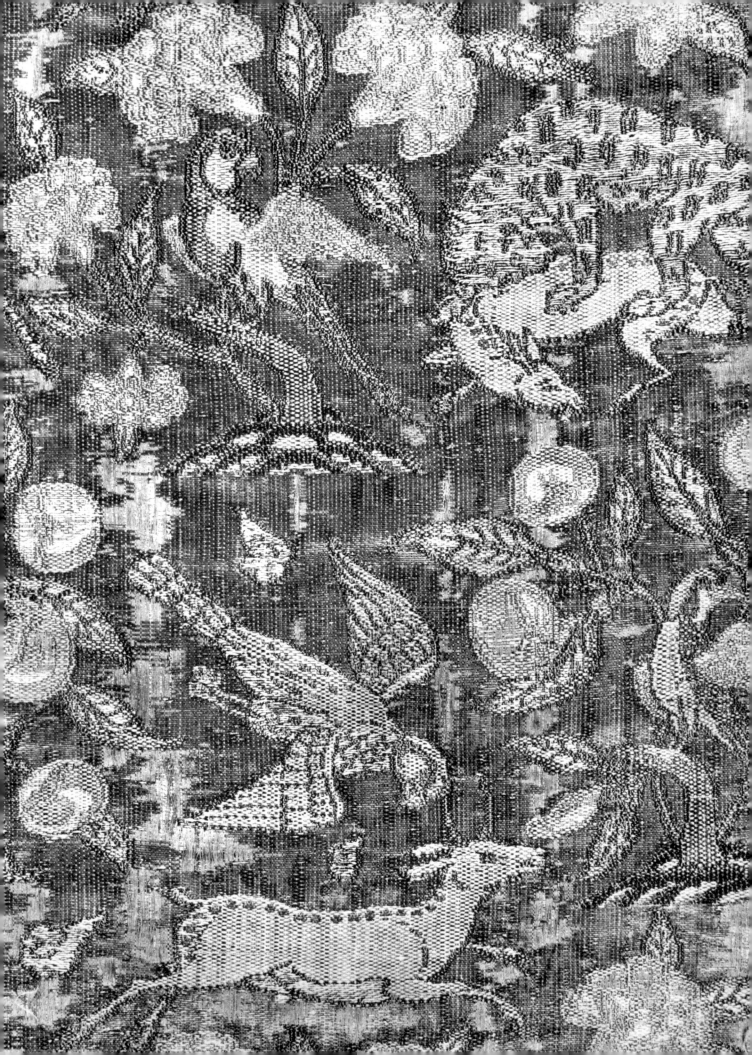

92. Light Blue Coat with Floral Decoration. L. 31 in.

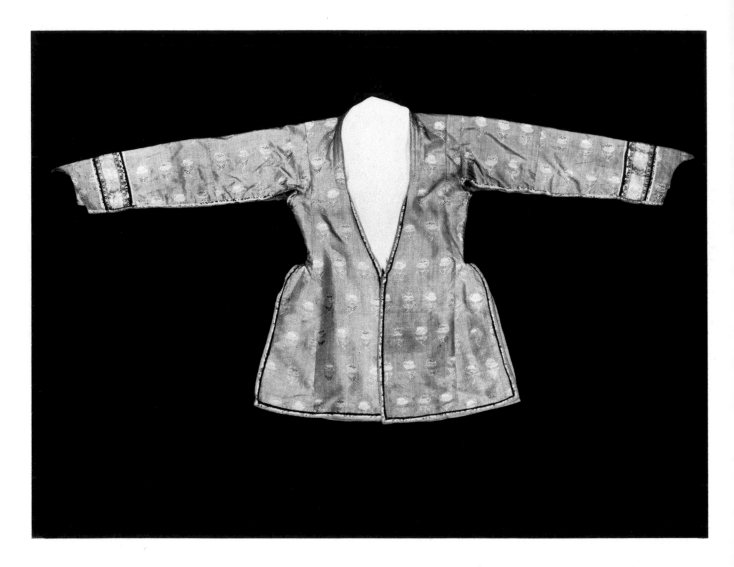

94. Gold Coat with Tulip Decoration. L. 41½ in.

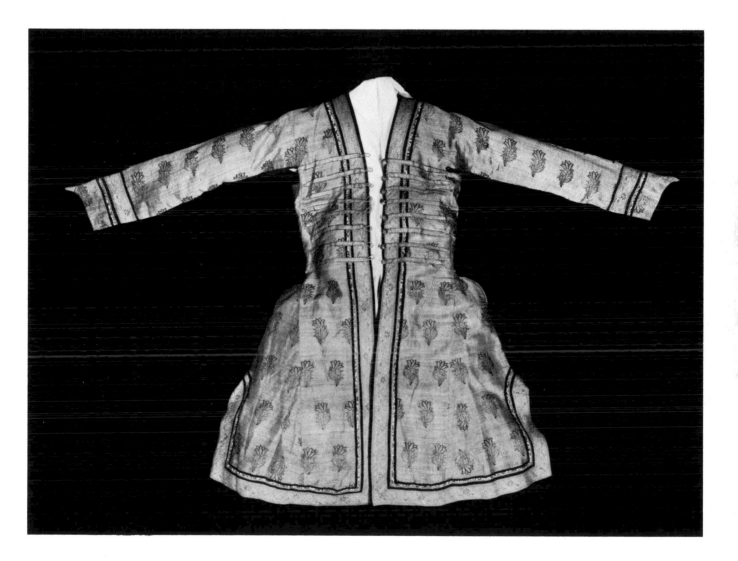

95. Brass Astrolabe. Diam. 7⅛ in. (Front and Back.)

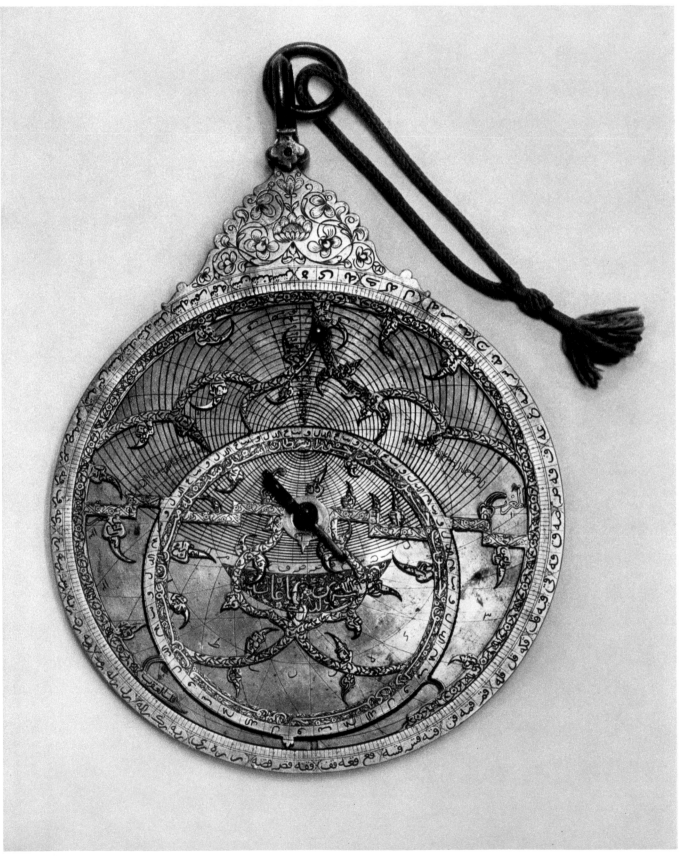

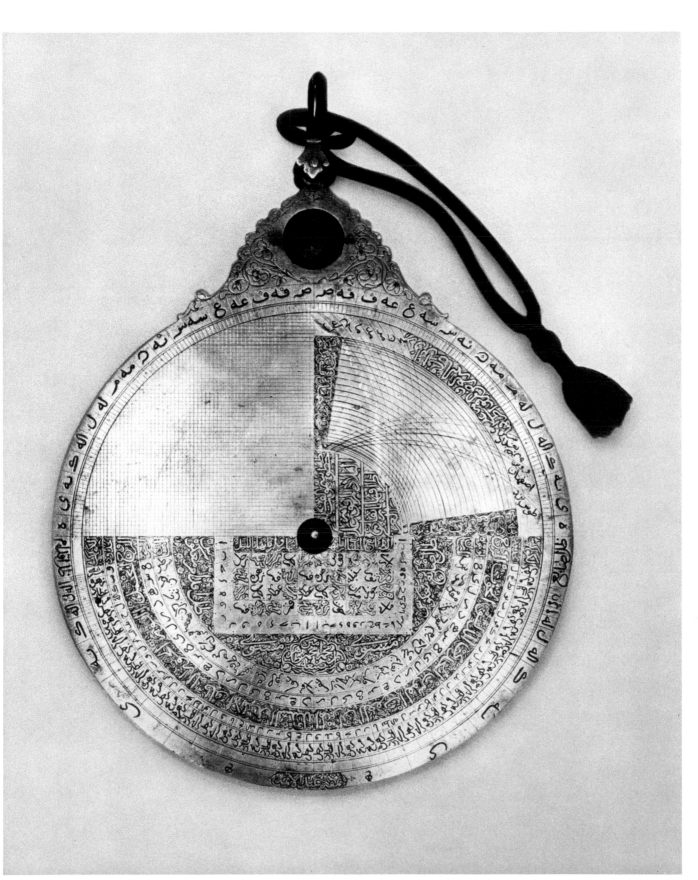

93. Blue Coat. L. 42¾ in.

85. Portrait of Shah 'Abbas I and a Page
Attributed to Mu'in Musavvir
Dated 1042 H. (1632/33) but probably finished in 1701
H. 10 in., W. 5⅞ in.
Fogg Art Museum; gift of John Goelet

The short inscription, apparently in Mu'in's hand, reads: "O, 'Ali! The picture of his excellency, the most high and most holy lord, Shah 'Abbas Safavi Bahadur Khan. Finished in the year 1042."

The picture is puzzling. Stylistically it is clearly Mu'in's work, but it is neither an original conception nor a complete painting. The key to its history lies in a large album page in Leningrad: in the upper right stand these same two figures; in the upper left, stretching his hands out to receive the cup the Shah offers, is Khan 'Alam, the ambassador sent by the Mughal emperor Jahangir to Isfahan in 1618; two youths and a horse stand by a stream at the bottom of the painting. Between 'Abbas and Khan 'Alam is a lengthy, precise inscription stating that the picture is the work of Riza yi 'Abbasi on the 17th of Rajab, 1042 H. (28 January, 1633) and that it was done at the order of the court physician Shamsa Muhammad.[1]

Despite the "wooden" character of the figures in this larger painting, it seems highly likely that it is the work of the aging Riza, painting an "official" group portrait some fifteen years after the event.[2] What may well be the preliminary sketches for this larger work exist in the form of two separate album pages in Paris, one showing 'Abbas and his attendant and the other showing Khan 'Alam.[3] Both bear inscriptions informing us that they were sketched by Riza in 1613 and 1615 (i.e., several years before the Mughal's visit in 1618!) but finished by Mu'in in 1701. Despite the less than exciting quality of the work, I would accept the inscriptions as essentially correct. The mistaken dates are easily understandable: whoever provided the inscriptions was writing eighty-three years after the Mughal's 1618 visit.

Stylistically, the portrait in this exhibition bears a closer relationship to the Paris picture than to the one in Leningrad. As in the Paris portrait ascribed to Mu'in, 'Abbas here carries a dagger stuck in his sash, wears bejeweled boots, and sports a fur hat topped with feathers. All of these features are absent from the larger Leningrad picture ascribed to Riza.

My conclusion is that Riza completed the larger painting in 1633, as the inscription says, but used as its basis the preliminary sketches he did at the time of Khan 'Alam's visit in 1618. In 1701 his aged student Mu'in turned to the sketches, refurbished and painted them, and was either so fond of the subject or so dissatisfied with his own reworking of his master's sketches that he painted a new version of at least one of them—our painting of Shah 'Abbas and his attendant.[4]

1. This page is reproduced in F.R. Martin, *Miniature Painting and Painters of Persia, India, and Turkey* (London, 1912) pl. 160; O.F. Akimushkin & A.A. Ivanov, *Persidskie Miniaturi XIV-XVII v.* [Persian Miniatures of the 14th-17th Centuries] (Moscow, 1962), pl. 66; E. Kühnel, "Han 'Alam und die diplomatischen Beziehungen zwischen Gehangir und Shah 'Abbas," *Zeitschrift der deutschen morgenlandischen Gesellschaft* (1942), vol. 96; and B. W. Robinson, "Shah 'Abbas and the Mughal Ambassador Khan 'Alam: The pictorial record," *Burlington Magazine*, 827 (February, 1972), pp. 58-63.

2. See the discussions in Stchoukine, *Manuscrits de Shah 'Abbas,* p. 27, and in the above studies.

3. E. Blochet, *Les enluminures des manuscrits orientaux de la Bibliothèque Nationale* (Paris, 1926), pl. 107.

4. All three paintings are good likenesses of the king, for they are strikingly similar to portraits of 'Abbas by the great Mughal portraitist Bishindas (see the above studies and Coomaraswamy, *Collection Goloubew*, pl. 73).

86. Portrait of a Russian Ambassador
'Ali Quli Jabbehdar
Dated 1129 H. (1716/17)
H. 12 in., W. 8 in.
Collection of Prince Sadruddin Aga Khan

In 1715 Peter the Great of Russia dispatched an embassy to Iran to negotiate a commercial treaty and to obtain first-hand information about the economic and military strength of the country. The Russian diplomatic expedition encountered enormous difficulties, not only in reaching Iran but also in attaining its several goals there, and did not return until 1719. Peter had appointed as his ambassador one of his younger officials, a man of good family named Artemii Petrovich Volynsky, who returned to Russia so shocked by the corruption, ennervation, and decay of Iran under Sultan Husain that he predicted the speedy collapse of the Safavi regime under the Afghan attack. (See L. Lockhart, *The Fall of the Safavi Dynasty and the Afghan Occupation of Persia* [Cambridge, 1958], pp. 103-108.)

The costume of this dignified gentleman clearly identifies him as a Russian. In 1716/17 when this sensitive portrait was finished, Volynsky was only thirty years old. The gray beard half-conceals a face relatively unlined, and this fact, coupled with the fine garments of the figure, make it seem highly likely that the person portrayed is the ambassador himself.

'Ali Quli Jabbehdar was by this time well advanced in age. His earliest dated work is 1675/76, and he must have been at least in his sixties when he painted Volynsky. Age has enriched his palette to lustrous reds and yellows and rich browns which are far from the pale tones of his two earlier works.

On the reverse of this painting, originally a folio in an album, is a page with four lines of calligraphy signed by Muhammad Amin and dated 1108 H. (1696/97). (See Appendix E.)

87. Calligraphy
'Ali Riza 'Abbasi
Late 17th-early 18th century
H. 9⁵⁄₁₆ in., W. 5⁷⁄₁₆ in.
Fogg Art Museum; gift of John Goelet

It is most unlikely that the great mid-Safavi calligrapher 'Ali Riza 'Abbasi lived until the end of the seventeenth century, and we are here dealing with another gifted master of the same name who, as the four smaller medallions between the lines of poetry indicate, served under Shah Husain (1694-1722).

The verses are extracts from the *Hadiqat al-Haqiqat* (Garden of Truth) of the twelfth-century mystical poet Sana'i. They have been gracefully translated by the late Eric Schroeder who remarked that they were applicable to the life of artists, for the margin concerns "the laborious acquisition of skill," while the center verses speak of "the anguished carefulness of skill's exercise."

Margin:

> *Like the Sun, named Khurshid,*
> *Yet in the light of certainty completely human,*
> *He allowed himself neither the Path of Food nor the Path of Sleep,*
> *Till even the thought of sleep was gone from his memory.*
> *Great possessions are for the grandees in this kingdom,*

For those whose lofty estate and nobility utterly
 separate them from the rest.
So he turned his face to the Mihrab of Worship
And tore a rent in the Veil of Habit.
Till one was sent to say to him:
O, thou, who seekest Good
In the path of sincerity and purity, but with so little skill—
It does no good for a man just to sit all alone;
The only one whom sleep not overtakes is God.

Center:

I have heard that the exalted Master of his Craft
Was driving a donkey loaded with glass.
Someone said to him: I marvel that you are so slow in
 action.
So slow in going ahead—what is your donkey loaded with?
He answered: Because my heart is full of anxiety,
For if this donkey falls down, I have nothing at all.

88. Qur'an with Red and Gold Lacquer Binding
Inscription on binding signed by 'Ali Riza 'Abbasi
Dated 1125 H. (1713)
H. 11¹³⁄₁₆ in., W. 8¹⁄₁₆ in.
Museum of Fine Arts, Boston

This *Qur'an* was very likely produced under the patronage of
the pious Shah Sultan Husain whose name appears on a
splendid page of calligraphy by this late Safavi master (No.
87).

Publ.: Pope and Ackerman, *Survey,* vol. 9, pl. 977/B.

(Shown only at the Fogg Art Museum.)

89. Blue and White Flask with a Silver Top
Late 17th century
H. 14⅝ in., Diam. 7⅞ in.
Museum of Fine Arts, Boston

Chinese export ware has exerted a more moderate effect here
than in No. 81: the tumbling crane, the dumbly startled doe,
the vacuous hunter with weakling arms and a puny gun con-
vert the scene into a humorous landscape more in keeping
with Iranian types.

90. Blue Floral Ikat
Chiné plain cloth, brocaded with small gold flowers
17th century
L. 16 in., W. 10½ in.
Textile Museum Collection, Washington, D.C.

A *chiné* design is one which is dyed in the warps before they
are woven. The result here is a brilliant, irregular zig-zag pat-
tern changing from dark to light blue. The technique flour-
ished in Indonesia, as its Indonesian name, ikat (to wrap
around), indicates. There is also a smaller piece of seven-
teenth-century Persian ikat in the Textile Museum, but no
other Safavi examples are known. Although Muslim mer-
chants had reached Indonesia as early as the thirteenth cen-
tury, a major expansion of trade and of Islam took place in the
sixteenth and seventeenth centuries, and it is surely as a result
of this increased interest in Southeast Asia that this weaving
technique reached Iran.

Publ.: Reath and Sachs, *Persian Textiles,* pp. 71, 72 (example 10);
Pope and Ackerman, *Survey,* vol. 5, p. 2134, vol. 11, pl. 1051.

91. Deer, Tigers, and Birds
Nagdeh: compound cloth of silk, silver, and gilt-silver yarns
Late 17th century
L. 25 in., W. 12½ in.
Museum of Fine Arts, Boston

This brilliant repeat pattern works in many directions—hori-
zontally, vertically, diagonally, and as a zig-zag—and each
reveals a different movement and different succession of
scenes. The several shades of silk (greenish yellow, yellow,
rose, and blue) cause these scenes to stand out as if in relief
from the flat metal ground which consists of thin strips of
silver.

See: Pope and Ackerman, *Survey,* vol. 11, pl. 1072/A (an additional
fragment from the same cloth).

92. Light Blue Coat with Floral Decoration
Stamped, plain, silk twill, with silk and gilt thread brocade
Late 17th century
L. 31 in.
Textile Museum Collection, Washington, D.C.

The subtle grace in both the cut and the material of this aristo-
cratic coat matches that of No. 94.

93. Blue Coat
Plain cloth, brocaded in gold, red, white, and green
Early 18th century
L. 42¾ in.
Yale University Art Gallery; Hobart Moore Memorial
 Collection, gift of Mrs. William H. Moore

The dark blue fabric is decorated with a pattern of rose trees
whose flowers are alternately red and white. Trimmed with a
gold band, the coat has long, tight sleeves at the end of which
are flaps to cover the hands. The buttons are covered with
silver thread.

94. Gold Coat with Tulip Decoration
Stamped, plain, silk twill, brocaded with flowers
Late 17th—early 18th century
L. 41½ in.
Textile Museum Collection, Washington, D.C.

The gold ground of this coat is made of an orange silk warp
and a gilt yellow weft. Silk brocade of various colors is used
for the floral decoration. Each flower is enclosed in a subtle
diamond-shape, composed of diagonal lines stamped on the
fabric.

Publ.: Reath and Sachs, *Persian Textiles,* p. 73 (example 13); Pope
and Ackerman, *Survey,* vol. 5, pp. 2116, 2208, 2254, vol. 11, pl.
1088/B.

95. Brass Astrolabe
Early 18th century
Diam. 7⅛ in.
The St. Louis Art Museum

Iranian, and particularly Safavi, interest in and dependence on
astrology necessitated a productive "astrolabe industry." On
the back of this instrument is inscribed the name of its maker,
Muhammad Amin ibn Muhammad Tahir, a well known master
whose father was also an astrolabist. The fine designs covering
the surface of the astrolabe are the work of another master,
'Abd al-A'imma, who not only decorated instruments but also
made them.

In the front of the astrolabe is a movable *rete* (a circular plate with many holes used to indicate the positions of the principal fixed stars) whose forty-two leaves point to the stars on the removable disk behind. The instrument is provided with six disks, each inscribed on both sides, which diagram the heavens for the latitudes of all the major cities of the Near East. The disks for latitudes 32, 34, and 36 are especially elegant, since these are the latitudes for Iran. On the inside of the astrolabe is a list of the longitudes and latitudes of forty-six major cities. On the back of the astrolabe are the maker's and decorator's names, as well as a number of astronomical tables and graphs.

The information given here is largely a summary of material provided by Dr. Owen Gingerich of the Smithsonian Astrophysical Observatory and Harvard University, who is preparing an historical study of astrolabes and who has concluded that of several "signed" examples of 'Abd al-A'imma's work in North American collections, this is the only authentic one.

96. Carnelian and Silver Oval Seal
Dated 1139 H. (1726/27)
H. 1½ in., W. 1⅝ in.
Seattle Art Museum; Eugene Fuller Memorial Collection

In the central oval medallion is a nasta'liq inscription in Arabic which reads: "May God be satisfied. I trust in God. There is no power and no authority except in God. His servant Hajji Mustafa 1139."

Circling around it is a Persian inscription, two verses citing the name of the saintly figure Khizr, who was traditionally regarded as aiding the helpless:

Oh, Lord, show favor to my helpless self
And grant assistance to me who am helpless.
Every man who has no one relies on Khizr.
My helpless self has no Khizr save you.

About the seal's owner, Hajji Mustafa, nothing is known, but the seal's date is four years after the Afghan occupation of Isfahan.

97a. Silver coin. "Urdu," 913 H. (1507/08). Reign of Isma 'il I (1501-1524). 44 mm.

Coinage Under the Safavis

In sheer beauty and technical quality the coins of Safavi Iran are rivaled only by those of the Mughals in India. While the Mughals produced a far greater variety of coinage, the Safavis struck money of greater calligraphic elegance. Influenced by the Hinduism of the majority of their subjects as well as by the imperial imagery of European coinage, the Indian emperors in the seventeenth century minted coins bearing their own profiles. The Safavis, however, in their coinage remained faithful to the Islamic strictures against portrayal of men or animals on coinage. As a result, with rare exceptions, the artistry of Safavi coinage relies on eloquent calligraphic compositions.

The basic inscription on the obverse of almost all Safavi coins is the Shi'a profession of faith: "There is no God but God; Muhammad is his prophet; 'Ali is his Regent." If there is a margin around this central inscription, the creed is supplemented by the names of the twelve imams. On the reverse is usually found the monarch's name, his royal epithets, the location of the mint, and the date. Beginning with Isma'il II and later continuing under 'Abbas II, Sulaiman, Sultan Husain, and his puppet successors, the monarch's name is mentioned as part of a distich, a characteristic confined to Islamic coinage in Persia.

In the coins issued under the early Safavi monarchs the script is the stately Naskhi, tall, slow-moving letters composed of controlled curves. By the middle of the seventeenth century it was replaced on the reverse by the shorter, more rounded, and more swiftly moving nasta'liq, though the obverse with the profession of faith still retained the use of the more traditional and perhaps more orthodox Naskhi. The late seventeenth century finds nasta'liq often used on both sides of the coin, and while the reign of the last independent Safavi monarch, Shah Sultan Husain, was the dynasty's least effective, his coinage is its most splendid.

All of the following seventeen coins, representing each of the Safavi rulers, have been lent to this exhibition by the American Numismatic Society.

139

b. Gold coin. Isfahan, 931 H. (1524/25). Reign of Tahmasp I (1524-1576). 18 mm. *Above left*

c. Silver coin. Fumin, date effaced. Reign of Isma 'il II (1576-1577). 21 mm. *Above right*

d. Gold coin. Qazvin, 987 H. (1579/80). Reign of Muhammad Khodabandeh (1577-1587). 18 mm. *Below left*

e1. Gold coin. Dizful, date effaced. Reign of 'Abbas I (1587-1629). 19 mm. *Below right*

e2. Silver coin. Mint effaced, 996 H. (1587). Reign of 'Abbas I (1587-1629). 24 mm. *Above left*

e3. Gold coin. Kashan, 997 H. (1588/89). Reign of 'Abbas I (1587-1629). 16 mm. *Above right*

f. Silver coin. Ganjeh, 1040 H. (1630/31). Reign of Safi I (1629-1642). 19 mm. *Below left*

g. Silver coin. Erivan, 1077 H. (1666/67). Reign of 'Abbas II (1642-1666). 33 mm. *Below right*

h. Silver coin. Isfahan, 1099 H. (1687/88). Reign of Sulaiman (1666-1694). 51 mm. *Above left*

i1. Silver coin. Isfahan, 1114 H. (1702/03). Reign of Sultan Husain (1694-1722). 49 mm. *Above right*

i2. Copper coin (fulus). Isfahan, 1115 H. (1703/04). Reign of Sultan Husain (1694-1722). 37 mm. *Below left*

i3. Silver coin. Isfahan, 1129 H. (1716/17). Reign of Sultan Husain (1694-1722). 18 x 26 mm. *Below right*

i4. Gold coin. Isfahan, 1134 H. (1721/22). Reign of Sultan Husain (1694-1722). 23 mm. *Above left*

j. Silver coin. Isfahan, 1144 (1731/32). Reign of Tahmasp II (1729-1732). 44 mm. *Above right*

k. Gold coin. Isfahan, 1145 (1732/33). Reign of 'Abbas III (1732-1736). 24 mm. *Below left*

l. Silver coin. Mazandaran, 1167 H. (1753/54). Reign of Isma 'il III (1750-1756). 29 mm. *Below right*

97A. Isma'il I (1501-1524)
Silver, "Urdu," 913 H. (1507/08)
44 mm.

In the early, unstable years of the Safavi dynasty Shah Isma'il I was frequently on the march in military campaigns against internal and external enemies. "Urdu" is the Persian word for "military camp," and it is apparent that a royal mint accompanied the Shah on these campaigns in order to supply him with ready Shi'a coinage for conquered provinces and to convert captured bullion and Sunni coins into Safavi money.

B. Tahmasp I (1524-1576)
Gold, Isfahan, 931 H. (1524/25)
18 mm.

"Isfahan" first appears on coinage under the Seljuqs, when the city served as capital for some time. Although the northwest Iranian city of Tabriz was still the capital of Iran in 1524, Isfahan was a major center of commerce and culture.

C. Isma'il II (1576-1577)
Silver, Fumin, date effaced
21 mm..

On the obverse the Shi'a creed has been abandoned, and instead we read a rhymed couplet:

*If an Imam there be between the east and west,
'Ali alone with 'Ali's house for us is best.[1]*

Although R. S. Poole reasons that Isma'il II departed from the standard, pious formula in order to prevent God's name from passing through the hands of unbelievers, there is a more significant explanation. Demented by a twenty-year incarceration and an eventually fatal drug addiction, Isma'il II seems to have been driven by a compulsion to undo all the stability which, over his long reign, his cautious father Tahmasp had achieved. Zealously he attacked all the foundations of the Safavi state: he extirpated some of the leading feudal nobles and several of the great tribes; he persecuted the Sufi orders which had been mainstays of the Safavi regime; and he attempted to move Iran back into the fold of Sunni orthodoxy. On coinage he dropped the Shi'a profession of faith and replaced it with a reference to 'Ali which clearly has a double meaning.[2]

1. This, as well as the following five distichs, has been translated by R.S. Poole (see Bibliography).

2. This hypothesis has been advanced by W. Hinz (see Bibliography).

D. Muhammad Khodabandeh (1577-1587)
Gold, Qazvin, 987 H. (1579/80)
18 mm.

E. 'Abbas I (1587-1629)
1. Gold, Dizful, date effaced
19 mm.

The four previous coins' inscriptions have been in Arabic. On this coin appears the first use of Persian—a single phrase "the servant of the Shah of Holiness," a Shi'a epithet popularized by Shah 'Abbas. The "Shah of Holiness" refers to 'Ali. 'Abbas was particularly proud of his family's claim to descent from 'Ali, and the same epithet appears on his seal (see No. 6) and his sword (No. 45).

2. Silver, mint effaced, 996 H. (1587)
24 mm.

3. Gold, Kashan, 997 H. (1588/89)
16 mm.

F. Safi I (1629-1642)
Silver, Ganjeh, 1040 H. (1630/31)
19 mm.

While the wording of the profession of faith on this coin has not changed, 'Ali's name follows immediately after God's, while the Prophet's follows 'Ali's. This alteration may well be evidence of the tendency of Shi'ism to equate 'Ali's role in the formation of Islam with that of Muhammad.

G. 'Abbas II (1642-1666)
Silver, Erivan, 1077 H. (1666/67)
33 mm.

The couplet on the reverse reads:
*Throughout the world imperial money came,
Struck by God's grace in 'Abbas II's name.*

H. Sulaiman (1666-1694)
Silver, Isfahan, 1099 H. (1687/88)
51 mm.

This finely struck, elegant coin displays a distich which reads:
*Since on my soul I struck the stamp of 'Ali's love,
The world obeyed my rule by grace of God above.*

I. Sultan Husain (1694-1722)
1. Silver, Isfahan, 1114 H. (1702/03)
49 mm.

The coinage of Sultan Husain is the most elegant and the most abundant of the entire Safavi period. On the reverse is an elaborate distich:

*Money he struck by the grace of the Lord of east and west, the twain,
Everywhere, dog of the Prince of the Faithful's Shrine, Sultan Husain.*

The "Prince of the Faithful" refers not to 'Ali, but rather to the Imam 'Ali Riza, the eighth Shi'a Imam, nominated for the caliphate in the early ninth century but martyred before he became caliph. His tomb in Meshhed, long an object of veneration, was promoted by the Safavis as a pilgrimage site, as a counterpoint to the holy places of Kerbela and Najaf in Iraq which were frequently in Ottoman hands. The appearance of his epithet on the coinage of the pious Sultan Husain is an indication of the enormous popularity of his cult.

2. Copper fulus, Isfahan, 1115 H. (1703/04)
37 mm.

Rulers' names appear only on the gold and silver coinage of the Safavis. Coins in copper were also issued, though not from royal mints. Each city probably had local mints which issued the many copper coins which can be dated or attributed to the seventeenth and eighteenth centuries. The value of the fulus is uncertain, but the coin is of striking visual appeal: the image of the lion and sun has long been a symbol of the Iranian monarchy.

The appearance of an image of a specific living creature is unusual, but not unprecedented. Undoubtedly the less official nature of this type of coinage permitted greater laxity.

Other copper coins of this type depict peacocks, elephants, camels, rams, rabbits, swans, horses, and falcons.

3. Silver, Isfahan, 1129 H. (1716/17)
18 x 26 mm.

Oblong coinage was a peculiarity of the later Safavis, beginning with Sultan Husain.

4. Gold, Isfahan, 1134 H. (1721/22)
23 mm.

This elegant coin was struck the year before Isfahan fell to the Afghans.

J. Tahmasp II (1729-1732)
Silver, Isfahan, 1144 H. (1731/32)
44 mm.

Sultan Husain and almost all his family were murdered by the Afghans. Of the surviving children Tahmasp II was the eldest. His coinage was more elegant than his rule. Rarely effectual by himself, he became a puppet in the hands of the ambitious and effective Khorasani general, Nadir, who later deposed and murdered his "master." The distich reads:

Throughout the world imperial coinage came,
Struck by God's grace in Tahmasp II's name.

K. 'Abbas III (1732-1736)
Gold, Isfahan, 1145 H. (1732/33)
24 mm.

When Nadir deposed Tahmasp II, he set up the Shah's infant son 'Abbas as Shah. The distich reads:

Throughout the universe by grace divine a golden
money came,
Struck by God's shadow, a new emperor 'Abbas III
[by name].

Despite the hyperbole of the verse, the popularity of the Safavis had sunk to a low ebb, and it is apparently for this reason that Nadir issued a concurrent coinage, minted not in the Shah's name but rather in that of the Imam Riza in Meshhed.

L. Isma'il III (1750-1756)
Silver, Mazandaran, 1167 H. (1753/54)
29 mm.

With even less justice than in the case of Tahmasp II or of 'Abbas III can we refer to Isma'il III as a monarch. The son of one of Sultan Husain's daughters, and only one of several Safavi claimants to the throne, the unfortunate man was never more than a puppet in the hands of three successive king-makers, under each of whom he "issued" coinage. This particularly striking example was minted during his "tutelage" under Muhammad Khan Qajar in one of the Caspian provinces in northern Iran.

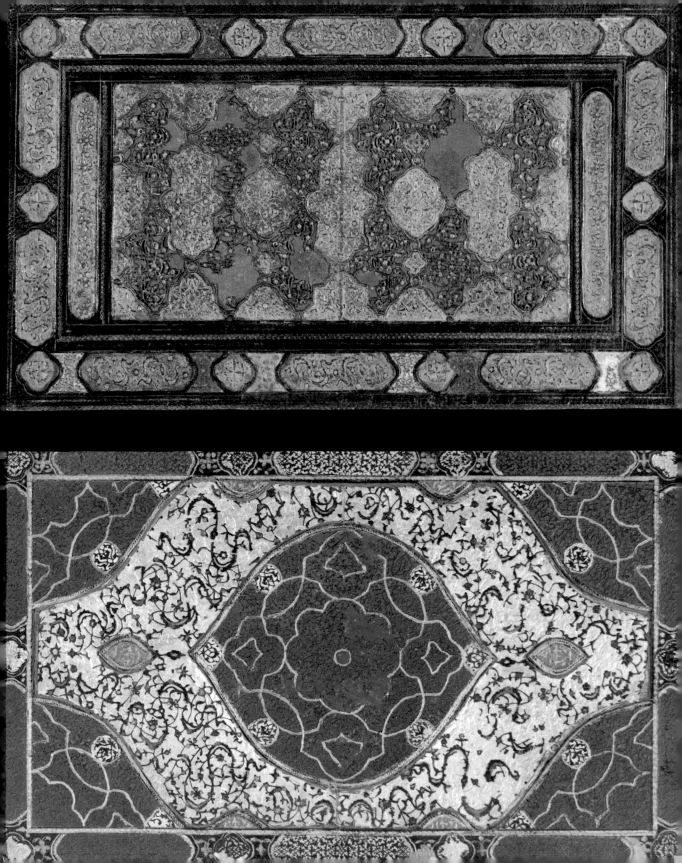

Biographies of Artists

The painter Sadiqi Bek Afshar Appendix A

Sadiqi (1533/34; ca. 1612 H) entered the royal service as a painter under Shah Tahmasp I (1524-1576) and trained under the great calligrapher Mir San'i and the master painter Muzaffar 'Ali. An accomplished painter, prolific writer, and skilled poet, he rose fast in the service of Shah 'Abbas I and soon became Director of the Royal Library, the most prestigious and lucrative appointment in the Safavi artistic hierarchy. His tenure was short. Always a highly critical and unforgiving man, he rubbed not only his underlings the wrong way, but also his superiors. About the year 1593 the Shah dismissed him from his post, even though Sadiqi continued to receive his salary and hold his official rank until his death some eighteen years later.

The Directorship which he had lost was transferred to 'Ali Riza 'Abbasi, one of the two great calligraphers who served under Shah 'Abbas (see No. 15). By all accounts the two men hated each other with a passion. Official artistic life at the royal court was far from smooth. Though deprived of his powerful position, Sadiqi was hardly idle. He continued to produce single paintings and drawings and even went so far as to commission his own manuscript, a 1593 *Anvar-i Suhaili* which he illustrated himself with 107 miniatures. It is the only known instance of a major artistic undertaking under the patronage of an artist and is singular evidence of Sadiqi's high opinion of himself.

By the turn of the century, when he was well established in the new royal capital of Isfahan, he had produced several important works of literature, including a collection of incisive and often sarcastic biographies of the kings, aristocrats, officials, calligraphers, painters, and poets whom he had known in his long life. He also composed an invaluable treatise on the theory and practice of painting, an Iranian counterpart to Cenino Cennini's *Craftsman's Handbook*. He finished as well some nine other books on a variety of subjects, including a well timed and properly praiseful poetic *Book of Victory of the Illustrious 'Abbas.*

The painter Aqa Riza Appendix B

"The painter of beauty Aqa Riza[1] is the son of Maulana 'Ali Asghar; it is fitting that the present age should be proud of his existence, for in the flower of his youth he brought the elegance of his brushwork, portraiture, and likeness to such a degree that, if Mani and Behzad[2] were living today, they would praise his hand and brush a hundred times a day. In this age he has no rival; master painters, skillful artists who live in our times regard him as perfect."[3]

So Qadi Ahmad, the turn-of-the-seventeenth-century chronicler of the arts, begins his discussion of Riza, the painter who, more than any other, shapes the course of seventeenth-century painting in Iran. His praise is not exaggerated. The pampered artistic "darling" of Shah 'Abbas, Riza revived the flagging traditions of late-sixteenth-century art and brought a new vision into Safavi painting. He knew he was a genius of the first order and he was not an easy man to live with. Isfahan seems hardly to have been able to contain him. He rose to high personal favor under the young Shah and later knew the bitterness of royal displeasure. His life style swung from that of the aristocracy of the imperial court to the rough-and-ready living of the down-and-outs. Like many Safavi artists, he did not fit into the traditional role of artists wearing the royal livery.

'Abbas was only seventeen years old when he assumed power in 1587. Riza could not have been much older, and he must have joined the royal atelier at about the same time. He flourished and produced not only a series of single-page miniatures and drawings, whose svelte elegance and ultimate refinement have never been equaled, but also five paintings of astounding power for the great *Shahnameh* which the young Shah commissioned.[4] In this project, as in others, he came into contact with Sadiqi. A rivalry seems to have been established—Riza presenting a virtuoso performance of the traditions Sadiqi had so painfully attained, and Sadiqi striving to affirm his own achievement and to beat the younger master at his own game. But they were also painfully alike:

"In spite of the delicacy of his touch, (Riza) was so uncultured that he constantly engaged in athletic practices and wrestling, and became infatuated with such habits. He avoided the society of men of talent and gave himself up to association with such low persons. At the present time he has a little repented of such idle frivolity, but pays very little attention to his art, and like Sadiqi Bek he has become ill-tempered, peevish, and unsociable."[5]

Midway in his career, about 1605, Riza largely gave up his profession. Though the Shah frowned, he continued to support the painter, and when Riza surfaced from his plunge into "the company of hapless people and libertines,"[6] it was to work actively again in the royal atelier. But his touch had been coarsened by his experience and, perhaps, by his age. His work after 1620 is not simply less delicate; it is also less refined. His subjects frequently look like the low associates who dismayed our sources. Others are courtly types, but with an added layer of fat and a decided erotic lure. The aging Riza inclined toward two extremes: a coarsened genre and a surfeit of luxury.

The painter Mu'in Musavvir Appendix C

The most gifted of Riza's many students, Mu'in is the last great representative of the Safavi tradition: to the end of his extraordinarily long career of seventy-two years he largely avoided the European influences which characterize the works of most of his contemporaries, among them Muhammad Zaman and 'Ali Quli Jabbehdar. Mu'in was born about 1617. His first dated work occurs in 1635 and his last in 1707. He reportedly died the following year.

A brilliant and ingenious draftsman and a colorist of skill and daring, Mu'in sustained an enormous level of production during his lifetime: his securely attributed work rivals that of his famous teacher in quantity and frequently in quality. He not only executed stunning single-page drawings and paintings but also turned out an extraordinary number of finished manuscripts, some containing dozens of miniatures so uniform in style that we must conclude we are dealing with the work of his own hand and not that of his studio (see No. 57).

1. Riza's work from ca. 1587-1635 bears two signatures: Aqa Riza and Riza-yi 'Abbasi. The name "Riza" has been used here for the sake of simplicity. The careful analysis of I. Stchoukine (*Manuscrits de Shah 'Abbas*, pp. 85-133) has established that the two names undoubtedly belong to the same man. For a bibliography of Riza the reader is referred to the above publication.
2. The traditional paragons of painterly virtues.
3. Qadi Ahmad, *Calligraphers and Painters,* trans. V. Minorsky (Washington, D.C., 1959), p. 192.
4. Minovi, Robinson, Wilkinson, and Blochet, *Chester Beatty Library,* no. 277.
5. Iskandar Munshi, *Tarikh-i 'Alamara-yi 'Abbasi* [History of Shah 'Abbas and his Predecessors] (Tehran, 1896), p. 176, translation from T. W. Arnold, *Painting in Islam* (New York, 1965), p. 143.
6. Qadi Ahmad, *Calligraphers and Painters,* p. 193.

Mu'in's passion for accurate dating and thorough biographical details also lets us assume that the presence of his signature in his own highly distinctive hand means just what it says. Occasional miniatures in his manuscripts bear no inscription: they are also, for the most part, of lesser quality. It seems clear that these pages are largely the work of what must surely have been an active and extensive atelier operating under his direction.

Working in a milieu heavily impressed by the achievements of European painting, Mu'in, nevertheless, flourished under four successive monarchs—Safi, 'Abbas II, Sulaiman, and Husain. The only city name ever to appear on his inscribed work is Isfahan, and we can assume that he served steadily, and clearly diligently, in the royal atelier all his life. Though we have regrettably little information about his life, the inscriptions with which he supplied much of his work allow us to form a plausible estimate of his appealing character.

He was a meticulous man, sure and careful in his draftsmanship and with a developed sense of time and history which is a delight to the art historian. He surely recognized his role as the transmitter of Riza's innovations, and the scarcity of European influences in his work suggests that he possessed a conservative respect for his own traditions. He was a warm and observant man: humor and whimsey are notes as frequent in his art as are tradition and an almost journalistic concern with reporting the commonplace. His sense of history does not move on a grand scale, and his thumbnail sketches, both verbal and visual, deal with things of interest which passed through his apparently very bourgeois life. He produced a drawing of a young man carrying a rooster and inscribed it fondly for one of his three sons: "Drawn in haste for my child Aqa Zaman, Thursday, October 4, 1656. May he be blessed!" (See Stchoukine, *Manuscrits de Shah 'Abbas,* pp. 62-67.) A drawing in this exhibition (No. 75) records a sudden local tragedy that must have stunned the city and was made, says Mu'in, some time later as a distraction to pass the time on a bitterly cold day. He does a loving portrait of his master Riza and tells us in a note written decades later that the old man died that same year (see No. 76). And he sketches the head of a man simply "for his own amusement."

It is abundantly clear that where Mu'in is concerned old assumptions of patronage no longer apply. While producing impressive manuscripts and, presumably, single album pages for his royal master, Mu'in also did a considerable number of drawings and paintings for less exalted patrons who, we assume, paid him in cash or kind for his service. Nor was he an anonymous artist working humbly for his prince. He was fully conscious of his role and of the fact that his art (and his name inscribed on it) would survive long after both he and his patron had died. Surely this is why his apparently easy-going and gentle ego delighted in recording precisely when he produced his art, and how, and why. The whole Safavi period is marked by this kind of art-historical consciousness. But where Riza's historical sense seems methodically earnest, Mu'in's is lighter, and there is frequently a note of friendly whimsey in his comments.

The painter Muhammad Zaman Appendix D

Muhammad Zaman, born about 1640, was the son of one Hajji Yusuf. Of the artist's youth and education we know nothing, though it is likely that he, like most painters of the time, began his training very early. His strongly Europeanizing style does not necessarily indicate that he studied in Italy,

as has previously been assumed: first, because his painting reveals Flemish rather than Italian influence; second, because he easily could have become aware of Flemish techniques and motifs through prints of Flemish painting which circulated widely in seventeenth-century Iran.

By 1675 Muhammad Zaman must have been highly regarded at the royal court in Isfahan, for he was given the prestigious task of augmenting and refurbishing two of the great manuscripts of the previous century—the celebrated 1539-1543 *Khamseh* of Nizami, now in the British Museum, and the ca. 1587-1595 *Shahnameh* of Firdausi, now in the Beatty Library. One of his paintings in the former manuscript is his earliest dated work, 1086 H. (1675/76). From that date he continued in the royal service until his death, presumably in the first decade of the eighteenth century, for his last dated work was completed in 1115 H. (1703/04). (See Martin, *Miniature Painting,* pl. 173.)

Although four of his surviving works deal with themes from the Old and New Testaments, there is no reason to suppose that the artist was ever a Christian (although there has been scholarly dispute about this theory). What is far more likely is that the subject matter was determined by patronage rather than by personal inclination. All four paintings may have been part of an illustrated Bible commissioned by a Christian, most likely by one of the leading dignitaries of the large and important Armenian community in Isfahan. No. 72 in this exhibition includes an inscription which would hardly have been provided on a painting for a Muslim patron.

Of Muhammad Zaman's personality we know little, except that he must have had a high opinion of his own talents. In his refurbishing of the 1539-1543 *Khamseh* he not only added his own work to that of the greatest painters of the early sixteenth century but also took it upon himself to "improve" the paintings of Aqa Mirak, one of the most esteemed painters of Shah Tahmasp's time. When he turned to the Beatty *Shahnameh* he freely set about redoing both the faces and the landscapes of three of the illustrations by Sadiqi Bek. His activity in both cases does not seem to be that of a humble man with boundless respect for his illustrious predecessors.

The painter 'Ali Quli Jabbehdar Appendix E

Little is known about this painter who flourished in the second half of the seventeenth century. Our earliest information speaks of him as 'Ali Quli Bek Farangi, the last word an epithet meaning European. He came to Iran in the middle of the seventeenth century, was converted to Islam, and "was taken into the service of sultans," an expression which may indicate that he did not work in the royal atelier itself but served instead under a provincial aristocrat resident either in Isfahan or in another city. His *nisbah* Jabbehdar means Keeper of the Armor, apparently his formal assignment or title. His main period of activity falls within the reign of Shah Sulaiman.

His known work is most richly represented in the great Indo-Iranian album in Leningrad, whose folio 93 bears the date 1085 H. (1674) and an inscription stating that it was completed in the district of Qazvin, the former capital of Iran but by this time a far less important city than Isfahan. Since later Safavi Shahs, Sulaiman among them, were reluctant to leave Isfahan, it would seem likely that 'Ali Quli was not in the royal employ in Qazvin. Two additional miniatures in this album (folios 98 and 99) are inscribed in Georgian, and

we may suggest that 'Ali Quli was serving under one of the Georgian nobles who were active supporters of the Safavi royal house and often occupied high military and governmental posts, not only in Isfahan but also in other Iranian cities.

'Ali Quli's European origins would account for the dominant Western flavor in the paintings in this exhibition. As his work as a European painter is clearly not of the first rank, we may have a clear reason for his emigration to the Safavi empire whose connoisseurs were surely more concerned with the exotic flavor of his work than with its lack of sophistication. In fact, a number of European painters were employed at the Safavi court. Unlike Muhammad Zaman's version of the Rubens "Return from the Flight into Egypt," none of 'Ali Quli's works appear to be based upon a known European model, and we are left with the probable conclusion that they are original paintings.

'Ali Quli's son 'Abdullah Bek was head painter at the royal court, but there is no known work by his hand. The latter's son, Muhammad 'Ali Bek, continued the family profession under Nadir Shah (1736-1747) and died in 1758/59 in Mazandaran. He was particularly famed for his portraiture.[1]

1. Much of the information in this account of the painter is obtained from Ivanov, Grek, and Akimushkin, *Album indiskikh i persidskikh*.

Bibliography

Ackerman, P. *Guide to the Exhibition of Persian Art.* Catalogue of an exhibition at The Iranian Institute. New York, 1940.

Akimushkin, O. F., and Ivanov, A. A. *Persidskie Miniaturi XIV-XVII v.* [Persian Miniatures of the 14th-17th centuries]. Moscow, 1962.

Arnold, T. W. *Painting in Islam.* 1928. Reprint. New York, 1965.

Arnold, T. W., and Grohmann, A. *The Islamic Book.* Paris, 1929.

Bayani, M. *Mir 'Imad.* Tehran, 1951.

_____. *Khushnevisan* [Calligraphers]. Tehran, 1966.

Bellan, L. L. *Chah Abbas I.* Paris, 1932.

Binyon, L.; Wilkinson, J. V. S.; and Gray, B. *Persian Miniature Painting.* 1933. Reprint. New York, 1971.

Blochet, E. *Les peintures des manuscrits arabes, persans, et turcs de la Bibliothèque Nationale.* Paris, 1911.

_____. *Les enluminures des manuscrits orientaux de la Bibliothèque Nationale.* Paris, 1926.

_____. *Musulman Painting.* London, 1929.

Blunt, W. *Isfahan, Pearl of Persia.* New York, 1966.

Browne, E. G. *A Literary History of Persia.* 4 vols. Cambridge, 1959.

Bruyn, C. *Travels into Muscovy, Persia, and Part of the East Indies.* London, 1737.

Burlington House. *An Illustrated Souvenir of the Exhibition of Persian Art.* London, 1931.

Carswell, J. *New Julfa.* Oxford, 1968.

Chardin, J. *Voyages du Chevalier Chardin en Perse.* Edited by L. Langlès. 10 vols. Paris, 1811.

A Chronicle of the Carmelites in Persia and the Papal Mission of the XVII and XVIII Centuries. 2 vols. London, 1939.

Coomaraswamy, A. *Les miniatures orientales de la collection Goloubew au Museum of Fine Arts de Boston.* Ars Asiatica 13. Paris and Brussels, 1929.

Dilley, A. U. *Oriental Rugs and Carpets.* Revised by M. S. Dimand. Philadelphia and New York, 1959.

Dimand, M. S. "The Seventeenth-Century Isfahan School of Rug Weaving." In *Islamic Art in The Metropolitan Museum of Art.* New York, 1972.

Erdmann, K. *Oriental Carpets.* London, 1962.

_____. *Seven Hundred Years of Oriental Carpets.* Berkeley and Los Angeles, 1970.

Ettinghausen, R. *From Persia's Ancient Looms.* Catalogue of an exhibition at the Textile Museum. Washington, D.C., 1972.

Falsafi, N. *Zindigani Shah 'Abbas Awwal* [The Life of Shah 'Abbas I]. 2 vols. Tehran, 1965.

Godard, A. "Isfahan." *Athar-e Iran* 2 (1937).

Gray, B. *Persian Painting.* Lausanne, 1961.

Grube, E. *Muslim Miniature Painting.* Venice, 1962.

_____. "The Spencer and the Gulestan Shah-nama." *Pantheon* 22 (1964).

_____. "The Language of the Birds: the 17th century miniatures." *The Metropolitan Museum of Art Bulletin,* n.s. 25 (1967).

_____. *The Classical Style in Islamic Painting.* Venice, 1968.

Gulbenkian Foundation. *Oriental Islamic Art, Catalogue of the Collection of the Calouste Gulbenkian Foundation.* Lisbon, 1963.

Hanway, J. *An Historical Account of the British Trade over the Caspian Sea: with a Journal of Travels through Russia into Persia.* London, 1753.

Herbert, T. *A Description of the Persian Monarchy.* London, 1634.

Hinz, W. "Schah Esma'il II, Ein Beitrag zur Geschichte der Safaviden." *Mitteilungen des Seminars für Orientalische Sprachen* 36 (1933), pp. 19-100.

_____. *Irans Aufstieg zum Nationalstaat im 15. Jahrhundert.* Berlin and Leipzig, 1936.

Honarfar, L. *Gonjaneh Athar Tarikhi Isfahan* [A Treasure of the Historical Monuments of Isfahan]. Tehran, 1965.

Iskandar Munshi. *Tarikh-i 'Alamara-yi 'Abbasi* [History of Shah 'Abbas and his Predecessors]. Tehran, 1896.

Ivanov, A. A.; Grek, T. B.; and Akimushkin, O. F. *Album indiskikh i persidskikh miniatur XVI-XVIII v.* [Album of Indian and Persian Miniatures, 16th-18th centuries]. Moscow, 1962.

Krusinski, J. T. *The History of the Revolutions of Persia.* London, 1728.

Kühnel, E. "Der Maler Mu'in." *Pantheon* 29 (1942).

_____. "Han 'Alam und die diplomatischen Beziehungen zwischen Gehangir und Shah Abbas." *Zeitschrift der deutschen morgenländischen Gesellschaft* 96 (1942).

Lane, A. *Later Islamic Pottery.* London, 1957.

Malcolm, J. *History of Persia.* 2 vols. London, 1815.

Mans, Raphael du. *Estat de la Perse en 1660.* Paris, 1890.

Marteau, G., and Vever, H. *Miniatures persanes.* 2 vols. Paris, 1913.

Martin, F. R. *Miniature Painting and Painters of Persia, India, and Turkey.* 2 vols. London, 1912.

Martinovitch, N. "The Life of Mohammad Paolo Zaman." *Journal of the American Oriental Society* 65 (1925).

McMullan, J. V. *Islamic Carpets.* New York, 1965.

Minovi, M.; Robinson, B. W.; Wilkinson, J. V. S.; and Blochet, E. *The Chester Beatty Library, A Catalogue of the Persian Manuscripts and Miniatures.* Dublin, 1959-1962.

Müller, H. *Shah 'Abbas der Grosse in der Chronik Qazi Ahmad.* Mainz, 1960.

Olearius, A. *The Ambassador's Travels into Muscovy, Tartary, and Persia.* London, 1669.

Poole, R. S. *Catalogue of the Coins of the Shahs of Persia in the British Museum.* London, 1887.

Pope, A. U. *Persian Architecture.* New York, 1965.

Pope, A. U., and Ackerman, P., eds. *A Survey of Persian Art.* 6 vols. 1938. Reprint (12 vols.). Tokyo, 1964.

Qadi Ahmad. *Calligraphers and Painters.* Translated by V. Minorsky. Washington, D.C., 1959.

Rabino, H. L. *Coins, Medals, and Seals of the Shahs of Iran, 1500-1941.* Hertford, 1945.

Reath, N. A., and Sachs, E. B. *Persian Textiles.* New Haven, 1937.

Robinson, B. W. *A Descriptive Catalogue of the Persian Paintings in the Bodleian Library.* Oxford, 1958.

_____. *Persian Drawings.* New York, 1965.

_____. *Persian Miniature Painting.* London, 1967.

Röhrborn, K. M. *Provinzen und Zentralgewalt Persiens im 16. und 17. Jahrhundert.* Berlin, 1966.

Roemer, H. *Der Niedergang Irans nach dem Tode Isma'ils des Grausamen.* Würzburg, 1939.

Sadiqi Bek Afshar. *Tadhkireh-yi Majma' al-Khwass.* Tabriz, 1948.

_____. *Qanun al-Suvar.* Baku, 1963.

Sakisian, A. *La miniature persane.* Paris and Brussels, 1929.

Sanson, N. *Voyage ou relation de l'état présent du Royaume de Perse.* Paris, 1695.

Sarre, F., and Mittwoch, E. *Die Zeichnungen von Riza 'Abbasi.* Munich, 1914.

Savory, R. M. "The Development of the Early Safavi State under Isma'il and Tahmasp." Unpublished Ph.D. thesis, Oxford University, 1958.

Schroeder, E. *Persian Miniatures in the Fogg Museum of Art.* Cambridge, Mass., 1942.

Schulz, P. W. *Die persisch-islamische Miniaturmalerei.* 2 vols. Leipzig, 1914.

Schuster-Walser, S. *Das Safawidische Persien im Spiegel europäischer Reiseberichte (1502-1722).* Baden-Baden, 1970.

Sherley, A. *Relations of his Travels into Persia.* London, 1631.

Siroux, M. *Anciennes voies et monuments routiers de la région d'Ispahan.* Cairo, 1971.

Stchoukine, I. *Les peintures des manuscrits Safavis de 1502-1587.* Paris, 1959.

_____. *Les peintures des manuscrits de Shah 'Abbas I à la fin des Safavis.* Paris, 1964.

Tadhkirat al-Muluk [A Manual of Safavid Administration]. Translated by V. Minorsky. London, 1943.

Tavernier, J. B. *Les dix voyages de M. J. B. Tavernier en Turquie, en Perse, et aux Indes.* Paris, 1713.

Valle, P. della. *Les fameux voyages de Pietre della Valle.* Paris, 1723-1724.

Welch, A. *Catalogue of the Collection of Islamic Art of Prince Sadruddin Aga Khan.* 2 vols. Geneva, 1972.

_____. *Late 16th Century Painting in Iran.* Minneapolis: forthcoming.

Welch, S. C. *A King's Book of Kings.* New York, 1972.

Welch, S. C., and Dickson, M. *The Houghton Shahnameh.* Forthcoming.

Wilber, D. N. *Persian Gardens and Garden Pavilions.* Rutland, Vt., 1962.

Wilkinson, C. *Iranian Ceramics.* New York, 1963.

Zander, G. *Travaux de restauration de monuments historiques en Iran.* Rome, 1968.

Catalogue designed by Joseph del Gaudio
Production supervised by Françoise J. Boas
Composition by York Typesetting Co., Inc., New York, N.Y.
Printed in gravure and lithography by Nissha Printing Company Ltd., Kyoto

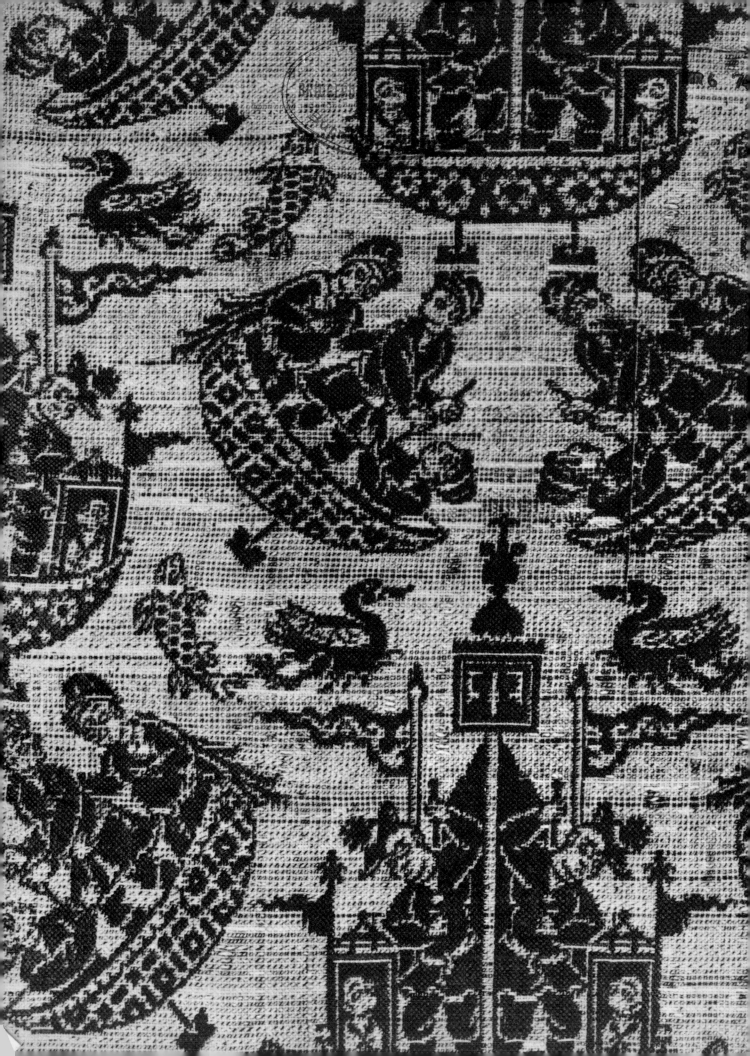